HAWAI'I

A History of the Big Island

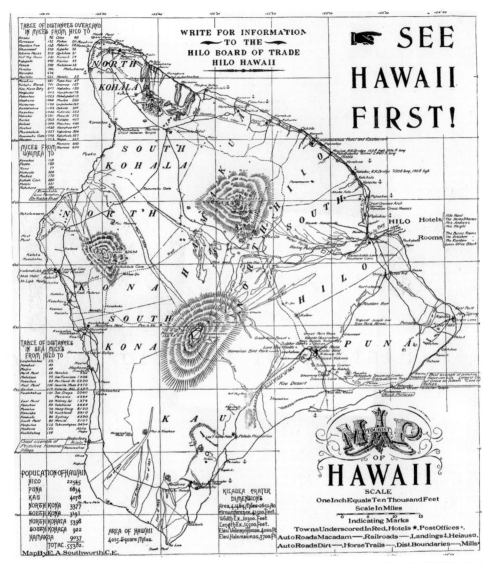

Map of the Big Island, c. 1915. The population figures in the lower left corner are from the 1910 United States Census. Courtesy Laupahoehoe Train Museum.

THE MAKING OF AMERICA

HAWAI'I

A History of the Big Island

ROBERT F. OAKS

ARCADIA

Copyright © 2003 by Robert F. Oaks.
ISBN 0-7385-2436-0

Published by Arcadia Publishing,
an imprint of Tempus Publishing, Inc.
Charleston SC, Chicago, Portsmouth NH, San Francisco

Printed in Great Britain.

Library of Congress Catalog Card Number: 2003103789

For all general information contact Arcadia Publishing at:
Telephone 843-853-2070
Fax 843-853-0044
E-Mail sales@arcadiapublishing.com
For customer service and orders:
Toll-Free 1-888-313-2665

Visit us on the Internet at http://www.arcadiapublishing.com

CONTENTS

ACKNOWLEDGMENTS

Writing a brief history of the Big Island is an undertaking as big as the island itself. The subject is huge, often complex, covers many centuries, and transcends various scholarly disciplines. If I have succeeded at all in distilling the story into a readable narrative, it is largely because of the help and support of many people and institutions.

I could not have written this book without access to the unparalleled manuscript and book collections of the Bancroft Library at the University of California, Berkeley. The staff was always friendly, helpful, and generous with their knowledge.

On the Big Island itself, I especially wish to thank Sheree Chase and Terre Kriege of the Kona Historical Society, Lynne Wolforth of the Lyman Museum, Jill Sommer of the Pacific Tsunami Museum, and Lisa Barton of the Laupahoehoe Train Museum. The State Archives in Honolulu provided most of the pictures in this book, and I very much appreciate the help of Luella Kurkjian and her very friendly staff. The staffs of the Mauna Kea Beach Hotel on the Kohala coast and the Crockett Museum in Crockett, California also provided welcome support and photos. I also received some good suggestions from Joseph Castelli, who, despite his disclaimers and modesty, really is a Kona historian. Finally, Rob Kangas, my editor at Arcadia Publishing, guided and supported this project to completion and made many suggestions that undoubtedly improved style and readability.

Necessarily, this book is largely derived from the scholarly works of others who have written in much greater detail about the topics included here. I thank all of them and hope I have not greatly distorted or misinterpreted their endeavors. Readers who want more information on particular subjects are directed to the bibliography.

INTRODUCTION

Sometime around 25 million years ago, great cracks or rifts in the Pacific Ocean floor began to erupt, gradually rising over millions of years and eventually producing a mountain range in excess of 1,500 miles long that became the Hawaiian Archipelago. The entire group consists of 132 islands, reefs, shoals, and atolls, stretching from Midway Island in the northwest to Hawai'i in the southeast.

The archipelago is among the most isolated land on earth. Despite the large number of islands in the chain, most of the soil rests on six major plots (Hawai'i, Maui, O'ahu, Kaua'i, Lana'i, and Moloka'i) and two smaller ones (Ni'ihau, and Kaho'olawe). The last to develop, and by far the largest formation in the chain, is what we now know as the Big Island of Hawai'i.

Seven separate volcanoes actually formed the Big Island. Mauna Kea, Mauna Loa, Hualalai, Kohala, and Kilauea are all well known. Two smaller volcanoes, Ninole and Kulani, were long ago buried under Mauna Loa's lava flows. Kohala is the oldest; Mauna Loa and Kilauea the youngest. Kilauea continues to erupt, increasing the size of the island. Mauna Loa erupted as recently as 1986, Hualalai in 1801, and the others several thousand years ago. Mauna Kea, with a peak at 13,784 feet above sea level, ranks as the highest mountain in the world if measured from its base deep beneath the sea.

The volcanoes have greatly influenced the history of the Big Island for centuries. First, they obviously made it "big"—larger than all other Hawaiian islands combined, and the biggest in the United States. Secondly, their high summits prevent many storms that affect the eastern or windward side of the island from reaching its western or leeward side. The result is a dramatic difference in climate and weather patterns most obviously between the two halves (wet and dry) of the island, but also at various elevations. Hilo, the wettest city in the United States, receives on average 130 inches of rain a year. Farther up the mountain, some areas receive as much as 300 inches annually. At the other extreme, Kawaihae in Kohala receives less than 10 inches a year.

Thirdly, the volcanoes caused major environmental disasters from time to time, destroying vegetation and villages, altering weather patterns, occasionally killing both people and animals, and thoroughly disrupting human life. This destructive power

was incorporated into Hawaiian mythology and religious practices. And finally, beginning in the early nineteenth century, the volcanoes became a major attraction for explorers, scientists, and ultimately tourists.

As the islands formed, trade winds and storms carried plant and animal life from one island to the next. Migrating birds carried seeds and spores to disperse native plants throughout the island chain. According to Hawaiian legend, Pele, the goddess of the volcano, visited each new island in turn until she finally took up residence on the Big Island. But while native flora and fauna developed over millions of years, isolation ensured it would be one of the last places on earth to see human settlement. Even after gaining a permanent population, all the islands in the chain remained secluded. They were and continue to be the most isolated inhabited region on earth, which inevitably helped determine the culture and history of the island chain.

Human settlement on the Big Island goes back nearly 2,000 years. Though other parts of the United States provide ample evidence of habitation long before that, few if any other places can trace a coherent history back as far as Hawai'i. This history is sometimes epic, often tragic and even depressing, occasionally heroic, frequently controversial, but always fascinating.

To help readers who are unfamiliar with its terms, there is a glossary of common Hawaiian words at the end of the book. To help with the pronunciation, where appropriate, Hawaiian words include the 'okina, or glottal stop, which results in something like the pause in the English expression "uh-oh."

ORIGINS

Who first discovered and settled the Big Island? Where did they come from? When did they arrive? How did they get there? Where did they settle? How did they live? And how do we know? These are all questions archaeologists, historians, anthropologists, and others have debated for many years. There is no written account of Hawaiʻi until the English Captain James Cook visited (not really "discovered") the island as he attempted to sail around the world in 1778. The history of the Big Island before the time of European contact must be constructed from other kinds of evidence.

There is no disagreement that the original Hawaiians were part of a larger Polynesian culture, but beyond that there has been substantial controversy over the last 100 years on many other fronts. Only in the last 20 years or so have new scientific techniques led to a growing new consensus (almost) on the questions listed above.

Despite the lack of a written record, there are several sources for the study of ancient Hawaiian history. First, we have written accounts of Captain Cook and other subsequent European visitors, who recorded the life they found in the late eighteenth and early nineteenth centuries. These chronicles may provide a good picture of the Big Island at that time, but they offer few clues regarding the previous several hundred years. Hawaiʻi in 1800 was almost certainly very different from Hawaiʻi in, say, the year 1000. In addition, Europeans who wrote these accounts viewed that picture through their own cultural lenses, observing a very different society and culture from their own.

A second source is the remarkable Hawaiian legends and stories orally handed down from generation to generation. These tales, which consisted of very detailed genealogical narratives of Hawaiian rulers, were not written down until the nineteenth century. They provide a wealth of information, yet they also present problems. Sometimes different legends will give various versions of the same event, and it is very difficult to estimate the dates of these experiences.

The legends, with meticulously detailed genealogies, are similar in some respects to the Old Testament. When we try to map them into our western calendar system, the common method is to apply a standard number of years to an average generation. If

we know that something happened 15 generations ago, we can guess at the date by applying a standard. However, experts throughout the years have used different standards. Some scholars use 30 years as the average length of a generation, others 25 years, and some use 20 years. The latter figure is most commonly accepted today.

Obviously, there will be dating problems when one scholar uses 20 and another 30 as the standard, especially if we are trying to go back 40 or 50 generations. Moreover, of course, no generation will be exactly average in length. Compounding the difficulty, one legend may relate that Chief A was the father of Chief B (two generations), while another states that the two were actually brothers (one generation).

A third source for the historian is the physical remains. The Big Island, especially the western half, is one of the richest areas for archaeological study in the United States. We have the remains of heiau (temples), houses, walls, sacred stones, petroglyphs, caves, and fishponds that tell part of the story. Advances in scientific techniques available to archaeologists, such as carbon dating, have challenged some traditional beliefs about early Hawaiians. Unfortunately, many archeological sites that once existed on the eastern half of the island were destroyed in the nineteenth century in the drive to plant more and more sugar cane. The picture we get from these remains, then, is incomplete.

Finally, computer modeling also helps determine early settlement patterns from estimates of climate at the time, population estimates based on food production and supply capabilities of a particular region, and navigational possibilities based on wind and current patterns.

Returning then to the questions presented above, who were the first Hawaiians and where did they come from? In the nineteenth and early twentieth centuries, most scholars would have said Tahiti was the "Kihiki" mentioned in Hawaiian legends as their homeland. By the 1960s, however, the consensus began to shift in favor of the Marquesas, north and east of Tahiti. The language of these eastern Polynesian islands is closer to Hawaiian than the dialect of Tahiti. There are also greater similarities with the archaeological remains and artifacts of the Marquesas.

While there is general agreement on the "where," there is less agreement on the "when." Three primary theories compete within the range of years sometime between 0 and 300 A.D., between the 300s and the 600s, and one in the 700s. Tools such as carbon dating prove helpful, but this technique can be compromised by instances such as the presence of much older driftwood used in fires in later years. Most scholars accept the period from the 300s to 600s, though there is by no means unanimity on this subject.

How they reached the island chain is also controversial. In his historical novel *Hawaii*, James Mitchner popularized the long-held view that the original immigrants came from the Society Islands (Tahiti), discovered Hawai'i, went home for settlers, and returned with many colonizing voyages. Scholars began to challenge this view in the 1960s and 1970s. The likelihood that these Polynesian sailors, even with their recognized sophisticated navigational skills, could travel far from home and back again several times, against the wind no less, seemed implausible to some. The current generally accepted thesis is that early settlers arrived in one or maybe a few canoes and seldom if ever returned to their homeland.

We, of course, do not know how many people made the initial voyage. Computer models suggest as few as three couples (six people) would have had a 33 percent chance of producing a surviving population. Raising the number to seven couples increases the odds of the colony's survival to 80 percent. We also do not know whether these original settlers landed on the Big Island and later spread to the other islands or vice versa. However, the southern location of the Big Island is closer to their starting point and the sheer size of the island makes it easier to find.

Regardless of whether they came directly from the Marquesas or indirectly from another island, the first Big Island settlers brought with them many of the crops, animals, tools, religious beliefs, and skills of farming, building, and fishing of their Polynesian homeland. The most likely place for the first settlers to set up their colony would have been on the eastern wet side of the island. Earlier speculation of a first settlement at South Point still appears in some guidebooks, but archaeologists now discount this location due to the harsh environmental conditions settlers would have encountered. Current thinking centers around locations such as Hilo Bay, or perhaps in the Waimanu or Waipi'o Valleys, as a logical first outpost.

Wherever the location, these men and women would have cleared trees to plant crops, such as taro, sweet potato, breadfruit, yams, and bananas. They undoubtedly survived on fishing and catching native birds until the crops came in. Wood from cleared trees would be used to build tools and houses, as well as for firewood.

As their numbers increased, the first settlement spread to other areas along the eastern side of the island and finally to the more hospitable areas of the dryer western side. Gradually, after 500 years or so, both sides of the Big Island probably supported many small kin-group settlements of perhaps 250 to 500 people; essentially independent nations governed by one chief. Communities in some of the more favorable locations may have been larger and begun to dominate the smaller nearby settlements. This pattern is speculative, but supported by the pattern found in the Marquesas and elsewhere at European contact.

At some point, around the year 900 or 1000, settlers gradually began to move into dry areas on the west side of the island. Archaeological evidence from this period exists in west Kohala, from 'Upolu Point to Kawaihae and in the area around Waimea. The ruins of the village of Lapakahi State Historical Park in North Kohala provide some clues of how people lived several hundred years ago. Similarly, there were settlements created between the 900s and 1200s in central Kona at Koloko, just north of Kailua, and other areas such as Ka'u. Perhaps the migration was driven by crowded conditions on the windward side of the island or maybe by limited opportunities to become a chief.

Because of the lower rainfalls, these pioneers must have developed new agricultural techniques, perhaps planting crops at higher elevations 2 or 3 miles inland to take advantage of more rain. Where the rainfall was insufficient to support taro cultivation, sweet potatoes, which could grow in dryer climates, became the dominant crop. Their houses, on the other hand, remained along the shore to take advantage of available fishing.

Though these leeward settlements grew, the windward side of the island continued to be by far more populous and thus more powerful than the settlements on the dry side. Over time, these societies became more complex politically and socially, evolving from a two-tier (chief and commoners) culture to a three or more tiered political organization with hierarchies of chiefs.

Around 1200, there were significant changes in political and religious ideas, beginning in Kohala. Nineteenth-century anthropologists theorized that this was the result of a second wave of migration to Hawai'i from Tahiti or other Polynesian islands. These supposedly superior immigrants overwhelmed and replaced existing rulers to establish new governments and religions.

Again, recent scholarship questions this view as both simplistic and inaccurate. There may indeed have been new arrivals, though perhaps not so many as to constitute a wave. There definitely was a new priest by the name of Pa'ao, who imposed a new religion and anointed his own chief, Pili. This ruler made significant changes in Kohala, but it is unclear as to whether these two were foreign invaders or native Hawaiians.

We do know that around 1200, political organizations became much larger geographically, perhaps even including the entire island from time to time. Society became much more complex and religion more important. It is from this period that we begin to see increasingly large temples, the implementation of both secular and religious kapus (taboos), and a widening social gulf between the ali'i (chiefs) and the common people. The kapu structure established a rigid caste system and imposed a strict social organization.

Ahupuáa

The people lived in self-contained communities, each comprising a large section of land called an ahupua'a. Each ahupua'a included a village, usually near its fairly small coastline with reefs and fishing grounds, and then extended inland and upward to elevations suitable for farming, then progressing higher into forest land. Elaborate fishponds, which allowed small fish to swim in from the ocean, but prevented larger specimens from escaping, provided a ready supply of food. The Mauna Lani Resort on the Kohala coast has a reconstructed functioning fishpond that covers over 5 acres. Hulihe'e Palace has a much smaller example, but it still shows how fish were caught and kept alive until they were needed.

Fishponds

Depending on the terrain, the ahupua'a might be triangular or rectangular as its territory pushed back from the shore. The idea was for each one to contain all terrain, climates, and natural resources necessary to support its inhabitants. When Europeans first reached Hawai'i, there were approximately 600 ahupua'a on the Big Island.

Pa'ao established a new religion and a distinctive priesthood. He in turn placed Pili in power in Kohala, and Pili's descendants eventually unified the entire Big Island. This religion over time evolved into the theology Europeans discovered when they landed. There were many gods, though only four major ones—Ku, Lono, Kane, and Kanaloa. Each of them had several forms and manifestations, such as thunder, clouds, and images. One of Ku's appearances was as Kuka'ilimoku, a war god special to Hawaiian kings who, as we shall see, played a large role during the reign of Kamehameha. Other lesser deities controlled sorcery or violent events. The most famous of these lesser deities was Pele, who conducted volcanic activity at Mauna Loa and Kilauea.

Appeals to these gods for success in war, death to enemies, agricultural fertility, and other favors were made at major heiau (temples), called luakini, which were built and consecrated by rulers. The luakini were temples of human sacrifice, built at their royal centers, and became the focal point of each kingdom's religious observances. The luakini consisted of huge stone platforms with either wooden or stone-walled enclosures. Inside was an altar with images of Ku or other gods. Priests (kahuna), overseen by a high priest (kahuna nui) lived close by, cared for the heiau, performed ceremonies, and attempted to persuade the king to follow proper religious behavior.

For eight months of the year, the luakini was dedicated to the god Ku. There were strict ceremonies four times each month, and anyone who failed to observe proper practices as stipulated in the kapus could have his property seized or he might even be sentenced to death. Anti-social acts were causes for immediate death, as was defeat in war. This attitude prevailed in most Polynesian societies, but there was also a concept of refuge where one could escape these severe penalties. Each district had sites

designated as sites of asylum. Anyone who violated a kapu or who had been defeated in battle could have his life spared if he could reach one of these sanctuaries. These places were called pu'uhonua. The most famous today is the example at Honaunau in South Kona, but there were at least ten throughout the island. Sometimes a pu'uhonua was not a place, but a high ranking ali'i. If you could reach this chief's presence, you could obtain sanctuary.

For four months in the fall and early winter, the god Lono replaced Ku as the religious focus in the luakini. During this period, known as the Makahiki season, people of high rank gave up eating pig, and war and sacrifices were both suspended. Ku could bring success in war; Lono could bring rain and abundant crops. During the second month of Makahiki, each ahupua'a sent a tribute to the king, who in turn distributed it to the gods, priests, and retainers. The image or symbol of Lono—Lonomakua—was a pole with a carved head and a crosspiece consisting of a feather lei, a fern, and white kapa (native cloth made from tree bark). A group of priests and athletes then carried this image clockwise around the entire Big Island, collecting additional tributes.

In addition to this new religion, the priest Pa'ao and king Pili established a royal lineage that ultimately led to Kamehameha. We do not know much from oral histories about Pili's immediate successors, but by the late 1500s, two of them are well chronicled. Liloa, who ruled from approximately 1580 to 1600, and his son 'Umi, from approximately 1600 to 1620, both consolidated their authority and ruled the entire island.

By Liloa's time, the six major districts of the island that we now know were already established. Liloa appointed high chiefs in Hilo, Puna, Ka'u, Kona; he apparently directly ruled the other two: Kohala and Hamakua. Frequently moving around his kingdom to maintain control, Liloa used the religious system to attract support by rededicating many heiau. His primary one was Paka'alana in Waipi'o, the location of his court.

Liloa also consolidated his power through marriages to women in high-ranking families on both O'ahu and Maui. His son 'Umi, however, was the product of an affair with a commoner woman in Hamakua. As the boy grew up and was increasingly favored by his father, his half-brother Hakau, who was heir to the throne, grew to hate his potential rival.

Shortly before he died, Liloa confirmed Hakau as his heir, but entrusted 'Umi with the important task of maintaining the heiau and rituals of the war god Kuka'ilimoku. This assignment further inflamed Hakau's jealousy, and when he became king (around 1600) 'Umi found it prudent to leave the court at Waipi'o and seek exile in Hilo where, with the support of a Hilo priest, he raised an army.

Two of Hakau's own high priests, previously insulted by the king, also joined the plot. These holy men persuaded Hakau to send his followers into the mountains to gather feathers for the war god. While the men were away, 'Umi and his forces arrived at Waipi'o and slaughtered Hakau and all his chiefs and attendants.

'Umi then became mo'i (king) of the Big Island. After offering the body of Hakau and his attendants to Ku, he further consolidated his power. There are conflicting accounts as to whether all the island chiefs submitted to the new king or whether it was necessary to subdue some of them by force. Conscious of his mother's (and consequently his) low class position, 'Umi married three high-ranking women, one of them his half-sister. Rank was extremely important in commanding respect, and it could be passed to children by either parent.

One important change 'Umi made was to move his court from Waipi'o to Kona, where he built the area's first heiau (Ahu a 'Umi) in the mountains, 5,200 feet above Keauhou. He later lived in Kailua, and possibly Kahalu'u, where additional heiau are attributed to him. 'Umi's practice of moving his court around, but focusing it *Umi* in the Kona area, started a tradition that lasted through Kamehameha's reign 200 years later.

'Umi's eldest son Keali'iokaloa succeeded his father, but he was unpopular and soon overthrown. Disagreement over who should be the next king led to renewed warfare and ultimately victory for 'Umi's second son Keawenui and the execution of those chiefs who had not supported him. Keawenui moved his primary residence to Hilo and successfully maintained peace for the rest of his reign, partly the result of marrying five high-ranking women.

The kingship eventually passed to Keawenui's youngest son Lonoikamakahiki, or simply Lono, around 1640. There are many stories about Lono in the oral histories. *Lono* He and his wife Kaikilani, a chiefess of Puna, apparently had a somewhat tempestuous marriage. While visiting Moloka'i, they were playing a game of konane (vaguely similar to Chinese checkers) when Lono thought he heard his wife's lover calling to her. In a rage, he struck his wife with the stone konane board, vowed never to live with her again, and fled to O'ahu.

Back on the Big Island, Kaikilani's supporters, including most of Lono's brothers and the district chiefs, rebelled when they heard these reports and threatened to kill Lono if he returned. The couple apparently patched up their difficulties, for they returned together to face the revolt of his brothers. Some of the rebels gave up their opposition and rejoined with the couple, and after several fierce battles Lono defeated his rebellious brothers. This unified his control over the entire island and ushered in a period of stability.

· Period of stability

With Hawai‘i firmly under his control, Lono paid a state visit to Kamalalawalu, the elderly king of Maui. Kamalalawalu, however, repaid the favor by launching an invasion of the Big Island. He and his forces landed at Puako in Kohala and defeated a force led by Lono's brother Kanaloa. The invaders captured and tortured him, gouged out his eyes, and tattooed his body before finally executing him.

Moving north to Waimea, the Maui forces met a larger force commanded by Pu‘uoaoaka, another of Lono's brothers. After three days of skirmishes, the issue was settled by hand-to-hand combat with war clubs between a Hawaiian high chief named Pupuakea and Kamalalawalu's nephew Makakuikalani. The victorious Pupuakea slew Makakuikalani, and the Maui forces fled back to Puako. There the Hawaiian forces overtook them, defeated the invaders, and killed the Maui king. The victors took Kamalalawalu's body to the Ke‘eku heiau in Kahalu‘u, near the present site of the abandoned Kona Lagoon Hotel, and offered it to Ku. Petroglyphs still visible on the pahoehoe (smooth lava) at the heiau commemorate the event.

There are many archaeological sites from Lono's reign in Kohala and Kona, such as the Ke ahu a Lono shrine on the grounds of the Hilton Waikoloa Resort. The ruins of Lono's residential complex at Kahalu‘u are just south of one of modern day Kona's most popular snorkeling and surfing beaches. Perhaps appropriately, Ku‘emanu heiau, popular today with surfers on the north side of Kahalu‘u Bay, is actually a surfing heiau. Its large stone platform now serves as a base for the tiny St. Peter's church.

Just south of the Kona Lagoon Hotel, on the property of the Keauhou Surf and Racquet Club, is a structure that is sometimes referred to as Lono's residence. Its massive size, however, suggests it was possibly another heiau rather than a residence. Lono and subsequent rulers probably lived on the south shore of Kahalu‘u Bay, near a pond called Po‘o Hawai‘i.

As an illustration of the complex familial and sexual relations of old Hawai‘i, Lono was succeeded in 1660 not by one of his sons, but by Keakealanikane, the son of his wife Kaikilani and his older brother Kanaloa. Because there was no appropriate male heir, Keakealanikane in turn was succeeded by his daughter Keakamahana, whose mother was his sister.

Keakamahana's daughter Keakealaniwahine then succeeded her. The new queen attempted to enhance her authority by taking several husbands, one of them her half-brother. Even so, civil war broke out during Keakealaniwahine's reign when Hilo chiefs revolted. The rebels captured Keakealaniwahine and banished her to Moloka‘i for a couple of years before restoring her to power over the western half of the island. Her son Keawe married the granddaughter of the ruling Hilo chief, eventually reuniting the two halves of the island under a single king.

The ruins of Keakealaniwahine's residence, just mauka (in the direction of the mountains) of Aliʻi Drive halfway between Kailua and Keauhou, include a large walled area that is now overgrown, unmarked, and accessible only to the most determined. At the urging of a local preservation group, Pulama Ia Kona, the state acquired the site. There are plans to preserve it, along with a major heiau across Aliʻi Drive, as part of a large royal center historic complex.

When Keawe succeeded his mother, he brought the Hilo side of the island back into his kingdom both through political marriages and the force of his own personality. During his reign (1720–1740), he had at least six wives, and at least one of them had several other husbands. He moved the royal court from Kailua to Honaunau, where either he or his son built the Hale o Keawe as a royal mausoleum for Keawe's bones. Honaunau had been a puʻuhonua for many years before Keawe chose it as the site for his court and eventual burial.

A wall, nearly 1,000 feet long, surrounded the complex, which contained several structures. However, it was the Hale o Keawe that most distinguished Honaunau from other puʻuhonua. By the time of Captain Cook's arrival later in the century, Honaunau had a reputation as the burial site for ruling chiefs. Even after the old religion was abandoned in 1819 (see chapter four), leading to the destruction and desecration of many heiau, the Hale o Keawe lay undisturbed until the Regent Kaʻahamanu herself had it broken up. The bones of Keawe and other royal chiefs were transferred to a burial cave at Kealakekua and eventually moved to the Royal Mausoleum on Oʻahu.

A brief rebellion following Keawe's death resulted in another branch of the royal family gaining control under Alapaʻinui (1740–1760), who managed to enforce a fragile unity and stability for most of his reign. He successfully fought off another invasion from Maui and moved his court north to Kohala, then Kokoiki, next to the historic and sacred Moʻokini heiau.

According to one tradition, the invading priest Paʻao had built this massive heiau 500 years earlier. Other legends claim it dates back to the early 400s. In any event, it was and is a rectangular enclosure measuring 280 by 140 feet. Alapaʻinui restored and repaired it, then made it part of the royal complex he established. This luakini, still maintained today by an active kahuna nui, remains a link to the Hawaiian past.

From this location, Alapaʻinui planned a counter invasion of Maui. During preparations for this venture at Kokoiki, a son was born to Keoua, one of Alapaʻinui's nephews and generals. They named this baby Kamehameha.

The invasion of Maui coincided with an attempt by the kingdom of Oʻahu to conquer Molokaʻi. The throne of Maui at that point had been passed to the son of

Alapaʻinuiʻs half-sister. The two related kings quickly concluded peace and moved their joint forces to Molokaʻi to oppose the Oʻahu expansion attempt. After a lengthy battle, the Oʻahu king was killed and his forces driven back to their island. Alapaʻinui and his forces followed. They landed at Kailua (Oʻahu), but avoided battle when the regent for the new infant king of Oʻahu negotiated a truce with Alapaʻinui.

Soon the peace with Maui disintegrated. Alapaʻinui led another invasion force of 8,440 men to Maui, which now had the support of Oʻahu. A bloody battle near Lahaina resulted in the Maui kingʻs capture and death and the installation of a new moʻi friendly to Hawaiʻi. After these tempestuous events, Alapaʻinui spent his remaining years in peace, primarily in Hilo.

Yet in the overall dynamic of the islands, peace remained illusive in these times. Alapaʻinuiʻs death again resulted in a dynastic revolt, a lengthy battle near Honaunau, and the victory of Kalaniʻopuʻu (1760–1782), a descendent from another line in the family of Keawe. The new king based his court at Kaʻu, where he soon recognized the military prowess of the legendary warrior Kekuhaupiʻo. He assigned to Kekuhaupiʻo the responsibility of training his nephew, the young Kamehameha, and thus treated him as a son.

In the mid–1770s, Kalaniʻopuʻu led yet another invasion of Maui, providing both Kekuhaupiʻo and his student Kamehameha the opportunity to enhance their skills and fame as warriors. The Maui forces eventually succeeded in repelling the invaders, with heavy losses, but this setback did not discourage Kalaniʻopuʻu from attempting yet another attack a few years later. It was in the midst of this new campaign that two British ships, under the command of Captain James Cook, reached the islands and ultimately affected both the reign of Kalaniʻopuʻu and the entire future of all the islands in profound ways.

TRAGEDY AT KEALAKEKUA

Captain James Cook, at the height of his career and already a national hero in Britain before his third voyage of exploration in the South Pacific, came upon the islands of Oʻahu, Kauaʻi, and Niʻihau in January 1778. He had left Britain 18 months earlier, just as rebellious colonists were signing a Declaration of Independence in Philadelphia. His previous journeys led him to places such as Tahiti, New Zealand, and Australia. His mission now was to find the mythical and long sought after Northwest Passage. Europeans had been searching for nearly 300 years for a route to Asia that would allow them to sail above the North American continent, greatly shortening the treacherous route around Cape Horn at the tip of South America.

Cook's two ships, the Resolution and Discovery, spent several days on Kauaʻi near the village of Waimea, where they found the natives friendly and eager for trade. In exchange for hogs, taro, sweet potatoes, and fish, the natives were especially eager to acquire iron. The British were amazed by what the islanders would give them in return for one single nail.

They already had little bits of iron, which gave them an advantage when added to their weapons. Where the source originated was unclear to Cook (and still is), but possibly the natives had obtained it from pieces of previously wrecked European or even Japanese vessels that washed ashore.

Indeed, the residents were so eager for iron that on a few occasions some of them snuck on board one of the ships and took implements that contained the substance for themselves. This episode convinced the British that the islanders, though friendly, were also thieves. Cook had had similar experiences with other Polynesians in his previous voyages, so he was not especially surprised when the natives of Kauaʻi stole items.

In one instance, a small boat approached the shore and the eager locals tried to help beach it. One man appeared to try and grab the iron boat hook and thus was shot and killed by one of the British officers. He later admitted that the man probably acted more out of curiosity than from a desire to harm or steal from the British.

When Cook himself came ashore later in the day, the natives fell to the ground and lay face down until he bade them to get up. Possibly this action stemmed from

fear—a strange new weapon had shot and killed their compatriot just hours earlier. On the other hand, this may have been an act of respect for someone they considered a great and powerful man. Perhaps it was a mixture of the two, but ultimately we cannot know.

In any event, other residents flocked to Waimea as news of the British ships, and the availability of iron, spread through the island. Despite the tragic boat hook incident, good relations and trade continued between the two groups. After a few days, the ships had as much food as they needed to continue their voyage, and Cook gave orders to continue on their way in late January.

The captain was also eager to leave because he knew many of his men were infected with venereal diseases, from which the natives had no immunity. Attempts to prevent the intermingling with native females were futile; much to the delight of the sailors, Hawaiian women were very affectionate. Cook had seen unfortunate consequences on his previous voyages, and he undoubtedly knew that the only way to prevent contamination was to leave the area. As his two ships left to sail north to Alaska, the captain named the three islands the Sandwich Islands. This was in honor of his sponsor the Earl of Sandwich, British First Lord of the Admiralty.

Cook spent several months in Alaskan waters in a vain attempt to find a passage, but all he found was impenetrable ice. With his ships in need of repair, he decided to return to the Sandwich Islands for the winter and resume his search the following year. He arrived to come across the previously unknown (to the British) island of Maui, then at war with the invading Hawaiian forces under Kalaniʻopuʻu. The people there seemed to know about the British and their earlier visit to Kauaʻi. Unfortunately, according to Cook, the Mauians exhibited symptoms of what he feared from the earlier visit, "venereal distemper."

Kahekili, the king of Maui, visited the Discovery and gave its captain, Charles Clerke, a red feather cloak. After a day of trading, the two ships moved on, searching for a good anchorage. A few days later, on the northeast coast of Maui, the old and feeble invading King Kalaniʻopuʻu visited Cook on the Resolution. Some of the Hawaiian men stayed overnight on the ship, and the British provided medicine to those who exhibited signs of venereal disease.

On December 1, unable to find a decent harbor on Maui, Cook set off for yet another nearby island, which the natives called Hawaiʻi (Cook spelled it Owhyhee). The visitors from "Mowee" stayed behind, possibly because the two islands were still at war. As they approached the Big Island, the British were surprised to see the mountain tops covered with snow. A few islanders, shy at first, were enticed to board

the ships and return to the island for supplies. Among other items, they brought back an abundance of sugar cane, from which Cook made "a very palatable beer," though the crew generally refused to taste it.

They sailed down the east coast of the island, trading several times with natives who came out to their ships, but failed to find a good harbor. Cook was impressed with how these people were "so free from reserve and suspicion" that they loaded their trading goods on the British ships before coming on to bargain about the price. He noted that the Tahitians had not "put so much confidence in us."

Their progress was slowed at times by heavy rains or total lack of a breeze, and it was not until January 5, 1779, that they finally rounded South Point. They found "a pretty large village, the inhabitants of which thronged off to the ship with hogs and women." It was impossible, Cook lamented, "to keep the latter from coming on board." The countryside had obviously been devastated by volcanic eruptions, making it an unlikely spot to find fruits and vegetables.

It was here that the Resolution and the Discovery, separated when they left Maui, were finally reunited and turned north together to search for a suitable bay. On January 16, they came upon a promising inlet, and Cook sent William Bligh, one of his officers and later the object of the mutiny on the Bounty, ahead with a few boats to explore the area.

While Bligh investigated, canoes came out to meet the ships. By 10 a.m., according to Cook, there were at least 1,000 canoes, crowded with people, hogs, and other goods for trade. This happy occasion was marred, however, when one of the natives took a rudder from one of the ship's boats and escaped back to his canoe before the deed was discovered. Cook thought this "a good opportunity to shew these people the use of firearms." His men fired two or three muskets and small cannon over the heads of the occupants in the fleeing canoe. Cook wanted to warn more than harm the Hawaiians. The islanders seemed surprised by the noise, but not frightened. Possibly, they did not realize that these noisemakers could be lethal. If so, because Cook fired over their heads, the impression he gave was exactly opposite of what he meant to convey.

When Bligh returned in the evening to report that he had found a bay with a good anchorage and an ample supply of fresh water, Cook decided to use the opportunity to refit the ships and refresh his men. They remained outside the bay for the night, allowing several natives to sleep on the ships. Discovering the next morning that several items were missing, Cook resolved to be less hospitable to guests in the future.

The two ships sailed into the bay that, according to Cook, residents called "Karakakooa." The scene was memorable. Natives crowded onto the two ships, which were surrounded by a "multitude" of canoes. The shore thronged with spectators, and "many hundreds were swimming round the ships like shoals of fish." Never before in his voyages had Cook seen such a large number of people assembled in one place. The disappointment at not finding a Northwest Passage was replaced by joy at the prospect of spending the winter in the Sandwich Islands surrounded by these friendly people.

The timing of the British arrival at Kealakekua was critical to the nature of the reception they received. The village of Kealakekua (now known as Napoʻopoʻo) on the south side of the bay was the center of Lono, the god of peace and harvest. The people were in the midst of the annual Makahiki festival, celebrating that god. During this period, the war god Ku was pushed to the background and the Hikiau heiau in the village was refurbished for Lono. The entire festival annually went on for four lunar months, but the climax came during a 23-day period when Lono left Kealakekua and made a circuit around the island of Hawaiʻi. While Lono was making his circuit war was kapu, and the king remained in the spot where he was when the circuit began. For King Kalaniʻopuʻu, this meant he was stuck in Maui when the British arrived in Kealakekua.

Some Hawaiians apparently thought Cook was a human manifestation of Lono, and according to prophecy, Lono would end his circuit by returning from the sea. With a little imagination, the sails of his ship were similar to the symbol for Lono (the Lonomakua). The natives saw and reported the slow progress of the Resolution along the east coast of the island, around South Point, and finally "back" to Kealakekua in the clockwise direction that the Lonomakua image of Lono took each year. The estimated 10,000 people who turned out to greet the actual Lono, as opposed to the spiritual one, was a far larger number than the usual population of the area.

Some, if not all, Hawaiians apparently believed Cook was Lono. The Kealakekua priests assigned a "tabu-man" to Cook, who accompanied him everywhere shouting the name Lono, causing people to prostate themselves before him. Whether everyone really believed that Cook was Lono is impossible to say. During the Makahiki festival, priests exercised more power than they did at other times and for the rest of the year political tension between secular and religious leaders usually favored kings and chiefs. But now the religious authorities prevailed, and Cook himself did little if anything to discourage the honors bestowed upon him.

Shortly after the ships anchored, before going ashore, Cook received a visit from a priest named Kaʻoʻo. He was, according to Cook's principal aide Lieutenant James

kava →

King, "a little old man [with] sore eyes & a Scaly body," addicted to kava, a mildly narcotic Hawaiian drink. Ka'o'o presented Lieutenant King with a red cloth, a small pig, and a long speech. He stayed for dinner, and in the evening escorted Cook, King, and the expedition's astronomer, William Bayly, ashore.

They went to the Hikiau heiau, near the shore. In the absence of the king, who traditionally presided over the return of Lono, Ka'o'o prepared a ceremony at the temple. He offered Cook a sacrificial pig, previously placed on the stage and now quite rotten, so Cook declined the favor. After some religious chanting and prostrating by the priests, Cook and Ka'o'o climbed to the top of the heiau, where a procession of islanders brought a baked hog, pudding, bread-fruit, coconuts, and other vegetables for a feast. The meal was accompanied by kava, prepared by natives who chewed on a pepper root and then spat into a communal drinking vessel.

The pig was pulled apart and the meat passed around. Ka'o'o removed a piece and offered it to Cook, but the captain refused because Ka'o'o had just handled the putrid pig he had presented Cook earlier. Even when Ka'o'o obligingly chewed the meat for Cook, the captain was not tempted. Despite everything, the English were "extremely well satisfied" by the meal, after which they returned to the ship.

Throughout the entire evening, the Hawaiians continued to regard Cook with what "seemed approaching to adoration." The natives prostrated themselves before him and many times repeated a short sentence in which the only word the English could distinguish was "Orono."

The view that the Hawaiians regarded Cook as Lono has provoked quite a bit of controversy in recent years among cultural anthropologists and others. On one extreme, some claim Hawaiians would not have been so easily taken in by Cook, for he neither looked nor talked like their image of Lono. They undoubtedly regarded him as a great chief, but hardly a god. The British, of course, had no problem believing that these "savages" considered an Englishman to be a god. It is they, some suggest, who perpetuated this interpretation in their glorification of the martyred Cook.

Others, who take a somewhat more cynical view, speculate that the priests were willing to use the opportunity of Cook's arrival to enhance their influence over the population. It was to their advantage to promote Cook as Lono. It is unlikely there was a single monolithic viewpoint among the Hawaiians. Some may indeed have regarded Cook as Lono, while others may have gone along with the idea to humor or please the priests during the Makahiki festival. Whether they considered him a god or a chief, the Hawaiians (especially the priests) treated Cook as a hero.

• Cook as Lono

The holy men also helped astronomer Bayly set up an observatory in the village, offering to tear down some houses if they obscured the view. The English declined that offer and settled on a spot in the middle of a sweet potato field next to the heiau. The priests placed a kapu on the area to keep people away. There was quite a contrast between the kapu-affected area where no one ventured, and the ships where large crowds of islanders flocked in such numbers that the crew needed to clear them away hourly just in order to perform ordinary shipboard duties.

A week after Cook arrived, King Kalani'opu'u came back from his war on Maui. He made an unofficial visit to the ships on January 25 and ceremonially received Cook the next day at the village of Ka'awaloa on the north side of the bay. This was home of the ruling chief of Kona, but also the site of the royal court whenever the king came to Kealakekua. The villages of Ka'awaloa and Kealakekua (modern day Napo'opo'o), on opposite sides of what makes up Kealakekua Bay, were centers respectively of secular and religious authority.

In the welcoming ceremony, Kalani'opu'u took off his cloak and put it on Cook. He then gave the Englishman a feathered helmet and a curious fan. Cook in return gave Kalani'opu'u a linen shirt, a sword, and a tool chest. At this ceremony, one of Kalani'opu'u's attendants was his nephew Kamehameha, who according to Lieutenant King, "had the most savage face I ever beheld."

A few days later, the Hawaiians put on a sports festival, which included boxing matches. To the English the combatants were "awkward," without any attempt to parry the blows of the other. The fight ended when one of the fighters was knocked or fell down. Though the English were invited to participate, they "turned a deaf ear to their challenge," remembering a similar exercise the previous year in Tonga when they had gotten the worst of the bargain. Instead, the English put on a fireworks show, which both delighted and terrorized the Hawaiians.

On the day of the boxing match and fireworks display, William Watman, an old sailor on the Resolution, died of a stroke. The Hawaiians requested that Watman be buried at the Hikiau heiau. Cook agreed and performed the naval service for Christian burial, the first public Christian service in the islands. As they filled the grave, the Hawaiians threw in a dead pig, some coconuts, and some plantains. The priests continued their ceremony for three nights.

After two enjoyable weeks at Kealakekua, the ships prepared to leave. To replenish their fuel supply, Lieutenant King asked the priests if he could take the wooden railing from the top of the heiau. King had reservations about the "decency" of the request, but was surprised when the priests of Lono offered the wood without requesting any payment. The holy men themselves helped carry the

wood to the ships, even including some of the carved wooden statues. Possibly, the priests cooperated because the Makahiki festival was ending and the heiau again had to be set up for Ku.

Finally, on February 4, after a farewell ceremony from Kalani'opu'u, the English dismantled their observatory and sailed out of the bay to continue their survey of the islands, still hoping to find a more protected harbor. A great number of canoes followed and stayed with the English ships for two days. Sailing north, they reached Kawaihae on February 6. The priest Ka'o'o, who with many other Hawaiians remained on board the Resolution, told Cook that this was a safe and commodious harbor. William Bligh, sent ahead to investigate, reported that it was definitely not either.

The ships then ran into a winter storm, during which the foremast of the Resolution came lose. It also wrecked several native canoes, leading the English to rescue them, which added to the crowded conditions on board. Because of the broken mast and a desire of the Hawaiians to leave the ships, Cook decided to return to Kealakekua on February 11.

It took two days to remove the mast and take it ashore for repairs. Lieutenant King and Bayly again set up the observatory, pitched their tents on the heiau, and renewed their "friendly correspondence" with the priests. They were surprised, however, that the general reception from the population was quite different from what it had been before. There were no shouts, no great number of canoes sailing out to meet the ships, no "great joy at our return."

Change in attitude

The landing simply did not fit into the framework of religious traditions, for Lono was not supposed to return after the conclusion of the Makahiki festival. A broken mast did not explain things nor the fact that the god's ship was not functioning—neither fit with the constructs of Lono's legend. The event was especially unsettling to the king and his chiefs, who had regained their predominant authority from the priests. There was always a tension between the secular and religious authority, so would Lono's return upset the balance in favor of the priests?

On February 13, the commander of a water collection detail reported that several chiefs had driven off residents hired to help in the task. Their "extremely suspicious" behavior led him to suspect further trouble. A marine, sent by Lieutenant King to investigate, found that the "very tumultuous" natives had armed themselves with stones. King himself went to the scene, and the men threw down their stones. After the lieutenant spoke to several chiefs, the crowds dispersed and water collection resumed.

A short time later, after King and his men returned to their tents at the heiau, they heard musket fire coming from the Discovery. A canoe raced towards the shore, hotly pursued by a pinnace from the ship. A native visiting the ship had stolen the blacksmith's tongs and a chisel, jumped overboard and fled in the canoe. His pursuers lowered the boat so quickly that the men left the ship unarmed.

Cook and King, observing this action from shore, ran to the spot where they assumed the canoe would land in hopes of catching the thief. They arrived too late to catch anyone but did recover the stolen items, apparently left behind as the natives fled. Meanwhile, the English boat arrived and the officer in charge decided to seize the offending canoe while Cook and King pursued the fleeing Hawaiians. Unaccompanied by priests, Cook now received no deferential treatment from the rapidly gathering crowd. He demanded that the islanders hand over the thieves. He even raised his pistol, but when he did not fire, the crowd laughed at him.

Meanwhile, chief Palea, who owned the seized canoe, arrived at the scene. He said at the time of the theft he had been on board the Discovery, and claiming innocence, he demanded the return of his canoe. There was a struggle, and someone hit Palea on the head with an oar and knocked him to the ground. The gathering crowd attacked the unarmed English with stones, forcing them to retreat. The Hawaiians then seized the pinnace. In the process, two Englishmen were badly beaten. Palea, recovering from the blow, managed to stop the melee and offered to return the pinnace to the ship.

Cook learned about the incident with "much uneasiness" and decided he would have to use some "violent measures" to prevent the Hawaiians from believing they had gained an advantage over the English. He ordered all natives off the ships and posted a double guard at the observatory.

Later that night, the Discovery's cutter was stolen, presumably to obtain its nails and iron. When Lieutenant King boarded the Resolution the next morning, he found Cook loading his double-barreled gun and arming the marines. He ordered an embargo of the bay, forbidding any canoes from leaving, and then decided to take Kalani'opu'u hostage. If he did not get the stolen cutter back, he threatened to destroy all canoes. Cook himself led an armed party in three boats to Ka'awaloa to seize Kalani'opu'u, sending King and another party to the beach to assure the natives that they were not in danger.

When Cook arrived at the village, the "dejected and frightened" old man had just gotten out of bed. Cook talked with the king and "invited" him to return to the Resolution. Kalani'opu'u at first agreed, but one of his favorite wives, in tears, begged

him not to go. Two chiefs, who had come with her, forced the king to sit down on the beach. Natives, who were soon collecting in prodigious numbers along the shore, surrounded both Cook and Kalani'opu'u. Both sides tried to persuade the king until Cook, realizing he could not accomplish his mission without bloodshed, abandoned the attempt. At this highly charged moment, native messengers arrived to report that some sailors had fired at a canoe trying to run the blockade and they had killed a chief.

The crowd turned ugly. Women and children retreated from the beach, and men donned war mats and armed themselves with spears and stones. One of the natives approached Cook, threatening him with a stone and a spike. Cook raised his pistol and fired a shot, but it was a small caliber ball, possibly intended just to frighten him off. But when the shot did no harm, it merely encouraged the crowd.

In the melee that followed, Cook fired again and killed one of the Hawaiians. The crowd headed towards Cook, who ordered his men to fire and then retreat to the boats. The islanders, much to the surprise of the English, "stood the fire with great firmness," and when the marines tried to reload, rushed in with "dreadful shouts and yells."

Cook was killed, as were four marines and several Hawaiians, when he turned to give orders to the boats and was stabbed in the back, falling face first into the water. With a "great shout," the islanders dragged his body onto the beach, where they displayed "a savage eagerness to have a share in his destruction." Unable to recover the bodies of Cook and the marines, the survivors quickly retreated to the ships.

Captain Charles Clerke of the Discovery assumed command of the expedition. He ordered Lieutenant King to abandon the observatory, send back to the ship the sails on shore for repair, and post a guard next to the damaged foremast that was still on the beach. From the Discovery, Clerke could see additional Hawaiians gather on shore and carry the bodies of Cook and the dead marines inland.

Several canoes sailed out to the ship, their occupants shouting and making insulting gestures. On shore, the natives continued to arm, potentially threatening the poorly guarded foremast and remaining sails. Boats brought English reinforcements ashore, and the natives took cover behind stone walls.

King arranged a temporary truce, allowing the retrieval of the observatory instruments, the mast, and the sails. The Hawaiians then occupied the heiau and threw a few stones, but did no damage. Clerke and his officers were determined to try to recover Cook's body and the stolen pinnace that had started the whole disastrous affair. However, they also wanted to avoid a major battle, since at best it would only delay the repair of the Resolution and the departure of the expedition.

The lieutenant, appointed to arrange a parley, approached the shore alone in a small boat, waving a white flag. To his "satisfaction," the islanders seemed to understand the meaning of this gesture. The men took off their war mats and sat down, and women returned from the hillside. King remained suspicious until he saw the priest Ka'o'o, swimming towards his boat, also holding a white flag. To the Hawaiians, however, a white flag did not mean peace, but that a kapu was in place.

Though King later confessed that he had never liked or trusted Ka'o'o, he welcomed him into his boat. He demanded the return of Cook's body and told the kahuna that the consequences of non-compliance would produce war. Ka'o'o assured King that the body would be returned, and then after asking for some iron, jumped into the water and swam ashore, yelling to the Hawaiians that they were all friends again.

Several hours later, "after various delays, negotiations, and hostile preparations," two people in a canoe approached the ship in the dark at around 8 p.m. The sentinels fired in the direction of the paddling sounds, but when the occupants yelled King's name and said they had something for him, they were allowed to come on board.

Appearing frightened, the Hawaiians threw themselves on the deck, wailed at the loss of Lono, and presented a small bundle containing parts of Cook's body. King wrote that it was "impossible to describe the horror which seized us on finding in it a piece of human flesh about nine or ten pounds weight." The bundle included Cook's recognizable hands, scalp, thighbones, and arm bones. They also returned his gun, the barrels pounded flat, and a few other items belonging to Cook. The stolen pinnace had been burned to collect its iron.

This, the Hawaiians said, was all that remained. The rest of the body had been cut up and burned, except for the head and some of the bones, which had been given to Kalani'opu'u. What they brought were pieces meant for the priests for religious ceremonial purposes. Ka'o'o had sent these body parts "as proof of his innocence and attachment to us."

Despite the horror, the English read a burial service for Cook, fired a cannon salute, and lowered his partial remains into the water. After the service, several canoes came out and several chiefs boarded the Resolution, expressing sorrow at what had happened to Cook and happiness at what they hoped was renewed friendship. Several chiefs who did not venture out, including Kamehameha, sent large hogs and other peace offerings out to the ships.

On February 22, the two ships sailed out of the bay, past Maui, Lana'i, and Moloka'i. They paused briefly at Waimea, O'ahu, and anchored at Waimea, Kaua'i,

before finally leaving the islands on March 15 to continue the explorations of North America and then Asia.

Despite the tragedy at Kealakekua, many Hawaiians continued to regard Cook as Lono and used the bones they retained in subsequent Makahiki celebrations. The British, shocked when they heard of the murder of a national hero, deified him in their own way. And when Cook's journals, completed by Lieutenant King, were published in London and elsewhere throughout Europe and America, the Sandwich Islands would be changed forever.

KING KAMEHAMEHA

An old King Kalaniʻopuʻu died in early 1782. Though he had selected his son Kiwalaʻo to succeed him, Kalaniʻopuʻu gave his nephew Kamehameha custody of the war god of Hawaiian kings, Kukaʻilimoku. This was not the first time (nor the last) that a king had divided authority in this manner. Liloa had done it 200 years earlier; Kamehameha himself would do it upon his own death 37 years later. Such a division inevitably led to conflict. Kamehameha's high rank—nearly equal to that of his cousin, the new king—planted seeds of jealousy and mistrust.

When Kiwalaʻo took his father's bones to Hale o Keawe at Honaunau for burial, Kamehameha arrived to participate in the ceremony accompanied by several other Kona and Kohala chiefs. Though Kamehameha and Kiwalaʻo maintained a respectful decorum during the funeral ceremonies, a rift developed soon afterward. King Kiwalaʻo was already under the influence of his uncle Keawemaʻuhili, chief of the Hilo district, which only increased the distrust.

As was customary at the death of a king, the new moʻi redistributed land among major chiefs. The big winners in the redistribution were his uncle Keawemaʻuhili and his Hilo chiefs; the big losers were Kamehameha and the Kona chiefs. This resulted in a battle at Mokuohai near Kealakekua in July 1782, where Kamehameha emerged victorious when his cousin King Kiwalaʻo was killed.

After this skirmish, the island was divided into three kingdoms. Kamehameha ruled over Kona, Kohala, and parts of Hamakua. Kiwalaʻo's half brother Keoua (younger son of Kalaniʻopuʻu) gained Kaʻu and parts of Puna. Keawemaʻuhili consolidated his power in Hilo, while adding parts of Hamakua and Puna. Thus, within months after the death of Kalaniʻopuʻu, unity on the island and all hopes of achieving the old king's dream of adding Maui to his domain were shattered. Instead of harmony, more than a decade of bloody warfare followed.

As the Big Island disintegrated politically, Maui grew stronger. Kahekili, that island's king, consolidated his authority on Maui, Molokaʻi, and Lanaʻi, conquered Oʻahu outright, and entered into an alliance with the king of Kauaʻi. By the mid-1780s, anyone predicting the future of the island chain probably would have selected Kahekili as most likely to unite all the islands.

According to legend, however, Kamehameha was destined to overcome Kahekili's seeming advantage. As a teenager, Kamehameha supposedly went to Hilo, site of the Naha Stone. An old prophecy said that whoever could move the 5,000-pound stone would unite the islands. The 14-year-old Kamehameha apparently not only moved the stone, but turned it end over end. It was also the same year in which Kamehameha, with Kalani'opu'u's invasion force, fought his first battle against Kahekili.

The nature of warfare underwent significant changes in the intervening years, as islanders gradually acquired European weaponry. In the years following Cook's death and the publication of his voyage journals in Europe and America, additional ships visited the islands. Unfortunately, not all of these subsequent contacts were friendly or peaceful. In 1790, for example, the American ship Eleanora traded for food off Maui. One night a native killed an American sailor and stole one of the ship's boats for its iron.

The Eleanora's captain, Simon Metcalfe, retaliated by killing and wounding several Hawaiians. When the islanders began to arm themselves, Metcalfe bombarded and destroyed the village of Honuaula. The local chief returned the remains of the sailor and the stolen boat in a gesture of peace, but Metcalfe, in an unforgiving mood, plotted further revenge. He lured several trading canoes towards his ship and opened fire with cannon, killing and wounding over 100 natives.

This was not the first time that Simon Metcalfe had spread ill will between Hawaiians and Americans. Earlier, he had beaten and insulted a chief on the Kona coast of the Big Island. That chief had sworn revenge on whatever foreign ship next sailed into his waters. Coincidentally, that next ship was named the Fair American, a much smaller sister ship of the Eleanora, and was commanded by Simon Metcalfe's son Thomas.

The Hawaiians boarded the Fair American and threw the six members of the crew overboard. Five of them were beaten to death with canoe paddles, but an Englishman named Isaac Davis survived, and the islanders spared this one life while taking possession of the ship. Kamehameha, as senior chief of the region, then seized the ship's guns and cannon, the ship itself, and Isaac Davis.

The Eleanora, meanwhile, sailed down the Kona coast searching for the Fair American and anchored at Kealakekua Bay. The elder Metcalfe sent one of his crew, John Young, also English, ashore in search of news. Kamehameha, fearful of Metcalfe's reaction if he learned what had happened to the Fair American and his son, detained Young, preventing him from returning to his ship. After waiting several days, the Eleanora sailed away, probably regarding Young as a deserter.

Kamehameha now had two Englishmen, Young and Davis, who quickly became friends. They tried to escape together but failed. Despite the attempt, Kamehameha treated them so well that they resigned themselves to spending their lives in Hawai'i. They soon had Hawaiian wives, lands, and servants, and essentially became Hawaiian chiefs.

Kamehameha thus acquired his first foreign ship (albeit a small one), guns, and two experienced sailors. Other Hawaiian chiefs in this period also acquired western weapons from European and American ships, increasingly visiting the islands to trade. Most captains had no problem with supporting what was in effect an arms race in the islands.

Later that year (1790), Kamehameha determined that the time was right once again to invade Maui. Though he still only ruled one third of the Big Island, a wary peace existed among the three chiefs. The Maui king Kahekili, meanwhile, had moved his residence to O'ahu, and the troops he left were no match for Kamehameha's invaders. Supported by Davis and Young, who manned the cannon taken from the Fair American, Hawaiian forces slaughtered hundreds of Maui troops in the Iao Valley.

Kamehameha then seized all of Maui and Lana'i before moving on to Moloka'i. On the latter island, two significant events occurred. First, Kamehameha reconciled with the chiefess Kalola, one of Kalani'opu'u's wives and mother of the dead Kiwala'o. Kalola herself, ill and near death, agreed to hand over to Kamehameha responsibility for her two daughters. One of these daughters, Keopuolani, an ali'i of higher rank than Kamehameha, later became his wife and mother of both Kamehameha II and Kamehameha III.

The other event on Moloka'i was a prophecy. Kamehameha sent a messenger to a soothsayer on Kaua'i asking what he would need to do to unite the entire Big Island under his rule. The answer was that he should build a great heiau for the god Kuka'ilimoku at Pu'ukohola near Kawaihae.

Before he could act on this prophecy, however, Kamehameha had to return home to address yet another rebellion. A quarrel between Keoua, the Ka'u chief, and his uncle Keawema'uhili, the Hilo chief, led to a battle in which the older man was killed. Keoua seized Hilo and marched into Kamehameha's lands in Hamakua and Kohala.

Kamehameha's and Keoua's forces met in two bloody and indecisive battles in Hamakua. Licking their wounds, Kamehameha's forces retired to Kohala, while Keoua returned to Hilo to consolidate his power before leading his army, accompanied by many women and children, back towards their home in Ka'u.

32

The route to Kaʻu took them past Kilauea. While they camped one night, the volcano exploded. After three days of eruptions, the thoroughly frightened but mostly unharmed troops tried to flee the area, dividing themselves into three groups. Unfortunately the biggest eruption caught the middle group, killing over 400 men, women, and children.

Keoua himself was unharmed, but this display of Peleʻs anger must have affected his morale. The incident did not prevent him from continuing the war with Kamehameha, however. Strengthened by the addition of Hilo to his domain, Keoua fended off simultaneous attacks on both Kaʻu and Hamakua. After nine years of intermittent warfare, neither chief seemed close to victory.

Kamehameha then began to build the great heiau at Puʻukohola to fulfill the prophecy he had received on Molokaʻi. Priests decided on the exact site, the orientation, and the dimensions. Common people came from all over Kamehamehaʻs lands to participate in the massive effort to pass stones hand-to-hand all the way from Pololu Valley 14 miles away. When completed in the summer of 1791, the heiau was 224 by 100 feet, surrounded by 20-foot high walls that at the base were also 20 feet thick.

Before it was completed, military necessity forced Kamehameha to suspend construction while he dealt with another invasion attempt led by the kings of Oʻahu (his old nemesis Kahekili) and Kauaʻi. They had reoccupied Molokaʻi and Maui and now turned their attention to Hawaiʻi. Crossing from Maui in a large fleet of canoes, the invaders pillaged the north coast of the Big Island before Kamehameha could marshal his own forces.

The Hawaiian king gathered a large fleet consisting of double canoes equipped with cannon and the Fair American, where Young and Davis would command the artillery. The invaders also had canoes, cannons, and foreign supporters. The two fleets met in the spring of 1791 near the entrance to Waipiʻo Valley in a bloody sea battle called Kepuwahaulaula (the battle of the red-mouthed gun). This first naval battle in Hawaiʻi was not a total victory, but it did convince the invaders to give up their attempt to conquer Hawaiʻi and to return home. Kamehameha then turned his attention back to Keoua.

He first finished the great heiau at Puʻukohola. It was a luakini heiau, dedicated to his war god Kukaʻilimoku, which meant there had to be a human sacrifice before Kamehameha could be assured of success in war. Kamehameha sent messengers to Keoua, inviting him to come to Puʻukohola and discuss peace. Ominously, the only remaining act to complete the heiau was the sacrificial event.

Keoua, perhaps surprisingly, accepted Kamehamehaʻs invitation even though he surely suspected the probability of treachery. Perhaps Peleʻs warnings at Kilauea

discouraged him from pursuing war. Alternatively, it may have been Kamehameha's increasingly superior weaponry and his recent sea victory over the invading forces from Maui. For whatever reason, Keoua accepted both the invitation and the inevitable and set out in a ceremonial procession from Ka'u. In order to make himself a less than perfect offering, Keoua cut off the head of his penis.

Keoua selected 26 worthy death companions to sail with him in his double canoe. As they approached Kawaihae they saw Kamehameha's war canoes massed offshore and men on the beach, armed with cannon and muskets. The two kings greeted each other from a distance and Keoua started to get out of his canoe. Then Ke'eaumoku, Kamehameha's most trusted lieutenant and the slayer of Keoua's older brother Kiwala'o nine years earlier, threw his spear at the younger sibling and killed him. Ke'eaumoku and his men then slaughtered most of the other men in Keoua's canoe and would have done the same with the rest of the entourage had Kamehameha not intervened to stop it.

The bodies of the dead Ka'u chief and his companions were then sacrificed on the altar of Pu'ukohola, and Kamehameha became chief of the entire Big Island. However, fulfilling the prophecy of ruling all the islands would take several more years.

By the early 1790s, political authority in the islands was divided between Kamehameha on Hawai'i and the old King Kahekili, who now controlled Maui, Moloka'i, Lana'i, and O'ahu directly and Kaua'i indirectly through his brother. It was still not at all clear which of these old rivals would ultimately prevail.

Into this uncertainty, three British exploratory expeditions commanded by Captain George Vancouver arrived in Hawai'i to continue the work begun by Cook. Vancouver, as a young midshipman, had been with Cook and was among those who stood beside the captain when he was murdered.

Despite this inauspicious experience, Vancouver displayed great affection towards the Hawaiians and was eager to help promote peace and prosperity in the islands. Kamehameha, whose friendship Vancouver cultivated on his second and third expeditions in 1793 and 1794, especially impressed him. They had first met in 1779 at Kealakekua. Both men had risen considerably in rank, and they formed a mutually advantageous friendship.

"I was agreeably surprised," Vancouver wrote, "in finding that his riper years had softened that stern ferocity which his younger days had exhibited." Kamehameha was now in Vancouver's opinion "open, cheerful, and sensible . . . of the most princely nature." He also met and admired Ka'ahamanu, Kamehameha's young and favorite wife. Distressed to learn on his third visit in 1794 that Ka'ahamanu had returned to her parents after some marital difficulties, the British commander was instrumental in

reuniting the couple. He persuaded her to return, but only after receiving a promise from Kamehameha that he would not beat her when she came home.

Vancouver was especially troubled by the bloodshed and devastation caused by the ongoing wars. He opposed the practice by European captains of trading arms to the Hawaiians and unsuccessfully attempted to make peace between Kamehameha and his rivals on other islands.

He was also interested in improving the prosperity of the Big Island. Vancouver imported from California the first cattle and sheep in the islands. When he presented them to Kamehameha, Vancouver persuaded him to place a 10-year kapu on the cattle so they would have an opportunity to breed and multiply. The cattle were sent to Waimea, where without any natural enemies and protected by the kapu, they multiplied far beyond expectations. In the long term, these animals formed the basis of the Hawaiian cattle industry; in the short term, they proved to be a pest to Hawaiian farmers.

Vancouver, along with Kamehameha's advisors Isaac Davis and John Young, convinced the king that he should favor the British over other nations. Kamehameha even went so far as to "cede" his kingdom to Britain, though his concept of what this meant was undoubtedly different from Vancouver's. Kamehameha most likely thought he was receiving British support against his enemies. The English, for their part, did not act on this "cession" while Kamehameha lived. Indeed, Kamehameha so admired the British that when he designed a flag for his kingdom, he incorporated the Union Jack in one corner.

Vancouver's carpenters helped Kamehameha's laborers build the king a European-style ship, which he of course named The Britannia. He also taught Kamehameha how to drill his troops in the European fashion. So, while Vancouver wanted to spread peace in the islands, these acts undoubtedly helped prepare Kamehameha for more war in his quest to conquer the other islands. It was only a few months after Vancouver's final departure in 1794 that King Kahekili died on O'ahu.

War broke out between his two principle heirs. Ultimately one of them, Kalanikupule, was victorious with the help of two English ships that were in the recently discovered harbor at Honolulu. Pearl Harbor, as it would later be called, was so vastly superior to any other anchorage in the islands that it would eventually be responsible for a shift in power and population away from the Big Island and towards O'ahu.

At first on the verge of defeat, Kalanikupule persuaded the captain of one of the English ships to supply him with guns and ammunition. With the help of English sailors in boats along the shore, Kalanikupule then defeated his rival. With victory in

hand, the new O'ahu king, impressed by the power of the English ships, plotted to extend his kingdom to the Big Island.

To do this, his soldiers captured the two English ships on January 1, 1795, killed both captains, and forced the crews to put out to sea. The crews managed to retake the ships, kill or drive off most of the Hawaiians, and send the humiliated king, his queen, and their retainers ashore in a canoe. The ships then sailed for China but stopped first in Hawai'i, where they informed Isaac Davis and John Young of the recent events on O'ahu.

Kamehameha determined that the time was right for him to launch his own invasion. In 1795, with Kalanikupule weakened, Kamehameha conquered Maui and Moloka'i and prepared to advance on O'ahu. While on Moloka'i, however, one of Kamehameha's chiefs, named Ka'iana, deserted to the enemy and took his troops to O'ahu. He had previously committed adultery with Ka'ahamanu, Kamehameha's favorite wife, so the relationship between the two men had been uneasy for some time.

Despite the defection, Kamehameha landed his warriors at Waikiki and Waialae. The combined forces of Kalanikupule and Ka'iana mounted a defense in Nu'uanu Valley, but after a furious and bloody battle, they were defeated and routed. Ka'iana was captured and killed; Kalanikupule wandered about for several months before being captured and sacrificed to Kuka'ilimoku.

The victorious Kamehameha stayed on O'ahu to consolidate his victory and plan for the final push to Kaua'i and its dependency Ni'ihau, as they were the only places still beyond his control. Kaua'i, however, was strongly defended and protected by treacherous waters, and Kamehameha's first attempt ended when high seas swamped many of his canoes. It would be more than a decade before this final piece of the puzzle was completed.

A brief rebellion back on the Big Island, led by Ka'iana's brother, forced Kamehameha to return home in 1796. He remained on Hawai'i for the next six years, spending most of his time in Kailua. During this period he refined his government and, as we shall see in a later chapter, increasingly traded with the growing number of foreign ships that sailed into Hawaiian waters. He had not given up his dream of ruling all the islands, thus the plan to invade Kaua'i was still in his sights.

To enhance his control over an expanded kingdom, Kamehameha modified the existing feudal aristocratic structure by appointing a governor over each of his islands. He rewarded his friends and supporters by granting them lands and required the high chiefs to remain close by so he could keep an eye on them. He also continued to support the old religious traditions and practices. The governors were not always native Hawaiians. From 1802 to 1812, while Kamehameha himself was away from

the Big Island, the governor was John Young. Another Englishman later served briefly as governor of Oʻahu.

Kamehameha was head of state, but he governed with the advice of a council of high chiefs and appointed an executive officer named Kalanimoku. As the king's principle advisor, he adopted the name of the current British Prime Minister William Pitt. Foreigners usually referred to him as Mr. Pitt or Billy Pitt, and many other Hawaiian leaders would follow this practice of adopting the names of famous British or American leaders.

By 1802, Kamehameha was ready to renew his attack on Kauaʻi. He had spent the past five years building as many as 800 double canoes, which could carry an army of several thousand men. He also had several small schooners built by foreign carpenters, and a formidable collection of muskets, cannon, and ammunition.

Kamehameha himself commanded the fleet, taking with him his son and heir Lilolilo. The first stop was Lahaina in Maui, where the fleet spent a year while Kamehameha sent eventually futile ultimatums to Kaumaualiʻi, the ruler of Kauaʻi. In late 1803 or early 1804, the fleet moved on to Oʻahu, only to be devastated that spring or early summer by a terrible epidemic.

The sickness, probably cholera, typhoid fever, or even bubonic plague, was undoubtedly carried to Oʻahu by an American or English ship. As happened many times over the next several years, the natives, without any hereditary resistance to foreign diseases, were decimated. Many chiefs and soldiers alike died, and Kamehameha himself caught the disease but fortunately survived. It was obvious to the kahunas that the gods were angry. Kamehameha offered sacrifices, both human and animal, but it was in vain. He was forced to call off the attack on Kauaʻi, and the armada, which he had spent so many years building, rotted on the beaches of Oʻahu.

Yet Kamehameha still did not give up his dream of adding Kauaʻi to his kingdom, and he continued to prepare for war for the next several years. He remained on Oʻahu during this period, enhancing his relationships with the ever-increasing number of foreign traders and merchant ships. These traders, who also bartered with Kauaʻi, wanted peace between Kamehameha and Kaumaualiʻi. The Big Island king let it be known he no longer desired to conquer Kaumaualiʻi and if the chief would merely acknowledge Kamehameha's sovereignty and pay him a token tribute, Kaumaualiʻi could continue to govern Kauaʻi as before.

Ultimately it was an American trader, Nathan Winship, who brokered an agreement between the two rulers. Kaumaualiʻi overcame his understandable suspicions and agreed to come to Oʻahu and meet with Kamehameha. He undoubtedly remembered what had happened to Keoua at Puʻukohola several years

earlier, but Kaumauali'i came on Winship's ship to pay homage to Kamehameha early in 1810.

Kaumauali'i's concerns were by no means unfounded. There actually was a plot by several of Kamehameha's chiefs to poison the Kaua'i leader, though Kamehameha himself most likely was not involved. Isaac Davis actually uncovered and foiled the plot, and for his troubles the plotters poisoned him in April 1810.

Nonetheless, Kamehameha now ruled all the islands, and perhaps more importantly ended the violence and warfare that had so far characterized his reign and that of his predecessors. He never again went into battle. In 1812, he returned to the Big Island, where he lived for the rest of his life in Kailua, indulging in his passion for fishing and concentrating on developing the political and economic institutions of his kingdom. Despite the occasional grumbling from Kaumauali'i in Kaua'i, there was no serious challenge to his authority.

He still continued to support the old kapu religious system, which was well-suited to maintaining his position as an absolute monarch (to use a European concept of the day) who ruled by divine right. The highest chiefs, backed by the gods, continued to demand prostration from all commoners who came into their presence. All aspects of life, including government, religion, sex, land holding, diet and eating habits, and social relationships were governed by the 700-year-old kapu system. Violating a kapu could be, and sometimes was still, punishable by death.

Although missionaries did not come to Hawai'i until after Kamehameha's death, he learned some rudimentary concepts of Christianity from sea captains and other westerners but had no inclination to substitute their religion for his own. By 1819, the year of Kamehameha's death, he ruled his kingdom from Kailua Kona with a firm hand, aided by the kapu system that continued to promote royal authority and social order.

SOCIAL CHANGE AND UPHEAVAL

When Kamehameha died at Kailua on May 18, 1819, he was approximately 70 years of age. His 22-year-old son and heir Liholiho immediately left with his entourage for Kohala to escape the defilement of the death site. Liholiho, as Kamehameha II, would reign for only a few years, but it would be a time of significant change and upheaval for the Hawaiian Kingdom and people.

Those who remained in Kailua prepared the late king's body for burial. After the ceremony was over, two of Kamehameha's closest companions took his bones and buried them in a still unknown location. Liholiho then returned to Kailua to assume his new role with an impressive ceremony. The young king wore a red and gold English uniform under the royal feather cloak and helmet. As he entered a circle of chiefs, also resplendent in feathers, the high chiefess Ka'ahamanu and favorite of his father's 21 wives met him.

Queen Ka'ahamanu, a remarkable woman whose influence spanned the reign of three kings, announced to the new king and the assembled chiefs the wishes of her late husband. "I make known to you the will of your father," she exclaimed. "You and I shall share the realm together."

Whether Kamehameha had really wanted Ka'ahamanu to share power is unknown, but no one was willing to challenge the words of the formidable queen. It is possible ✳ that Kamehameha realized that Liholiho did not have strong leadership qualities and it is known he consciously divided his command to some extent. While making Liholiho heir to the kingdom, he made his nephew Keku'aokalani custodian of the war god Kuka'ilimoku. Kamehameha must have realized that this division alone was a potential source of trouble as a similar division by Kalani'opu'u many years earlier between Kiwala'o and Kamehameha soon found the two cousins at war. The fact that Kamehameha risked repeating this scenario may indicate that he questioned his son's abilities. This doubt might also have persuaded him to give an ongoing role to his favorite wife.

An indication that Kamehameha's possible hesitations about his son's capabilities were legitimate comes from a visiting French explorer, who met the new king shortly after his succession. "I soon perceived that the authority of the young King was but

poorly established," wrote Louis Freycinet, "and that his wishes were frequently balked by some of the principal chiefs."

In any event, without any opposition from Liholiho or other high chiefs, Ka'ahamanu proclaimed herself kuhina nui, or high priest, which established in effect a dual monarchy. The new king and kuhina nui would govern the kingdom jointly; Liholiho would share authority with his strong-willed stepmother, whose ambition would soon bring profound changes throughout the kingdom. Ka'ahamanu in this role would become the most powerful person in the kingdom.

role of females

Despite her new authority, Ka'ahamanu chafed under the restrictions imposed on women by the kapu system. Females could not enter luakini heiaus, where most political decisions were made, and this was a source of irritation now that she was kuhina nui. She and Keopuolani, another powerful wife of the first Kamehameha (and mother of both the second and third), found the eating kapus (ai kapu) especially humiliating. Women could not consume certain foods such as bananas, pork, and shark meat; men and women could not eat together in the same room. Before Kamehameha's death, Ka'ahamanu had secretly eaten bananas and had suffered no obvious adverse consequences.

The two women were not the only people growing weary of the system. The few foreigners who lived in the kingdom paid little heed to the kapus, yet they seemed to prosper. Whether westerners were subject to the kapus was uncertain, and when they married Hawaiian women, the situation became even more confusing. So, even before Kamehameha died, there were cracks in the system and proponents for change.

Ka'ahamanu began suggesting that the new king abandon the kapu system, but Liholiho was reluctant to make such a drastic change. His cousin Keku'aokalani tried to dissuade him; as custodian of the war god, he would lose all power if such a change occurred, as would most priests and many high chiefs.

Ka'ahamanu and Keopuolani kept pressing Liholiho to end the kapu system by symbolically planning to attend a feast they arranged in Kailua for leading chiefs and several foreigners. Still uncertain and understandably nervous about unforeseen consequences of such a revolutionary action, the young king took a boat loaded with liquor out to sea and drank for two days in November 1819.

When Liholiho came ashore he joined the feast, suddenly sat down at the table occupied by the women, and began to eat. The "astonished" guests "clapped their hands, and cried out, 'Ai noa,—the eating tabu is broken.'" After the meal, Liholiho ordered the destruction of all heiaus and the burning of all idols throughout the kingdom.

There was resistance, of course, and many Hawaiians continued to follow the ancient religion for many years. The most serious opposition came from

—eating tabu broken

Keku'aokalani and most of the priests. Keku'aokalani prepared to use force to restore the old order and gathered an army near Kealakekua Bay.

When attempts at conciliation failed, Liholiho sent Kalanimoku, who retained the position of prime minister that he had held under Kamehameha, with an army to defeat the rebels. The two armies met just south of Keauhou Bay. At first the rebels seemed to gain the advantage, but Kalanimoku regrouped and trapped Keku'aokalani's forces at Kuamo'o, at the end of what is now Ali'i Drive, in December 1819.

Hundreds died in this last battle on the Kona coast, including Keku'aokalani and his wife. They were buried in a stone grave that still stands on the battle site. The bodies of dead soldiers from both sides were also committed to the ground there. This victory ensured the collapse of a second rebellion in support of the old religion that broke out in Hamakua. The gods themselves seemed to have abandoned the cause.

Liholiho pardoned the remaining rebels and restored peace through the kingdom, but because the old religion had imposed itself on all aspects of Hawaiian society, its destruction established a void. The kapu system no longer existed and there was nothing to take its place—at least for a few months.

By the time Kamehameha II (Liholiho) and Ka'ahamanu abolished the kapu system, European and American visits to Hawai'i were common. The visitors came for a variety of often-contradictory purposes. Some, such as Cook and Vancouver, came to explore and further scientific knowledge. Others came to make money, and still others to save souls. The posthumous publication of the martyred Cook's journals, complete with maps, provided a mostly flattering and appealing account of the islands. Soon ships from many nations stopped to trade or to re-supply before going on to China and other Asian destinations. While in the islands, the crews also took advantage of the favors offered willingly by Hawaiian women.

By the 1790s, ships from Great Britain, the United States, France, Russia, Spain, and the Netherlands had all paid at least one visit. The captains of most of these vessels, as we have seen, had no scruples about trading western arms to warring island chiefs, but to obtain these arms and other European products, the Hawaiians needed something to exchange. One of the earliest commodities westerners sought in Hawai'i was sandalwood. This fragrant lumber, which came from what Hawaiians called the iliahi tree, was popular with the Chinese, who burned it as incense among other applications.

Europeans had been trading with China for several hundred years. The Chinese had many products the Europeans wanted (silk, tea, spices, porcelain), but there was little the Chinese wanted from Europeans in return. Unless they could find tradable

products, Europeans and Americans had to buy Chinese products with gold or silver, creating what we would now call a severe adverse balance of payments.

Sandalwood was one answer to the problem, for it was something the Chinese wanted. Kamehameha, who among other things was a shrewd businessman, created a monopoly of the sandalwood trade for himself. Beginning in a big way around 1810, American and European traders stopped at Hawai'i on the path to China to harvest the wood. The trade was so popular that by the end of the 1820s iliahi trees virtually disappeared from the islands while Kamehameha greatly enhanced his own personal wealth. Indeed, one of the first controversies that confronted Kamehameha II was a demand from the chiefs that they be included in this lucrative trade. Unfortunately, by the 1820s American traders often advanced loans backed by future sandalwood harvests. As the iliahi trees disappeared, these loans were harder to pay off.

One result of the increasing number of ships coming to Hawai'i each year was a gradual shift of power away from the Big Island and toward O'ahu, since Pearl Harbor was so obviously superior to all other ports in the islands. While Kamehameha was alive, he lived primarily on the Big Island, usually at Kailua, ruling his kingdom from the island of his birth. But as the economic focus shifted to O'ahu, the political focus would soon follow. In late 1820 and early 1821, following the recommendation of a council of chiefs, the king and his attendants moved the principal royal residence from Kailua to Honolulu. Liholiho did not live there all the time, for he continued to travel around the islands, but it was clear that the seat of government had moved.

Before this shift, however, another momentous event in Liholiho's reign occurred when the first Christian missionaries arrived in the islands. Christians, at least of the nominal sort, had been coming to Hawai'i since the days of Captain Cook. Kamehameha, as we have seen, was acquainted with the rudiments of Christianity but chose to remain loyal to the old religion. However, a movement in the United States, especially in New England, to spread the Gospel to "heathens" throughout the world grew stronger in the second decade of the nineteenth century. The coincidental overthrow of the kapu system in Hawai'i soon provided fertile ground for missionaries eager to fill the spiritual vacuum.

In 1809, a young Kealakekua boy named Opukahaia, orphaned by the island's wars, came under the wing of an American ship captain who took the boy and a friend to New England for schooling. He converted to Christianity and began to call himself Henry Opukahaia. Protestant missionaries hoped to send the boy back to Hawai'i to convert his compatriots. Opukahaia, himself a fervent convert, readily agreed. In preparation, he translated the Book of Genesis into the recently developed written Hawaiian language and began working on other Hawaiian texts. Unfortunately,

religion +civilization

before he could make the return trip, he died of typhus at the age of 26. He did eventually make it back, but not until 184 years later in 1993, when his body was returned from Connecticut and reburied at Napoʻopoʻo.

Opukahaiaʼs death was a temporary setback for the American Board of Commissioners for Foreign Missions, the primary New England missionary group, but they pushed ahead with the project to save Hawaiian souls. These primarily Congregational and Presbyterian volunteers believed there was a special need for missionary work among Hawaiians, who after 40 years of contact with white men had adopted only the worst of their habits. Coupled with religion, of course, was "civilization." The missionaries had two related goals: to civilize the poor "savages" and to prepare them for eternity.

Under the leadership of Hiram Bingham, the American Board organized a missionary team to go to Hawaiʻi in 1819. In addition to several missionaries and their wives, the group included a printer, two teachers, a physician, and four other Hawaiian youths who had been educated in New England.

In October of that year the group formed a church in Boston and then boarded the ship Thaddeus for the 18,000-mile journey that took nearly five and a half months. On March 30, 1820, they saw snow on Mauna Kea, which they enjoyed, and bare-skinned "degraded" natives, which they did not. To Bingham it was "appalling." Some members of the missionary party "with gushing tears, turned away from the spectacle," and wondered if these were really "human beings."

Upon landing at Kailua, the missionaries learned both that Kamehameha was dead and that the old religion had been abolished. The latter, of course, they regarded as a favorable sign from God. Kamehameha II was cautious. He greeted the missionaries, but made them wait for several days while he decided whether to allow them to remain. He undoubtedly suspected this new religion could be as oppressive as the old one had been. The king himself had five wives at the time, two of whom had been his father's wives, and one of whom was his half sister. These were typical arrangements from the traditional Hawaiian standpoint, especially for royalty and high-ranking chiefs, but the missionaries had a very different perspective.

Additionally, Kamehameha II, even more enamored of the British than his father had been, worried that the Americans might alienate them. After considering these factors, the king gave the missionaries permission to stay in his kingdom on a probationary basis for one year. The Americans, unappreciative of the climate and terrain of the Kona coast, wanted to establish their mission in Honolulu. Not completely trusting them, Liholiho declared that half the group could go to Honolulu, but the other half would have to stay in Kailua where the king could keep

his eye on them. Reverend Asa Thurston, a physician, and two Hawaiian youth trained in New England all stayed in Kailua; the rest of the group, led by Bingham, went on to Honolulu.

Liholiho ordered small thatched houses built for the missionaries in Honolulu, Kailua, and Waimea. In these huts they set up schools and began to teach English. Thurston preached sermons outdoors and drew curious crowds, while others simply turned out to watch the missionary wives as they washed their husbands' clothes.

The schools also proved to be an attraction. Many Hawaiians came to see what was happening, but the difficulty of learning English, coupled with the requirement that students wear "proper" Christian clothes, was more than most could bear for long. The missionaries soon realized that if they were to educate the Hawaiians, they would need to do it in their own language. The Americans then learned the Hawaiian language and greatly enhanced the early attempts to develop a written form of it.

Despite these efforts, not many islanders were tempted to convert at first. Too many Hawaiian customs and cultural practices clashed with Christian "morality." The missionaries were appalled at "lewd dancing" (the hula), public nakedness, plural marriage, incest, and rumors of abortion and infanticide. Furthermore, despite the official abolition of the old religion, many people continued to practice some of the traditions.

Sexual freedom characterized Hawaiian society, especially for the young. Hawaiian marriages tended to be casual relationships that could easily be entered into and just as easily broken. Sexual activity began early and continued throughout the lives of Hawaiians with or without formal marriage. To the missionaries, this was "adultery," and they attempted with only limited success to convince Hawaiians to enter more formal, lasting, and especially monogamous relationships.

If they were to accomplish their goals, the missionaries would need the support of the high chiefs. Liholiho was unenthusiastic. He said he wanted to receive an education, but then sent his friends to school to do the learning for him. Ka'ahamanu also kept her distance in the beginning. She reconsidered, however, after she fell seriously ill and was nursed back to health by Hiram Bingham's wife. In gratitude, Ka'ahamanu became an eager convert, toured the islands spreading Christianity, and seriously studied with missionary teachers in Honolulu. While the king remained remote, spending much of his time drinking, the kuhina nui now became just as vigorous in supporting efforts to establish this new religion as she had been in destroying the old one. When a second group of missionaries arrived in 1822, they found their work much easier than the earlier group.

Ka'ahamanu's brother, the high chief Kuakini, was governor of Hawai'i. He showed some interest, but only because he saw Christianity as a substitute for the kapu system in helping to maintain control over the common people. When the government of the kingdom moved from Kailua to Honolulu, Kuakini's role and influence expanded to make him the most powerful and influential person on the Big Island. Following a common practice of many Hawaiian chiefs during this period, Kuakini adopted the name of a prominent British or American leader. He called himself "John Adams." Foreigners generally referred to him by that name or sometimes J.A. Kuakini.

He was born on Maui, but as an infant his father's relatives took him to Keauhou, where he grew up. As a youth, Kuakini excelled in canoeing and other sports and also exhibited an avid interest in the hula, alcohol, and women. On one occasion when discovered in a compromising situation with the wife of the governor of O'ahu, he fled and jumped over a stone wall, seriously injuring his foot. He almost died from this injury, but recovered and remained lame for the rest of his life.

Kuakini was governor of parts of the Big Island beginning in 1812, when he succeeded Kamehameha's advisor John Young. In 1820, he became governor of the entire island, a position he held until his death in 1844. During his tenure, Kuakini built many of the historical sites that still dominate Kailua today. The Great Wall of Kuakini, probably a major enhancement of an earlier wall, stretched from Keauhou to Kailua. Its purpose was to keep the troublesome descendants of George Vancouver's original cattle from continually wandering through the fields and houses of Kailua.

Additionally, Kuakini supported Asa Thurston in building Moku'aikaua Church (completed in 1837), the oldest surviving church in the state of Hawai'i. Kuakini sponsored additional churches in Waimea, Nunulu, Hamakua, Hilo, and Ka'u.

For his own home Kuakini built Hulihe'e Palace, which was completed in 1838. After his death, the palace passed to his stepdaughter-in-law, Princess Ruth Ke'elikolani. Upon her death, the building became a Big Island residence for the Hawaiian royal family. In the 1880s, the palace was remodeled by King David Kalakaua (the Merry Monarch) and Queen Kapi'olani in the Victorian style reflected in modern restoration.

Governor Kuakini's physical appearance was formidable. Like many Hawaiians, especially those of high rank, Kuakini was large in stature. In 1819, a visiting French captain wrote that the governor was 6-foot, 3-inches tall "and even heavier than his gigantic stature would indicate." His "pleasant and gentle face" reflected an "affable and kindly air." He spoke "tolerably good English" and was very interested in the fate of Napoleon.

Four years later, Reverend William Ellis, a missionary who traveled to Hawai'i after spending several years in Tahiti, described the governor as "tall, stout, well made, and remarkably handsome." As time went on, however, characteristic of many chiefly Hawaiians, Kuakini became remarkably more stout and less handsome.

In 1828, a Dutch merchant ship anchored in Kealakekua Bay. Governor Kuakini had himself rowed out to the vessel in order to welcome the visitors to Hawai'i. However, there was the embarrassing problem of how to get the reportedly 470-pound governor aboard. It was obvious he would not be able to climb up the side of the ship, and the chair designed to assist ladies aboard was obviously too small and the rope too weak. Ultimately a plank was placed on the chair, which was then supported by an additional rope, and "the whole crew" hoisted Kuakini aboard.

As soon as he was aboard, Kuakini got up from his hoisting seat and suddenly fell over backwards "with such force that in truth the whole ship shook from the impact." Fortunately Kuakini was not injured, and the captain suggested that the fall had been caused either by dizziness from hoisting the governor or the discomfort at wearing shoes (without socks). Recovering quickly, Governor Kuakini then warmly welcomed the visitors.

A few days later the Dutch sailed to Kailua where they again met the governor. Arriving on Sunday, they found all the islanders "in their Sabbath dress," preparing to go to the uncompleted but still impressive Moku'aikaua Church. To the Dutch, Kuakini was the foremost architect in the style of his country. They apparently had time to admire the building because Asa Thurston preached his sermon in the Hawaiian language, which the Dutch did not understand.

After the service, Kuakini invited the Dutch to his house for lunch. "The food," the captain reported, "was soup, pork, and goat's meat, and a very delicious fish; also a dish prepared with dog's meat appeared on the table," but the Dutch declined it. The house itself was American style, and Kuakini apparently used it mostly for eating and ceremonial occasions. He actually lived, according to the Dutch, nearby in a native-style house "much more convenient to sleep in."

A few years later in 1836, a French ship made a brief stop at Kailua. Theodore-Adolphe Barrot, who later published an account of the visit, reported that Kuakini came out to meet their ship, promising to help the French make the most of a brief visit of only a few hours. He took them first to the still unfinished church, which impressed them greatly: "a person here might imagine himself in a European temple, and the most of our villages are far from having churches comparable to that of Kailua." Kuakini, they reported, was very proud of what he called his "monument."

Their next stop was Kuakini's house, where the Frenchmen watched the governor and his wife eat lunch. Kuakini, according to Barrot, "perceived without doubt that we should find difficulty in adapting ourselves to his manner of eating, and truly, there is nothing more disgusting." Kuakini's wife, the Frenchman reported, was a "gigantic," "monstrous," and "hideous" woman, about 5-feet, 10-inches tall and "completely round." Their meal consisted of baked pork, salted fish, and poi. The French were amazed at the quantity that "this monstrous couple devoured."

The town of Kailua itself did not impress the French. Aside from the impressive church, they saw only a few huts scattered around without any apparent order. They also saw a crowd of curious "ragged men and women" that followed wherever they went. The only consolation was that they found Honolulu, their next destination, little more appealing.

The French may have been unimpressed, but what they probably failed to appreciate was the degree of social, political, and cultural change that occurred during the 30 years Kuakini served as governor of the Big Island. They also probably failed to appreciate the scope of his authority. The missionary Titus Coan, who observed Kuakini on his frequent visits to Hilo, described him as:

> governor and lord of all Hawai'i, [who ruled] with an iron will, fearing
> neither man nor monarch . . . [he could] call out a thousand men to build
> a causeway, or a dam for enclosing fish, to cut sandal-wood in the
> mountains, or to build a large church edifice.

Indeed, Kuakini's authority was so strong that he "sometimes refused to obey his king, saying that on Hawai'i his power was supreme." Unfortunately, he also sometimes oppressed his people. On his occasional tours of the entire island, according to Coan:

> the governor would send messengers before to command the natives to build
> him large houses at all places where he would spend a night or a day or two,
> and also to prepare large quantities of fish, fowls, pigs, eggs, poi, potatoes, etc.

On these tours, he brought "three score of men, women, and children, all to be fed by the people where he lodged." Sometimes he would stay for as long as a month, "consuming almost all the eatables within a radius of two or three miles."

When Kuakini died in 1844, his estate passed to his adopted son, who also died shortly thereafter. The estate then moved along to his son's wife, Princess Ruth

Ke'elikolani, one of the more colorful figures in nineteenth-century Hawai'i. A high-ranking chiefess through her mother, Princess Ruth was a direct descendent of Kamehameha I. She was also half-sister to Kings Kamehameha IV and Kamehameha V. After the deaths of both Kuakini and his son, Princess Ruth inherited Hulihe'e Palace. She also succeeded Kuakini as governor of the Big Island.

The princess was also a very large person, well over 6 feet tall and over 400 pounds. Her cousin Bernice Pauahi Bishop called her both the richest and the largest woman in all Hawai'i. The room dedicated to her in Hulihe'e Palace today gives some indication of her size. An ardent Hawaiian nationalist, Princess Ruth refused to speak English or practice Christianity. When she stayed at Hulihe'e Palace, she insisted in sleeping in a Hawaiian-style grass building erected on the palace lawn.

In 1872, she was a contender for the throne when the last of the Kamehamehas died. Without a direct heir, selection of the monarch became the responsibility of the legislature. Some have suggested that her very "Hawaiian-ness" acted against her candidacy. William Lunalilo won the election to succeed Kamehameha V, and when the new king himself died a little over a year later, David Kalakaua won the next royal election.

Princess Ruth died in 1882, leaving her fortune to her cousin, who in turn used it as a major component of the Bishop Estate that continues to control much of the land throughout the State of Hawai'i.

Chapter Five

THE MISSIONARIES

Of all the changes that occurred during Kuakini's tenure as governor, none of them had a more lasting impact than the arrival of Christian missionaries. Their landing, as seen in the previous chapter, coincided with the overthrow of the old kapu traditions, enabling them to pursue their mission with greater success than would have been possible previously.

In 1823, the Reverend William Ellis took a tour of the Big Island that lasted for several months, and in 1825 he published the most detailed account of the island to date. The narrative of his journey went through many editions in several languages and gave Europeans and Americans a remarkable snapshot of Hawaiian society, culture, and geography.

Ellis, who had spent several years in Tahiti as a missionary, spoke their language fluently, and because Tahitian was similar to Hawaiian, he could soon converse freely with the natives he met. The primary purpose of his trip, sponsored by the Hawaiian Mission, was to explore the Big Island for potential sites for mission "out stations." He and his companions, including the Kona missionary Asa Thurston, had the complete support of Governor Kuakini, who provided them with a guide, supplies, and a double canoe.

The group walked most of the island, reverting to the canoe only when the terrain proved impassable. They stopped at villages, met the people, took in the sites, and, of course, preached the Gospel whenever they could. They quickly learned, if they did not already guess, that the abolition of the old religion in 1819 had not been completely successful. There was still support for the old gods, even among those who accepted the missionaries' word. Reverend Mr. Ellis' "one true God" was to many Hawaiians only one of several.

Ellis described Kona, where the expedition started, as the most populous of the six regions of Hawai'i. If it were not for lava flows, he suspected that it would also be the most fertile region. The northern part (Kailua, Kealakekua, Honaunau) was densely populated and had much cultivated land on the mountainsides. Sparsely populated South Kona had little cultivation and existed principally on fishing.

These missionaries were the first westerners to visit and write about the Kilauea volcano. Fearing Pele, the native guide refused to accompany them, but Ellis and his

party hiked on. They expected the volcano to be a steep mountain with a steep summit. Instead they were surprised to find themselves "on the edge of a steep precipice, with a vast plain before us, fifteen or sixteen miles in circumference, and sunk from 200 to 400 feet below its original level." Upon reaching the edge of the crater, they found "a spectacle, sublime and even appalling. We stopped, and trembled."

After leaving the volcano, the party moved on through Puna and into the Hilo district to the village of Waiakea, now part of the town of Hilo. They found the countryside "the most beautiful we have yet seen," undoubtedly due to humidity, the rain, and the long-term absence of volcanic activity. The fertility of the soil, the fresh water, the harbor, the relative density of the population, and the friendliness with which the natives received them made this location "a most eligible spot for a Missionary station." Ellis estimated that there were approximately 400 houses surrounding the bay and probably at least 2,000 inhabitants.

Continuing up the Hamakua coast, the party split. Some went over land through the "saddle" to Waimea; Ellis with another group continued on to Waipi'o Valley. He reached the southern overlook of the valley just as the sun was setting. From that perspective, the basin spread out like a map. Below, Ellis observed "numerous inhabitants, cottages, plantations, fish-ponds, and meandering streams."

Their guide led the party down the cliffs (in the dark no less) in a venture that Ellis, with considerable understatement, described as "difficult." Nevertheless, the next morning the romance of their location was obvious to him:

> The bottom of the valley was one continued garden, cultivated with taro, bananas, sugar-cane, and other productions of the islands, all growing luxuriantly. Several large ponds were also seen in different directions, well stocked with excellent fish. A number of small villages, containing from twenty to fifty houses each, stood along the foot of the mountains.

After further exploration, Ellis estimated that the valley contained 265 houses, with probably 1,325 inhabitants. The soil, water, and the ability throughout most of the year to ship supplies from either Kailua or Kawaihae all made the valley another excellent candidate for a missionary station.

The need for such an outpost was apparent when they visited the valley's pu'uhonua, a place of refuge. Though smaller than the one at Honaunau, it contained in the Hale o Liloa (house of Liloa) the bones of that ancient king. The priests did not allow Ellis and his friends to enter the sacred spot, and when Ellis tried to

Hawaiians love of the water

convince them of the "folly of deifying and worshipping departed men," the Hawaiians responded: "Pela no i Hawai'i nei: So it is in Hawai'i here.'"

Fortunately, Ellis reported on more than just the religious shortcomings of the Hawaiians. Though not the first to write about it, he was very interested in the love Hawaiians had for the water. Children were taken into the ocean when only a few days old and often could swim before they could walk.

They also played many water games and sports and seemed to enjoy them most when the waves were largest. "On these occasions," Ellis wrote, "they use a board . . . generally five or six feet long, and rather more than a foot wide, sometimes flat, but more frequently slightly convex on both sides." Made of a wood called erythrina, these boards were stained black and treated with great care by their owners. After using it, an owner would dry his board in the sun, rub it with coconut oil, wrap it in cloth, then suspend it in some part of his house.

When engaging in this sport, Ellis reported, the Hawaiians preferred to choose a spot where there were rocks 10 or 20 feet underwater, making waves crash more violently. Each individual would take his board and push it out to sea a quarter of a mile or more. They would not attempt to go over the billows rolling towards the shore, but dive under them as they continued their journey out to sea.

Upon reaching a desirable spot "they adjust themselves on one end of the board, lying flat on their faces, and watch the approach of the largest billow." Poising on the highest edge of the wave, they would then paddle:

> with their hands and feet, ride on the crest of the wave, in the midst of the spray and foam, till within a yard or two of the rocks or the shore. [Just when] the observers would expect to see them dashed to pieces, they steer with great address between the rocks, or slide off their board in a moment, grasp it by the middle, and dive under water, while the wave rolls on, and breaks among the rocks with a roaring noise.

The more experienced would sit and even stand on the boards, making sure to "to keep on the edge of the wave." If they were not careful and got "too forward, they [were] sure to be overturned; and if they [fell] back, they [were] buried beneath the succeeding billow." This was a sport for all ages. Ellis reported seeing even high chiefs in their 50s and 60s, "large corpulent men," ride their boards "with as much satisfaction as youths of sixteen." When the waves were good, an entire village would take to the sea with their boards. At times he had seen 50 or 100 people riding the waves together for several hundred yards as "the most novel and interesting sport a foreigner can witness in the islands."

In addition to their religion and sports, Ellis also commented on the economic and cultural aspects of Hawaiian life. He made his journey at a time when sandalwood was still the main export product of the islands. At Waiakea, he and his party watched 300–400 men carrying sandalwood from the mountains for transport to Honolulu and then on to Canton. At Kawaihae several weeks later they were awakened early one morning by a "vast multitude," 2,000–3,000 men, each carrying from one to six pieces of sandalwood as they came down from Waimea. The number depended on the size and weight, since the men carried the burden tied to their backs with ti leaves. After depositing their loads in a storehouse in Kawaihae, they then returned to their respective homes.

Another economic venture still in its infancy depended upon George Vancouver's cattle, whose descendants were abundant around Waimea. Joseph Goodrich, a member of Ellis' party, left the main group to climb Mauna Kea. On his way to the mountain, Goodrich met a "Mr. Parker, who was employed in shooting wild cattle." Parker went on to establish Hawai'i's greatest cattle ranch, but at this point in the mid-1820s, the "immense herds" of wild cattle were only beginning to show signs of being profitable.

Ellis reported that the Hawaiians were afraid of the "wild and ferocious" beasts and would not go near them. The only advantage derived so far was from employing people ("principally foreigners") to shoot them. These men would then salt the meat in the mountains, dry it, put it in barrels, and transport the beef on men's shoulders 10 or 15 miles to the seashore to provision visiting vessels. This process of course involved much labor and expense.

The salt used, Ellis reported, was produced at Kohala by evaporating sea water. The Hawaiians used an abundance of salt both to flavor their food and preserve fish. They produced more than they needed and sold the surplus to foreign ships visiting Hawai'i. They even exported some to the Russian settlements in North America, where it was in great demand for curing fish. Lapakahi State Historical Park in North Kohala today includes some of the hollowed out stones Hawaiians used for harvesting sea salt.

Ellis' almost bucolic picture of life on the Big Island also touches on some dark aspects as well. The most tragic of these was the catastrophic decline of the population in the 50 years since Cook's contact. Captain Cook himself, without much hard evidence, estimated the population of the entire Sandwich Islands at about 400,000. Of this number, he believed 150,000 lived on the Big Island. Almost immediately, and continuing to this day, that figure has been both challenged and defended. Recent estimates have ranged from as many as 800,000 on all the islands, with 340,000 on Hawai'i, to as few as 110,000 for the entire chain.

- European Diseases

Obviously, the real number is both unknown and hotly disputed. What we do know, however, is that the first real census of the islands, which missionaries conducted in 1831 and 1832, put the population at 130,000. Most scholars agree the number is relatively accurate. We also know that most observers, such as Ellis, noted there had been a precipitous decline in the 50 years after Cook's contact. Ellis mentioned finding many abandoned villages as he made his way around the island.

The primary cause of this "horror" undoubtedly was the introduction of European diseases. Like the natives of North and South America, Hawaiians had no immunity to diseases that had existed for centuries in Europe. Venereal diseases were among the biggest contributors. When Captain Cook left Tahiti on the voyage that would lead to his "discovery" of the Hawaiian Islands, more than half of his crew was reported too sick from venereal disease to work.

The combination of the Hawaiians' easy sexuality and ailments to which they had no previous exposure was literally deadly. Yet venereal diseases were not the only culprits. The English also brought with them influenza, tuberculosis, small pox, measles, and a variety of other illnesses that wreaked havoc on the Hawaiians. Periodic influenza epidemics, for example, killed thousands of people.

Disease was not the only cause of the depopulation. Bloody warfare, which continued through the mid-1790s, contributed as did the practices of abortion, infanticide, and poor infant health care. The horrifying trend continued throughout the rest of the nineteenth century and was compounded by migration of Hawaiian men, who frequently signed on as crew for European and American sea trading and whaling vessels. At century's end, the population of native Hawaiians had declined by as much as an astonishing 90 percent or more.

Among those who succumbed to European diseases were King Kamehameha II (Liholiho) and his favorite wife Queen Kamamalu. Intrigued by what he knew about the British monarchy and hoping to solidify an alliance with the English Empire, the king along with the queen and several other Hawaiian officials undertook a lengthy trip to visit King George IV. Shortly after they arrived in London, and before they had an opportunity to meet the monarch, Kamamalu and then Liholiho himself contracted measles and died in the summer of 1824. The British returned the bodies of the deceased couple aboard the ship Blonde, commanded by Lord George Anson Byron (cousin and successor to the poet, who also died in 1824).

Liholiho was succeeded as king by his half-brother Kauikeaouli (another son of Kamehameha). The new mo'i, who would call himself Kamehameha III, had been born at Keauhou Bay, Kona. Because Kauikeaouli was still a boy of 11 when he became

king, the indomitable Ka'ahamanu, who served as regent during Kamehameha II's journey to London, continued in that position for several more years.

Ka'ahamanu was already a fervent Christian convert, and the death of Kamehameha II removed any hesitation that the government may have had about missionary activities. Their goal was to Christianize the islands, but that was impossible to do without also bringing about profound social and cultural changes.

And what a formidable task the missionaries had before them. Several years later, one missionary characterized the Hawaiians as deceptive, prone to steal, freely given to intoxication, addicted to gambling, notoriously cruel, and "grossly sensual and immoral." Indeed, he wrote, "there were no practices in Sodom that did not there pollute man and provoke God."

Asa Thurston, the first missionary on the Big Island, arrived and started preaching in 1820. In addition to his sermons, he and other missionaries fervently promoted education. Coming from the New England Puritan tradition that emphasized the ability to read the Bible, as noted in the preceding chapter, missionaries soon realized Hawaiians would need to be taught to read their own language.

This meant the Americans had to learn the Hawaiian language, reduce it to a written form, and then teach the natives to read their own tongue. By 1822, Thurston and his Honolulu colleagues had imported a printing press and printed a Hawaiian spelling book, and then school primers, hymn books, and sections of the Bible.

As a result of the journey that William Ellis, Thurston, Joseph Goodrich, and the others made in 1823 to scout out additional sites for activities, the missionary society sent Goodrich to Hilo. David Lyman and his wife Sarah followed in 1832. Shortly after the Lymans arrived, they attended their first Hilo church service where Goodrich preached to a "large and attentive" audience seated on mats in "true native style." Few of the congregation wore western clothes, Sarah reported, and most had "nothing on but Tapa."

Clearly, Sarah Lyman experienced culture shock. The natives' clothing especially troubled her. The men, she reported to her sister in Vermont, wore a strip of cloth, wrapped twice around the body above the hips "barely covering the private parts." The women "think no more of going with their breasts exposed, than we do our hands."

Worse still, both men and women "if they have occasion for it will sit down in, or by the side of the road to do their duties, right before our eyes too." And as for the children, nothing was private or kept from them: "When families sleep in one apartment and on the same mat; this is perhaps one of the greatest evils existing." The more she saw, the more Sarah Lyman realized the importance of "labouring to elevate" the Hawaiians.

This involved the missionaries' dual goals of education and preaching. The Lymans established a boarding school for Hawaiian boys in Hilo in 1836. The education they received was not limited to academic subjects. With satisfaction, Sarah soon observed that the boys "managed very well with their knife and fork." This school, the first of several established throughout the islands by the missionaries, was followed in 1838 by a girls' school in Hilo.

The Lymans, like many of their fellow missionaries, appeared to be more successful in fulfilling their educational than their religious goals. Despite the preaching, missionaries found few signs that their parishioners met the rigorous standards of evangelical Protestantism, and were reluctant to admit them to full church membership. Indeed, by the mid-1830s, only 1,200 Hawaiians in the entire kingdom were church members, even though as many as 50 percent of the population attended Sunday services.

A new breed of missionaries arrived in the 1830s, hoping to address this apparent failure. Hilo acquired the services of the Reverend Titus Coan. A follower and protégé of the New York revivalist Charles Grandison Finney, who convulsed the western part of that state with religious fervor and enthusiasm, Coan was a very different kind of preacher from Thurston, Lyman, and the other early missionaries in Hawai'i.

Though these earlier and more reserved clergymen sometimes questioned Coan's enthusiastic methods, there was no arguing with his success. When Coan began preaching at Hilo in 1835, Lyman's church had only about 20 full members. Coan took upon himself the task of personally talking to every one of the 15,000 or 16,000 people in the 100-mile-long parish of the Hilo and Puna districts. Soon Coan and Lyman divided the missionary responsibilities: Lyman focusing on education and Coan devoting himself to preaching.

He sermonized with such enthusiasm that he aroused strong religious emotions in his listeners. Coan soon had 80 additional converts, but that was only the beginning. One November evening in 1837, he received what he and his followers perceived as a sign from God. As many as 10,000 flocked to Hilo to hear him preach. At sunset, many of them gathered along the shore just as the sea inexplicably began to retreat.

As Coan later wrote, "The sea, moved by an unseen hand, had all on a sudden risen in a gigantic wave," which rushed "in with the speed of a race-horse." Upon reaching the shore, it swept "everything not more than fifteen or twenty feet above high-water mark into indiscriminate ruin." It destroyed "houses, furniture, calabashes, fuel, timber, canoes, food, clothing, everything floated wild upon the flood."

The captain of an English whaling vessel then in the bay reported that "the great part of the bay was left dry." The natives rushed down to see the strange sight only to be met by a sudden great surge. The 20-foot wave crashed on the shore at Waiakea, "as if a heavy mountain had fallen on the beach." Even the strongest of swimmers were swept away, though fortunately the English ship was able to rescue many of them.

The wave demolished at least 100 houses. Parents searched frantically for children, and wives for husbands. Fortunately, as Coan realized, the timing of what we now know as a tsunami was fortuitous. If it had occurred later, when everyone was asleep, hundreds of lives would have been lost. But "through the great mercy of God," Coan wrote, "only thirteen were drowned."

To Coan this "bolt of thunder from a clear sky," was obviously a signal from God, and it greatly impressed the people as well. Even the captain of the whaling ship, according to Coan:

> immediately told his officers and crew that he should drink no more intoxicants, swear no more, and chase whales no more on the Lord's day, but, on the contrary, observe the Sabbath and have religious services on that holy day.

The Hawaiians began to come from all over the district in even greater numbers to hear Coan preach. The religious revival he started spread throughout Hilo and then to Waimea, where Lorenzo Lyons, another young evangelical missionary, had established another mission. More and more Hawaiians began to exhibit, to Coan and Lyons at least, signs that they were ready for full church membership.

By the spring of 1838, the two of them had admitted more than 3,200 natives to membership. Within two more years, they had 10,000 additional members. Hilo and Waimea alone accounted for three-quarters of all church members in the entire kingdom. On one very busy day in 1838, Coan baptized over 1,700 converts.

There were some failures, however. Lyon's Waimea congregation lost several members, either voluntarily or because he excommunicated many of them when they did not live up to his ideals. The more conservative missionaries delighted in Lyon's failings but ultimately had to admit that Coan, who saw relatively little drop off in membership, was indeed a great success. He continued his preaching in Hilo for 40 more years before dying of a stroke.

Coan and the other Protestant missionaries were not the only messengers attempting to bring Christianity to the Hawaiians. To his great dismay, Coan

reported that Catholic missionaries "under the delusion that the Pope as the Viceregent of Heaven had dominion over all earthly principalities and powers," also showed up in Hilo. The Hawaiian rulers rejected the first Catholic missionaries in 1827 and expelled them. They persevered, though, with strong support (and threats) from the French government. Ultimately, the kingdom adopted a policy of religious tolerance, and Catholic priests came to the islands.

Coan complained of the "persistent aggression of the Catholics," who took a "bold and defiant stand," confronting him and other Protestants "everywhere." They "even came to my congregations in anger to command some of their claimed neophytes to leave the house." This "determined and unrelenting attack of the papal powers upon the church of Hilo and Puna" made Coan's life more difficult, but certainly did not diminish his enthusiasm. Many of the Hawaiians, on the other hand, were undoubtedly confused by these competing versions of the "true church."

The situation grew even more confounding in the 1850s with the arrival of Mormon missionaries. Coan had little use for this group either. They were, he believed, characterized by "ignorance, bigotry, impudence, and guile." The Mormons converted only those who Coan characterized as "numbers of low characters." Unlike the Catholics, Mormon influence for a time died out, leading Coan to report with satisfaction that "now they have neither church, or school, or meeting house in all Hilo and Puna."

Thurston, Lyman, Coan and their fellow Protestant missionaries were not content simply to win converts. They believed that the government, through the newly evolving legal system, should enforce what they regarded as God's laws. Ka'ahamanu and other high chiefs helped the missionaries because they hoped not only to spread Christianity, but also to wrench the Hawaiian kingdom into the "modern" world. The result was essentially a legal assault on much of native Hawaiian culture.

United States Navy Lieutenant Charles Wilkes, who commanded a scientific and exploring expedition throughout the South Pacific in the late 1830s and early 1840s, visited Honolulu in 1840. He was struck on a Sunday by the "decorum and quietness that would satisfy the most scrupulous Puritan." But he was bothered by "the absence of sports among the boys and children." When he inquired why, he was told that this was a result of "mature deliberation and experience." The missionaries thought it advisable "to deprive them of all their heathenish enjoyments, rather than allow them to occupy their minds with anything that might recall old associations." As a consequence, Wilkes reported, "the Hawaiian boys are staid and demure, having the quiet looks of old men."

The "heathenish enjoyments of sports" was not nearly as much a problem for the missionaries as was the Hawaiian attitudes and practices of intimacy. The very

different views about sexuality of traditional Hawai'i and Protestant New England became the focus of the struggle to "civilize" the islands. Not everyone supported this crusade, and merchants and sailors in particular denounced the attempt to stifle prostitution and alcohol. The missionaries of Hilo were more successful than their counterparts in Honolulu and Lahaina, greatly reducing the attraction of the port for whalers and traders.

To the missionaries, any sex outside of marriage was dangerous and sinful and had to be prohibited. Controlling sex was part of the process of "civilizing" the natives. Other aspects of this crusade included new rules for eating, dressing, and defecation. Missionaries such as Asa Thurston in Kailua decried the Hawaiian custom of going about in public with little—and in some cases no—clothing. They persuaded women to adopt more modest attire, giving rise to the mu'umu'u. Moreover, of course, they decried the lack of privacy in Hawaiian homes, allowing children to be present during their parents' sexual activity.

Hawaiians, on the hand, traditionally had very different concepts of sexuality. Unmarried people enjoyed considerable sexual freedom from relatively early ages, though there tended to be some restrictions with higher-ranking boys and girls. After marriage, promiscuity and adultery were discouraged, but divorce was easy to obtain. With the higher ranks, plural marriage was common for both men and women.

The struggle between these two views of sexuality became a legal and moral dilemma, and soon there were laws prohibiting prostitution, adultery, and other evils. Marriages had to be registered and divorce became more difficult. Campaigns against these depravities generally received the full support of the government and most of the ali'i. Their motives were not only religious, but also political. A reduction in adultery and a corresponding emphasis on marriage and the family, many hoped, might help stem the severe population decline affecting the kingdom.

A "Law Against Lewdness," first proclaimed in 1829 and revised in 1841, spelled out harsh penalties for adultery. Those found guilty were fined three pigs, which were given to the injured spouse, and an additional three to the governor and king. The 1841 version specified a fine of $30 split between the injured party and the government, or eight months at hard labor.

Fornication among unmarried people, less serious than adultery, resulted in a fine of only $15 or four months, and even this penalty might be reduced to $3 if the couple married. Other forms of carnal conduct, such as lewd conversation, could result in lesser fines.

Records of the Hilo District Court tell of adultery cases where constables chased couples through the fields, peered through thatched walls in houses, and stealthily

tried to catch people in the act. Sometimes church officials reported offenders, and at other times "injured" husbands initiated prosecution, if only to get their share of the fines. By the 1860s, the courts saw fewer cases of adultery and prostitution, but an increased number in which the courts forced deserting wives to return to their husbands.

In addition to sexual practices, there were other "lascivious" activities such as hula dancing that were soon outlawed. Surfing (often while naked) and eating with hands on the ground rather than with knives and forks at a table were other behaviors included in a campaign to eliminate anything that would be considered improper in New England.

The missionaries, with help from the government, profoundly changed Hawaiian culture and society. As recent scholars have observed, it was a "colonization" effort, and a successful one at that: "a slow insinuating invasion of people, ideas, and institutions." The number of convictions for fornication, adultery, and other outlawed sexual activity caused many missionaries and haoles to suspect that Hawaiians could not control their desires. It was perhaps not a great leap from there to the belief that Hawaiians were incapable of being "civilized" or of governing their own kingdom.

A CHANGING ECONOMY

In addition to the religious, cultural, legal, and political changes transforming Hawaiian life in the quarter century after the death of Kamehameha, the economy of the islands also underwent significant modification. Traditional Hawaiian society depended largely on taro farming and fishing. With the coming of the white man and subsequent attempt to wrench island society into the "modern" world, this rudimentary economy no longer sufficed.

When Hawai'i began exporting sandalwood in exchange for western goods, the economy of the islands changed forever as it was incorporated into the capitalistic system of Europe and America. Exports and imports were now essential. Hawaiians wanted these products, from guns to clothes, and could obtain them only if they had something to trade in return. However, since the supply of sandalwood was limited, and before long exhausted, the kingdom had to find other means to buy the western commodities that were increasingly in demand. The rest of the nineteenth century would see many different approaches to sustaining the Hawaiian economy.

Whaling provided the first alternative, as Hawaiian ports increasingly supplied the ships with food, water, and other essentials, and the whalers themselves with women and grog. The first whalers arrived in the islands in 1819 (another event in that crucial year), and most of these ships were American. Hilo was one of the ports frequented by these vessels, though it was less popular than either Honolulu or Lahaina, in part because the missionaries there were more successful in reducing the availability of what sailors wanted in port.

David Lyman, the Hilo missionary, made his opinions about whalers very clear in a letter to his sister: "They are an abandoned, hopeless class. They drink in iniquity like water and their feet are swift to do evil. Licentiousness and drunkenness are their besetting sins, and most of them are profane in the extreme." He obviously preferred that they go to Honolulu and Lahaina and stay out of Hilo.

In addition to local products, whalers also wanted European and American goods, thus providing an opportunity for merchants in Hawai'i to establish stores and shops selling products from all over the world. This opportunity in turn increased the

number of non-missionary foreigners in the islands, and these two groups were often at odds with each other because of conflicting goals.

The haoles who came to the islands, though small in numbers, often had the support of island kings and chiefs. The Hawaiians, as we have seen with Kamehameha II, were intrigued both by European royal trappings and western goods, and by a strong desire to preserve what they could of the Hawaiian kingdom. In this endeavor to remain an independent nation, natives relied heavily on western advisors, especially missionaries.

As the Keauhou-born Hawaiian scholar David Malo realized, the white men were "clever" and came from "big countries." They knew, he wrote, that "our people are few in number and our country is small." And they would, he predicted, "devour us." The United States, Great Britain, and France did not hesitate to send powerful warships to protect their citizens and interests in the islands. Britain and France had already gobbled up other Polynesian islands for their empires. In 1843, the British consul, backed by a naval frigate, forced King Kamehameha III to cede his kingdom. Though the British government repudiated this action a few months later and restored Hawaiian sovereignty, the humiliating incident was a warning.

Partly in an attempt to placate haoles in the islands, Kamehameha III's government consciously implemented changes to include a written constitution, religious toleration, representative government with a national legislature, universal male suffrage, public education, and a declaration of rights. These changes occurred both because of haole pressure and to try to ward off foreign intervention or conquest.

The one remaining reform that would have an especially strong impact on the lives of all Hawaiians involved land ownership. In traditional Hawaiian society, all land technically belonged to the king. In a system somewhat similar to that of feudal Europe, the king would grant the use of land to his principal chiefs, who in turn would grant it to their followers. When the ruler died, the new king would redistribute land to his own followers, who may or may not have been the same chiefs who held the land under the previous king.

Hawaiian rulers undoubtedly liked this arrangement, yet many others did not. Land ownership meant power, and in pre-contact Hawai'i where royal succession was often determined in battle, land redistribution by a new king often led to further warfare. However, Kamehameha's unification of the islands and subsequent peaceful royal successions made chiefs full supporters of the traditional system, since it was less likely that they would lose their lands upon the monarch's death.

The common people, who farmed small plots of land granted to them in turn by these overseers, remained at a disadvantage. According to David Malo, commoners held the chiefs in "great dread" and lived in "chronic fear" of offending them. Their

"life of weariness" meant working their small land holdings and sharing crops with the chiefs.

As in so many other areas, the major push for land reform came from the haoles. Missionaries supported reform because they hoped that land ownership would promote the virtues of hard work and thrift in the Hawaiians. For once, the foreign merchant class agreed with the missionaries on the need for land reform, though for very different reasons.

Haoles, like commoners, could only hold land at the pleasure of the king or one of his chiefs. The growing foreign community wanted to protect their business interests and promote additional endeavors (e.g., sugar) that would only work if they could hold title to land. A stirred up foreign community, backed by their respective governments, was an invitation for trouble.

On several occasions in the early 1840s, the issue of land ownership by commoners and foreigners came up. The chiefs, who had the most to lose, generally opposed reform. Yet as Kamehameha III grew more secure in his position, and was urged on by his American and British advisors, he came to accept the idea.

In 1846, the government appointed a Board of Land Commissioners, which revolutionized land ownership with the Great Mahele (division) of 1848. All land was divided between the crown, government, chiefs, and people. A revision in 1850 allowed foreigners also to hold land in fee simple (own, rather than lease).

Unfortunately, the commendable goal of distributing land to Hawaiians ultimately failed. In the end, the major beneficiaries were the haoles, who rapidly gained control over much of the land. Chiefs who wanted to get rich quick sold off their territory at bargain prices. Commoners, unfamiliar with new and unusual legal concepts of land title, deeds, and taxes, were also easy prey for whites who wanted to acquire it cheaply. By 1890, haoles or their corporations controlled three-quarters of all privately held land. With the exception of the overthrows of the monarchy in 1893, probably no event in the nineteenth century had a greater negative impact on Hawaiians than the Great Mahele.

One of the first white men to own land in Hawai'i was John Palmer Parker. Kamehameha III granted the enterprising New Englander 2 acres of land in 1846. He eventually acquired tens of thousands of acres and established a cattle industry that would be one of the major economic enterprises of the Big Island for over 150 years.

Parker first arrived in 1809, a 19-year-old seaman on a merchant ship engaged in the sandalwood trade. He was intrigued both by the beauty of the island and by the thousands of cattle that were by that time roaming freely throughout the island. These descendants of George Vancouver's original gift to Kamehameha I, a nuisance to most Hawaiians, presented an opportunity to Parker.

He jumped ship, befriended a few Hawaiians in the region around Kawaihae, and built a small house for himself. He learned the Hawaiian language and soon came to the attention of Kamehameha I, then living to the south on the Kona coast. Impressed by the young man, the king appointed Parker manager of the royal fishponds at Honaunau. While he apparently performed his duties diligently, he sought greater adventure and joined the crew of another merchant ship sailing for the Far East in 1811.

Trapped in Canton by the British blockade of American ships during the War of 1812, Parker must have gotten his fill of adventure because when the ship eventually returned to Kawaihae in 1815, he decided to stay for good. Again, he curried Kamehameha's favor and the king granted Parker the right to shoot troublesome cattle and thin the growing herds.

Realizing that the meat, tallow, and hides were a valuable commodity for visiting ships, Parker began trading both these goods and vegetables he grew. In 1819, he married the daughter of a high-ranking chief and began a dynasty that would last for nearly 200 years.

By the 1820s, Parker and others hunted or trapped cattle by catching them in pits. They salted and packed the meat in barrels, which they shipped to Honolulu from Kawaihae. As highlighted in the last chapter, Parker was busily engaged in salting beef when the Reverend Joseph Goodrich came across him on the tour of the island that William Ellis led in 1823. Salted beef became a substitute for the diminishing supply of sandalwood. Parker and his family eventually moved to Waimea, where he built a store and began to domesticate cattle. By 1851, there were an estimated 8,000 domesticated and 12,000 wild cattle on the Big Island.

During Kamehameha III's reign, the ever-growing wild herds were so dangerous that the king brought in Spanish-Mexican vaqueros to help control them. Called "paniolos," the Hawaiian term for Español, these cowboys provided the growing Hawaiian cattle industry with a distinctive flavor.

When Parker died in 1868, his original 2-acre grant had grown to over 250,000 acres, and would expand even further in later years. The Parker family came to dominate Kohala, became trusted advisors to several Hawaiian monarchs, and served in the kingdom's House of Nobles. John's grandson Samuel was a classmate and close friend of King David Kalakaua, who bestowed upon him the honorary title of colonel. The town of Waimea is also called Kamuela, the Hawaiian word for Samuel, in honor of Colonel Parker.

The Parker Ranch was the largest, but by no means the only, cattle ranch on the Big Island in the latter half of the nineteenth century. There were many others in

Kohala and Kona. For example, Henry Nicholas Greenwell, an English-born ex-soldier who tried his hand at mining during the California gold rush, hurt his back and ended up in Kailua selling English imports from a store he opened. He began to acquire land as well, raising oranges for California and then raising cattle. Eventually he owned 36,000 acres, much of which he leased to smaller farmers and ranchers.

In the beginning, the infant cattle industry concentrated on salted beef, tallow, and hides. In the first six months of 1859, for example, Big Island cattlemen exported 222,170 pounds of hides. Over the next few years, many ranchers added dairy products since they could ship butter to Honolulu easily. Shipping cattle themselves, on the other hand, was a much more difficult process. There were no facilities for slaughtering and processing the meat on a large scale on the Big Island. This meant the animals had to be shipped to Honolulu, and there were no ships large enough to do this until the 1880s.

The process, which continued well into the twentieth century, began with a cattle drive to one of several ports along the Kohala and Kona coasts, including Kawaihae, Kailua, and Napo'opo'o. Since none of these ports had piers, the inter-island steam ships anchored offshore. The cattle, when arriving at the harbor, first needed to be convinced that they really did want to swim in the ocean, often taking some effort. Sherwood Greenwell recalled that the process used in his youth in the 1920s took two horses (and up to six men) to get the cattle into the water, with one in front and the other in back so the "stubborn animal would be pulled sideways into the ocean."

Once in the water, a dozen or so cattle would be tied to a whaleboat, which then towed them out to the waiting ship. A sling placed around each animal would then lift it into the vessel. By the 1930s, piers and chutes made the cattle-loading process easier. Even later, once roads were improved, Kona ranchers could truck the cattle to Kawaihae, which had better facilities than the Kona ports.

Ranching was only one form of economic activity that developed during Kamehameha III's reign to replace the vanished sandalwood trade and the declining whaling industry. The California gold rush for a time provided islanders with an opportunity to profit. As the closest major settlement to California, Hawaiians were among the first to learn about the discovery of gold at John Sutter's mill in 1848.

Consequently, Hawaiians, both haole and native, were among the first to "rush" to the gold fields. A Honolulu newspaper editor observed that if California "isn't the land that flows with milk and honey, it abounds with wine and money, which some folks like better." However, in a nation suffering from a severe population decline, anything that promoted emigration was a concern. By the summer of 1849, the Honolulu missionary Samuel Damon, on a tour of California and Oregon, estimated

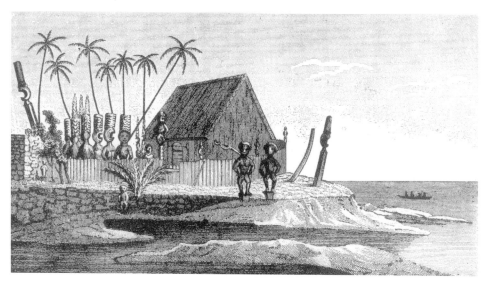

Hale o Kaewe as it appeared in 1823. From Reverend William Ellis' 1826 Journal. *Reproduced courtesy of Bancroft Library.*

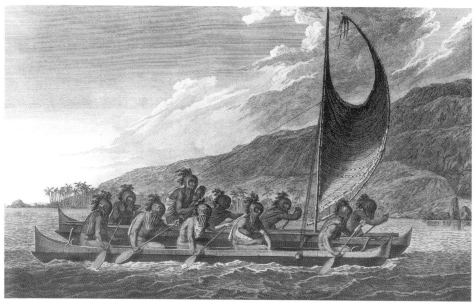

Hawaiian warriors in a double canoe. From Captain Cook's Voyages. *(Reproduced courtesy of Bancroft Library.)*

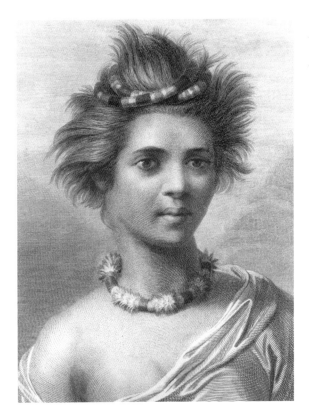

A young woman of the Sandwich Islands. From Captain Cook's Voyages. (Reproduced courtesy of Bancroft Library.)

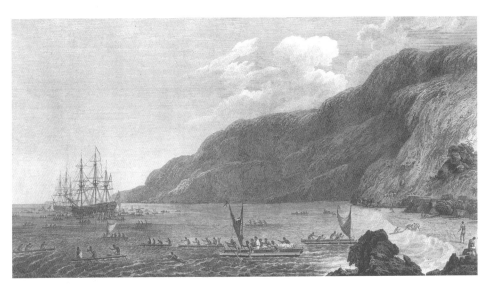

A view of Kealakekua Bay, with the Resolution *in the background. Note the man on the surfboard at the bottom of the picture. This is the earliest western depiction of surfing. From Captain Cook's* Voyages. *(Reproduced courtesy of Bancroft Library.)*

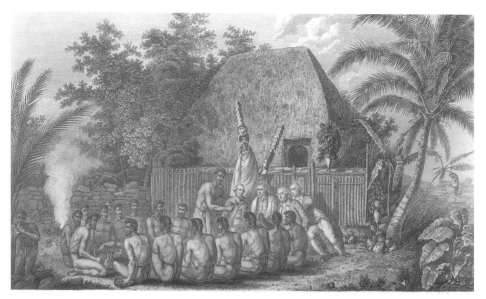

An offering presented to Captain Cook (second Englishman from left). From Captain Cook's Voyages.
(Reproduced courtesy of Bancroft Library.)

Captain James Cook. From Captain Cook's Voyages.
(Reproduced courtesy of Bancroft Library.)

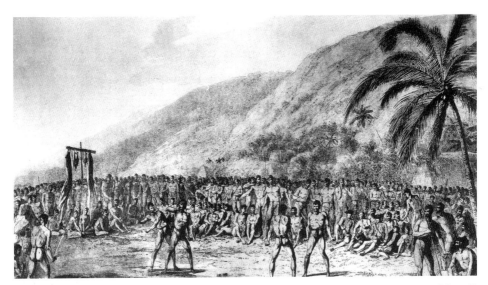

"Boxing Match Before Captain Cook." From Captain Cook's Voyages. *(Reproduced courtesy of Hawai'i State Archives.)*

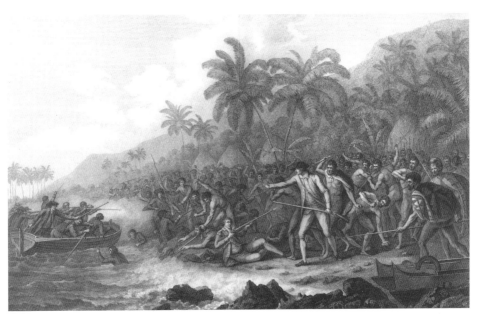

The death of Captain Cook. From Captain Cook's Voyages. *(Reproduced courtesy of Bancroft Library.)*

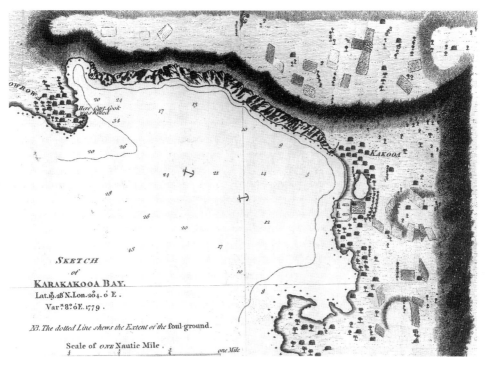

William Bligh's map of Kealakekua Bay, showing the villages and the spot where Cook was killed. From Captain Cook's Voyages. *(Reproduced courtesy of Bancroft Library.)*

Kamehameha. (Courtesy of Hawai'i State Archives.)

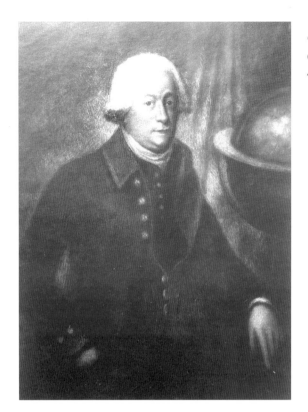

Captain George Vancouver.
(Reproduced courtesy of Hawai'i State
Archives.)

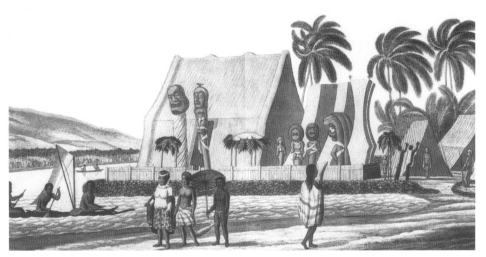

Ahuena Heiau at Kailua, 1816–1817. Ka'ahamanu and daughter are in the foreground. Drawn by Louis
Choris, official artist for Russian explorer Otto von Kotzebue. (Courtesy of Hawai'i State Archives.)

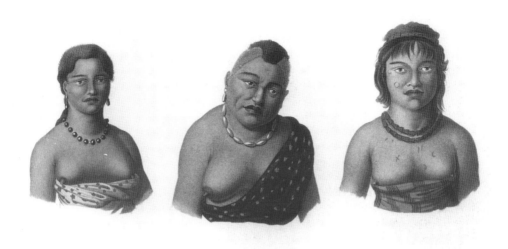

Three royal Hawaiian women. Ka'ahamanu is on the left. Kalanimoku's wife is on the right. From Louis Frecinet's Voyages. (Reproduced courtesy of Hawai'i State Archives.)

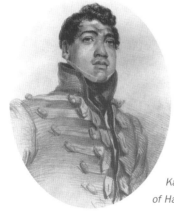

Kamehameha II. (Courtesy
of Hawai'i State Archives.)

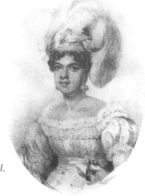

Queen Kamamalu, wife of Kamehameha II.
(Courtesy of Hawai'i State Archives.)

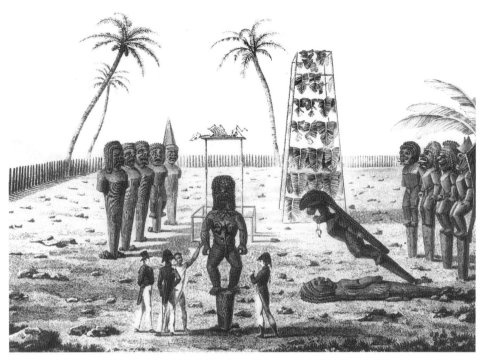

The King's Temple at Kailua. 1819 French drawing of the interior of KeikipuʻipuʻI Heiau. Probably built around the time of ʻUmi and restored by Kalaniʻopuʻu, the temple stood on the south shore of Kailua Bay. From Jacques Arago's Narrative of a voyage. *(Reproduced courtesy of Hawaiʻi State Archives.)*

Waipiʻo Valley, as drawn by William Ellis, 1823. From Reverend William Ellis' 1826 Journal. *(Reproduced courtesy of Bancroft Library.)*

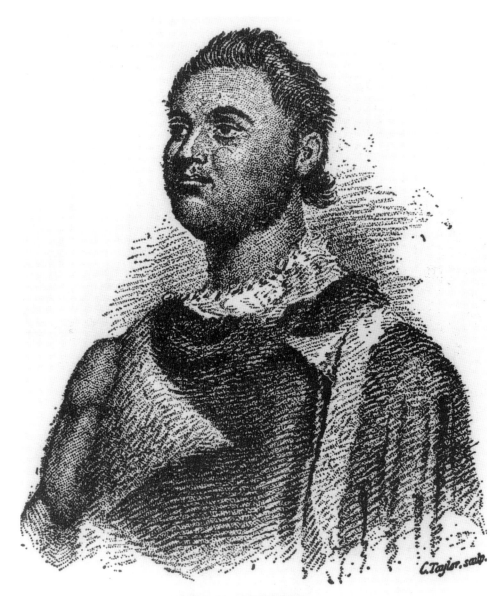

KUAKINI.

Governor of Hawaii

Governor Kuakini. From Reverend William Ellis' 1826 Journal. (Reproduced courtesy of Bancroft Library.)

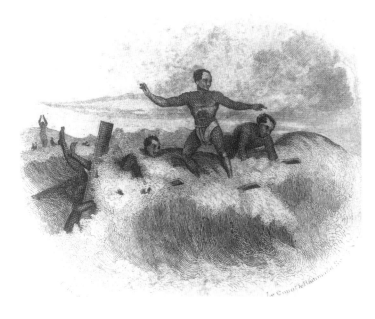

Surfing, as drawn by William Ellis, 1823. From Reverend William Ellis' 1826 Journal. (Reproduced courtesy of Hawai'i State Archives.)

Reverend David Lyman. (Courtesy of Lyman Museum.)

Sarah Lyman. (Courtesy of Lyman Museum.)

Reverend Titus Coan. (Courtesy of Lyman Museum.)

The Lyman House, Hilo, c. 1850–1855. (Courtesy of Lyman Museum.)

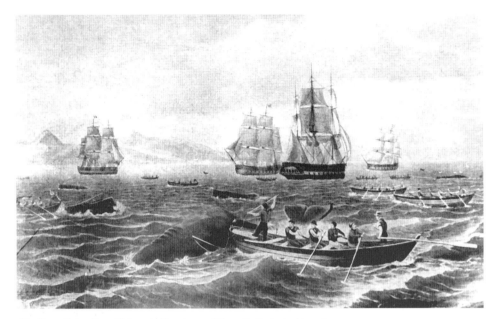

Whaling off the Hawai'i Coast. (Courtesy of Hawai'i State Archives.)

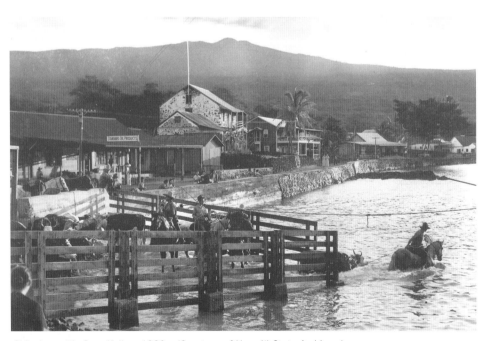

Shipping cattle from Kailua, 1930s. (Courtesy of Hawai'i State Archives.)

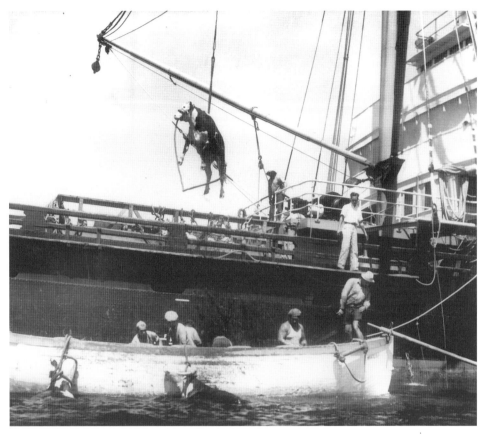

Loading cattle onto the ship at Kailua, 1930s. (Courtesy of Hawai'i State Archives.)

Honoka'a Coffee Mill.
(Courtesy of Hawai'i
State Archives.)

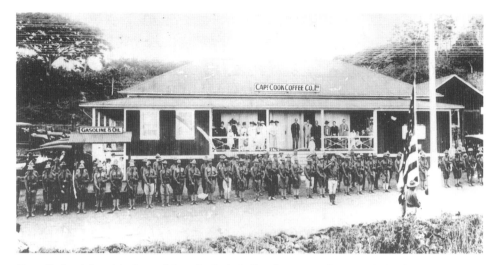

Kona National Guard in front of Captain Cook Coffee Company office, c. 1916. (Courtesy of Kona Historical Society.)

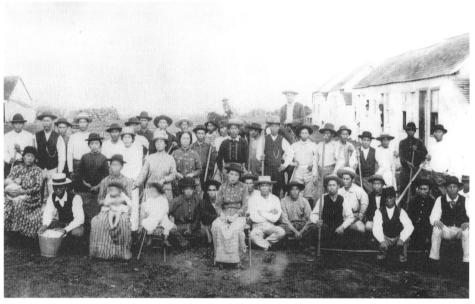

Japanese plantation workers. (Courtesy of Hawai'i State Archives.)

*Japanese women
plantation workers, c.
1910. (Courtesy of
Hawai'i State Archives.)*

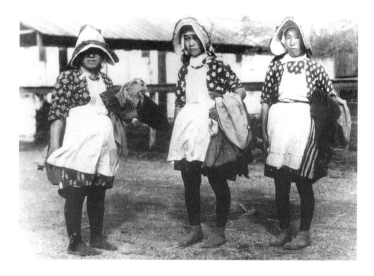

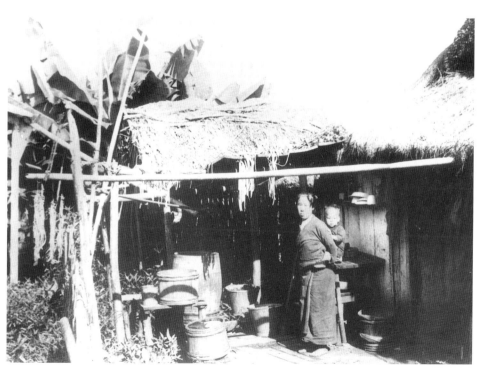

Japanese mother and child, Wainaku, late nineteenth century. (Courtesy of Lyman Museum.)

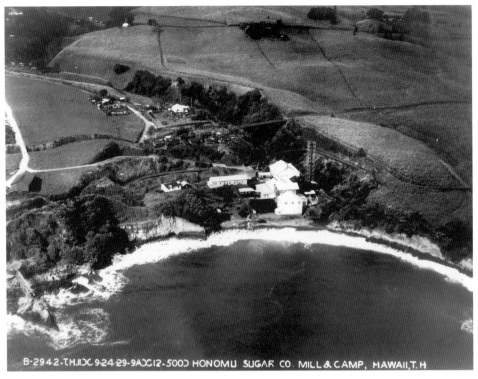

Honomu Sugar Company, 1929. (Courtesy of Hawai'i State Archives.)

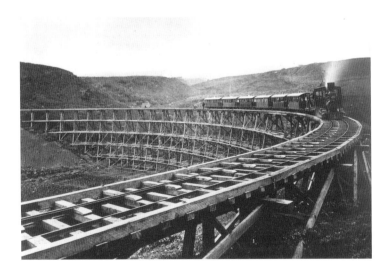

Hawaiian Railroad, near Mahukona. (Courtesy of Hawai'i State Archives.)

California and Hawaii (C&H) Sugar Refinery, Crockett, California, c. 1920. (Courtesy of Crockett Museum.)

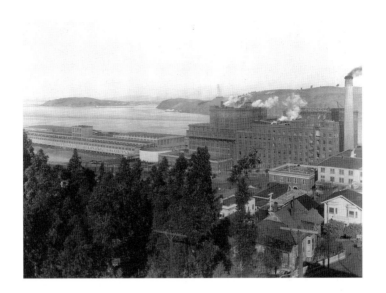

Sugar cane flume, Hamakua Coast. (Courtesy of Hawai'i State Archives.)

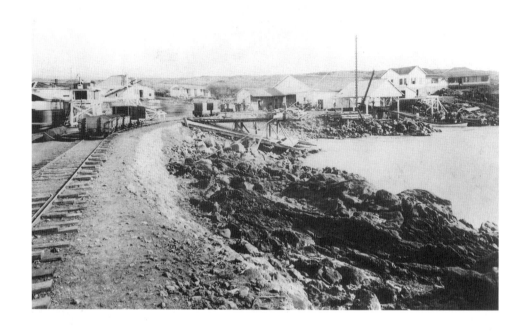

Above, Mahukona Landing. At right, view of the Kamehameha I statue of Kapaʻau. Below, Kinau locomotive at Mahukona, c. 1881. (All images courtesy of Hawaiʻi State Archives.)

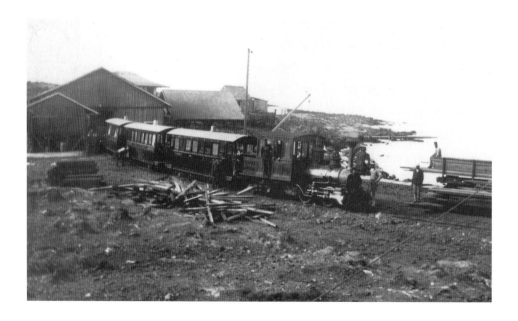

"Hilo Massacre," as first tear gas grenades were thrown. (Courtesy of Hawai'i State Archives.)

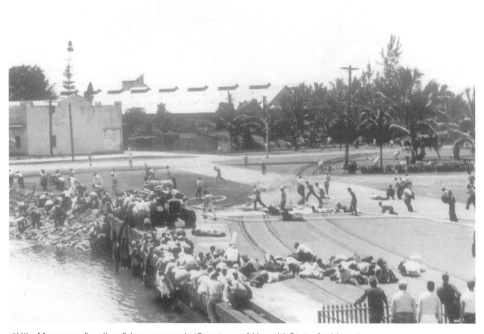

"Hilo Massacre," police firing on crowd. (Courtesy of Hawai'i State Archives.)

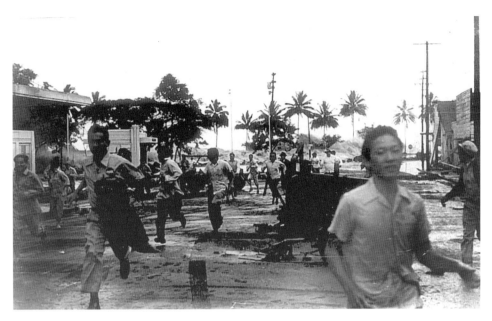

Men fleeing for safety from the April 1, 1946 tsunami up Ponahawai Street in Hilo. Cecilio Licos, photographer. (Courtesy of Pacific Tsunami Museum.)

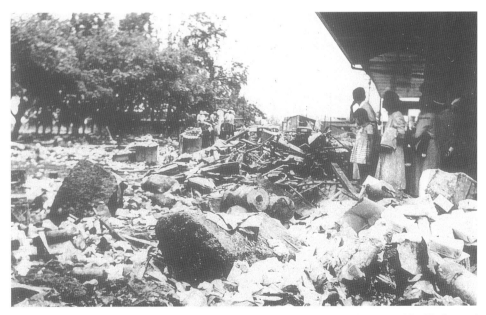

Aftermath of the April 1, 1946 tsunami, in front of S. Hata Building, Hilo. (Courtesy of Pacific Tsunami Museum.)

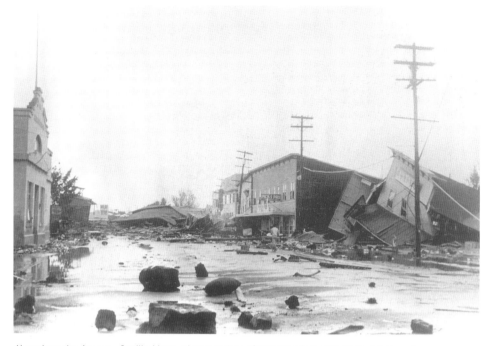

Kamehameha Avenue. Cecilio Licos, photographer. (Courtesy of Hawai'i State Archives.)

This Hilo town clock stopped when it was hit by the May 23, 1960 tsunami. (Courtesy of Pacific Tsunami Museum.)

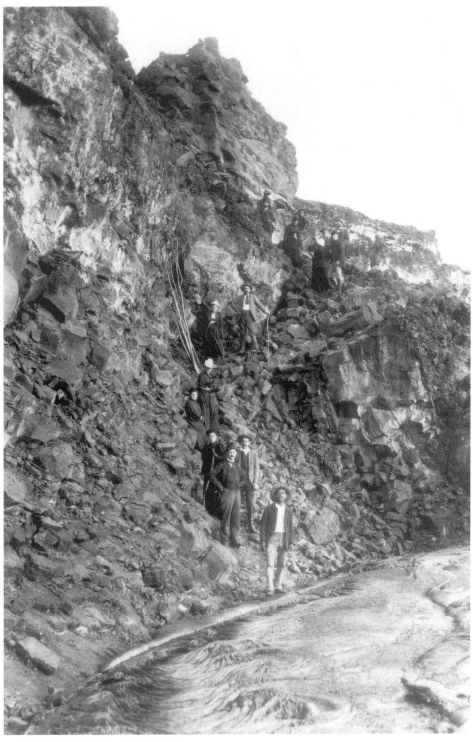

Alexander P. Lancaster, the first official guide at Kilauea Volcano, leading a tour into the crater, c. 1890.
(Courtesy of Hawaiʻi State Archives.)

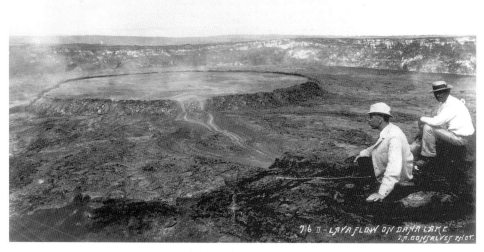

Halemaumau Crater, c. 1890. (Courtesy of Hawai'i State Archives.)

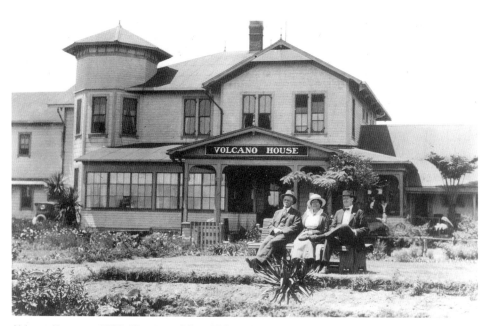

Volcano House, c. 1909. (Courtesy of Hawai'i State Archives.)

Eruption of Mauna Loa, 1881. (Courtesy of Hawai'i State Archives.)

Hulihe'e Palace, showing Princess Ruth's grass house, pre-1885. (Courtesy of Hawai'i State Archives.)

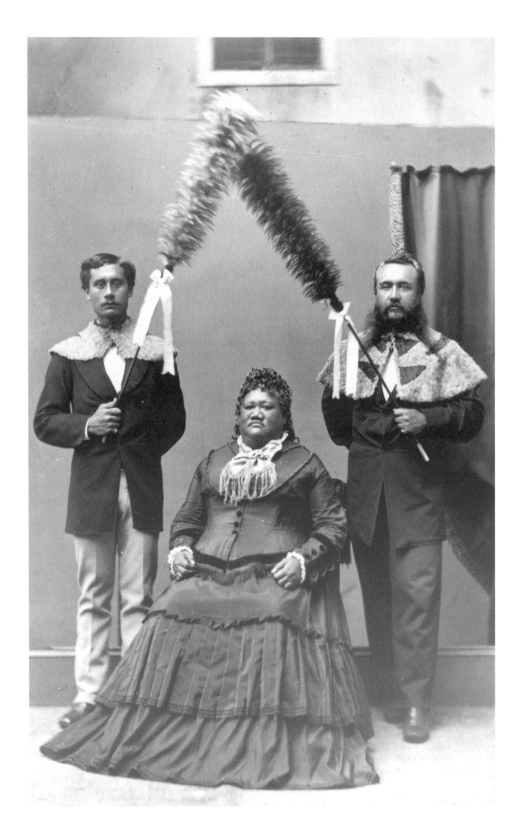

Above, King Kalakaua and Queen Kapi'olani visiting the Captain Cook Memorial at Kealakekua Bay, February 1888. Below, view of Kailua, c. 1889. The photographer may have been King Kalakaua. The Kahn Collection, At left, Princess Ruth Ke'elikolani. The man on the left holding her kahili (feathered staff symbolizing royalty) is Samuel Parker. (All images courtesy of Hawai'i State Archives.)

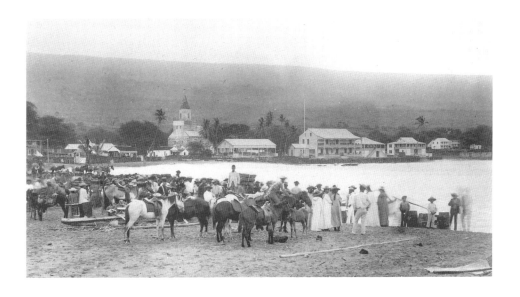

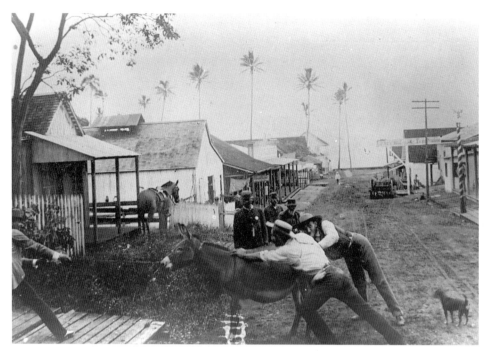

The mule seems to be winning this struggle on Waianuenue Avenue, Hilo, c. 1890. (Courtesy of Lyman Museum.)

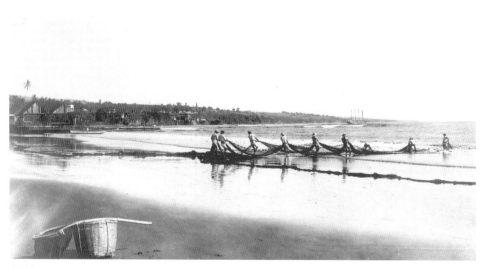

Hukilau (group net fishing) in Hilo Bay, c. 1900. (Courtesy of Hawai'i State Archives.)

Road scene taken on a tour of Kona, 1908. (Courtesy of Hawai'i State Archives.)

Kamehameha Avenue, Hilo, c. 1929. (Courtesy of Hawai'i State Archives.)

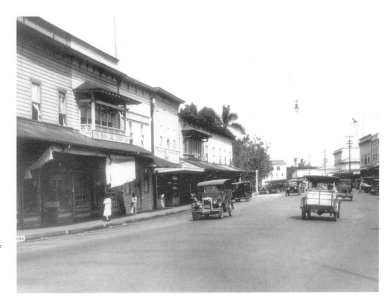

Kona Inn, early 1930s. (Courtesy of Hawaiʻi State Archives.)

Kona Inn Lobby, 1930s. (Courtesy of Hawaiʻi State Archives.)

*Inter-island steamship
Mauna Kea. (Courtesy of
Hawai'i State Archives.)*

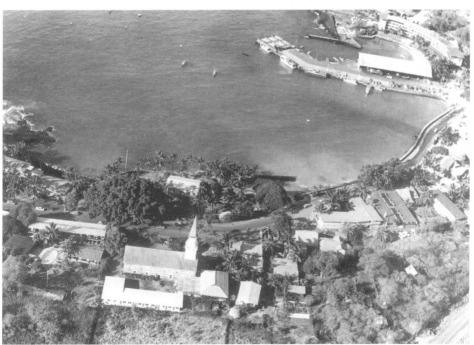

*Kailua-Kona, c. 1963, showing the first King Kamehameha Hotel (upper right). (Courtesy of Kona
Historical Society.)*

Robert Trent Jones Sr. standing on the spot that would become the third hole of his golf course at Mauna Kea Beach Hotel. (Courtesy of Mauna Kea Beach Hotel.)

Construction of the Mauna Kea Beach Hotel. Completed golf course is in background. (Courtesy of Mauna Kea Beach Hotel.)

that one-quarter of the population of San Francisco had come from Hawai'i, though admittedly the population of that city was not yet very large at the time.

The legacy of Hawaiian miners is still reflected in many California place names. These islanders were usually called "kanakas"—the word for common person—and there are no fewer than 13 places in California with names such as Kanaka Bar, Kanaka Diggings, Kanaka Town, and Kanaka Hill. Some kanakas engaged in mining; others reverted to more traditional activities, especially fishing. Hawaiians became a major source of the salmon supply for the growing city of Sacramento.

The California gold rush had a worldwide impact, and Hawai'i was no exception. Even for those who did not leave the islands, there were opportunities. Because Hawai'i was the closest population center to California, stores in the islands were quickly stripped of boots, axes, shovels, and any other equipment that might be even remotely useful in the quest for gold.

The islands also became a major source of food. Flour quickly sold out once the rush started. Some farmers grew food, especially potatoes, on Maui and near Waimea on the Big Island, expressly for the California market. Because of the Great Mahele, farmers could now buy land for as little as $3 an acre from the government, while potatoes could bring $4 to $5 dollars a barrel. Liquor, especially cognac and rum, coffee, and sugar were also shipped in large quantities. Some Hawaiians sent their old clothes to California, and even a few Bibles made their way to San Francisco.

Because of the gold rush, the islands experienced an economic boom, though it lasted only for a couple of years. Some of the more successful miners traveled to Hawai'i each winter to escape the cold of the gold fields. Because of the scarcity of labor in San Francisco, some Californians even sent their laundry to Hawai'i because it cost about half of what it would to have it done in San Francisco. It was $2 to $3 a dozen to send dirty shirts to the islands; in San Francisco washing and ironing cost $6 to $7 per dozen.

The downside was inflation in Hawai'i. The demand for scarce goods, food, and labor drove prices higher. The boom was also temporary. By 1852, agricultural prosperity was fading as farmers in California and Oregon began replacing the potatoes and other crops that had come from Hawai'i. Additionally, as San Francisco itself grew, merchants there began competing with Hawaiian businesses.

By 1850, San Francisco emerged as a primary commercial center, replacing Honolulu as the Pacific's major port. California also became the islands' principle market, especially for sugar. For the next 50 years, San Francisco was the primary destination for all Hawaiian exports.

In addition to the economic impact, the discovery of gold in California helped end the islands' isolation. The opening of a commercial route across the Isthmus of

Panama, to get miners more quickly to the gold fields, also greatly shortened the trip from the eastern United States to Hawai'i. Furthermore, the population growth in California created a destination much closer than any population centers had been previously. As Henry Lyman, son of the Hilo missionary, observed, "In place of a single lonely brigantine drifting to and from the 'Coast' once every year, or six months at the shortest, there were numerous sailing-vessels of every description plying between Honolulu and San Francisco." The trip by sailing ship from San Francisco to Hawai'i took about three weeks.

Not everyone considered the end of isolation a benefit. A German traveler in 1852 observed what he considered the death-blow to the simple life of the natives. The changes included such pernicious imports as billiards, bowling, and a theater. If these were not bad enough, Hawaiians were subjected to a performer "who danced on a wire-rope, swallowed whole oranges and swords, beheaded pigeons and brought them to life again." Soon an entire American circus arrived, which "seemed to overturn the whole island." He was referring to Honolulu, but the impact of California gold stretched throughout the kingdom. The economic boom may have been short lived, but the social impact was permanent.

As with sandalwood, the economic stimulus provided by the gold rush faded, but the whaling industry continued for a time. The pinnacle was in the years 1853–1854, when 80 whalers called at Hilo. But by the 1860s this livelihood was also in serious decline and Hawaiians again needed alternative ways to make money. For the Big Island, the next ventures were coffee and macadamia nuts.

By the mid-1850s, coffee was regarded as a promising new product. At first, farmers grew it on all the islands, but the main centers were Hanalei on Kaua'i, and Kona as well as Hilo on the Big Island. Even then, Kona coffee was recognized as the best, and the district's soil and climate were ideal. In the late 1850s an insect—usually called "the blight"—began to destroy coffee trees. Hanalei estates were so devastated that they were converted to sugar. In Kona the practice continued, but the blight reduced crops for several years.

In the early years, most coffee was grown on large plantations worked by Hawaiian laborers. Later in the century, Portuguese, Japanese, and others who wanted to escape from the backbreaking work of sugar plantations joined the coffee workforce. However, by the 1890s large-scale production did not produce profits the large landowners wanted. Consequently, they divided their lands into small plots of 3–5 acres, which they then leased or sold to individual growers.

In contrast to sugar and ranching, both of which were on an extremely large scale, the norm for coffee production from that time forward was the small farm. By the

early twentieth century, tenant farmers who were primarily Japanese, grew most of the coffee on the Kona coast. They relied on their families for weeding, pruning, harvesting, and drying the coffee beans before shipping them to mills.

By the 1920s, hired Filipino laborers increasingly worked on these farms during the harvest season from September through December. Coffee was profitable and Kona enjoyed an unusual period of prosperity, and the farmers themselves were not the only ones to prosper. Those who supported the farmers with stores and shops, the people who built their homes, sold them equipment, and provided them credit all profited as well.

The farmers sold most of their coffee beans to two major mills, American Factors and Captain Cook Coffee Company. The mills also sold goods to the farmers on credit and then repaid their debts at harvest time. Indeed, tenant farmers often had to sign contracts promising to sell their entire crop to one of the mills.

This arrangement worked well throughout the 1920s when prices were high, but then the value of coffee started to fall and farmers, unable to pay off their loans, fell deeper into debt. The Depression of the 1930s hit Kona coffee farmers especially hard. Some raised chickens and planted vegetables for survival; others took part-time jobs if they could find them; and still others left Kona for the sugar plantations or for Honolulu.

The number of coffee farmers fell by 50 percent during the 1930s, and prosperity did not return until after the end of World War II. American Factors and Captain Cook Coffee companies gave way to milling and marketing cooperatives owned by the farmers themselves, allowing the industry to remain one of small family farms. From the 1930s through the 1960s, the school calendar was based on a "coffee schedule," giving students their "summer" vacation from August through November so they could participate in harvesting.

Complementing the coffee industry and providing additional income for farmers, macadamia nut production helped both sides of the Big Island. The nuts originally came from Queensland, Australia, and were probably first introduced to Hawai'i in 1881, at Honoka'a. The manager of a sugar mill there planted a few trees primarily as an ornamental domestic fruit without any expectation of commercial success.

By 1910, however, trees on Big Island and on O'ahu were producing crops large enough to gain the attention of agricultural experts who saw the nuts as a potential commercial product. In 1912, the territorial Hawai'i Agricultural Experiment Station introduced seeds to Kona farmers, and within five years there were several small groups of trees growing there.

Kona had ideal conditions as the lava soil provided unusually good drainage. The trees grow from sea level to 2,500 feet, though they do best at elevations of 700–1,800

feet. They need between 50 and 100 inches of rain a year, depending on soil type and elevation, so in dryer areas they also need irrigation. It takes seven years to produce the first crop, and trees reach their peak in about 15 years, but they can produce indefinitely in the Kona environment after that.

Despite the ideal conditions, it took time for the industry to take off. To promote macadamia nuts, the territory gave coffee growers 1,000 seedlings as an alternative crop, but a rise in coffee prices after World War I caused them to lose interest. Similarly, in East Hawai'i people were much more interested in growing sugar.

The first real macadamia harvest was in 1926, by Honoka'a Sugar Company. Because there was no processing facility on the Big Island until 1940, growers sold nuts to the Hawaiian Macadamia Nut Company on O'ahu. However, by 1949, with its own processing plant, the Honoka'a Sugar Company had blossomed into the largest grower in Hawai'i by producing 350,000 pounds per year. The large number of military personnel stationed in Hawai'i during World War II discovered the nut and promoted it after the war ended.

In East Hawai'i, macadamia nut production, like sugar production, tended to be large scale. But after World War II, West Hawai'i had small independent farmers who began to grow the nuts, especially after a fall in coffee prices. Since they were less labor-intensive than coffee, this was an added inducement for production. As they had with coffee, Kona farmers set up cooperatives to process their nuts.

By the 1970s, United Airlines was the biggest customer for single servings of nuts in foil. The airline bought 4 million packets a year, introducing thousands of new customers to the product. The state of Hawai'i by that time produced over 98 percent of macadamia nuts worldwide. Though this percentage would drop in subsequent years as other areas of the world began growing the nut, the Big Island of Hawai'i remained the largest international producer.

KING SUGAR

All of the industries discussed in the last chapter (whaling, ranching, coffee and nut farming) influenced the lives of Big Island residents. Yet none of them, or even all of them combined, had the impact of the sugar industry. Sugar changed the landscape, influenced politics and foreign relations, provided thousands of jobs, produced new technology, and was largely responsible for changing the very ethnic and racial makeup of the population.

Sugar production requires a huge capital investment, great expanses of land, an abundance of water, and a plentiful and cheap supply of labor. To compete in a world market, Hawaiian planters also required diplomatic support from the Hawaiian government to secure favorable trading conditions.

The Hawaiian sugar industry began in 1835 at Koloa, Kaua'i, when Ladd and Company established the first plantation on land leased from Kamehameha III. The king gave the company permission to hire native workers, and the company agreed to pay a tax to the king for each man employed.

To some extent, working on the sugar plantation freed Hawaiian workers from the exploitation of the traditional land system that put them at the mercy of the chiefs. The company gave the workers food, shelter, medical care, and scrip that they could use as currency in the plantation store. The disadvantage, however, was that the workers no longer controlled their own lives, deciding what to plant or when to go fishing. Unaccustomed to rigorous work schedules, they required constant supervision from white overseers or they would not work at all.

The company, discouraged by early attempts to turn Hawaiians into plantation laborers, looked for substitutes. There were a few Chinese in Waimea (Kaua'i) working at a small sugar mill, and when Ladd and Company constructed their own mill, they recruited these Asian workers. But there were not enough Chinese to work both types of jobs, so for a time the Hawaiians continued to work in the field and the Chinese worked in the mill.

The Chinese, who did not have families, lived together in company barracks and were much easier to manage from the company's perspective. By the mid-1840s, Koloa Plantation was profitable even though it relied on native cane that produced a

low quality sugar. They sold their product to Australia, the eastern United States, and to a still small California market. The gold rush and population growth there provided a much bigger market and increased exports, but the poor quality of the sugar hampered growth.

The industry faced a severe shortage of necessary capital to expand and reach its potential. Emigration of hundreds of laborers to California gold fields aggravated the situation by depleting the labor supply as well. To offset the emigration, beginning in 1852, there was a move to import Asian laborers, though Hawaiians continued to comprise a majority of plantation workers until the mid-1870s.

An additional hurdle that dissuaded the foreign investment needed to spur the industry was the old land system. Foreigners were reluctant to invest large sums of capital as long as the future of the land remained uncertain. Thus sugar planters were strong supporters of the Great Mahele, and before long the largest beneficiaries as well.

Finally, complicating the growth of the sugar industry were American tariffs that made Hawaiian sugar more expensive in the United States. For more than a quarter of a century there were discussions between the Hawaiian and American governments on this issue. American sugar interests in states such as Louisiana resisted reducing the tariff, but so did some Hawaiians who feared that the elimination of trade barriers might be the first step toward annexation.

Improved agricultural techniques and equipment imported from the United States and Europe throughout the 1840s and 1850s gradually produced better sugar, especially on Kaua'i. Even so, the industry grew slowly and by the late 1850s there were still only five sugar plantations in the kingdom, none of them very successful.

The American Civil War provided an opportunity for the Hawaiian sugar industry. It created a tremendous demand for the product in the North as southern sugar disappeared from the market. Even before the outbreak of war, sugar had become the kingdom's largest export crop. With southern sugar now removed from competition, Hawaiian planters could make good money in the United States despite the high tariff. At the same time, however, the Civil War hastened the end of the already declining whaling industry as petroleum began to replace whale oil and vessels were converted to merchant ships and even warships.

In 1860, there were 12 sugar plantations in all the islands; by 1866, there were 32. Sugar exports during the same period went from less than a million-and-a-half pounds to over seventeen-and-three-quarter-million pounds. This was only the beginning. After 1876, when a Reciprocity Treaty with the United States finally eliminated the tariff, the industry grew explosively.

The treaty was controversial. Many Hawaiians, including the Big Island's representatives in the national assembly, opposed it for the reason mentioned above: they feared it would become the first step towards annexation to the United States. Representative Joseph Nawahi of Puna compared the treaty to the Trojan Horse. The issue was complicated by the bitterness that remained from the election in which David Kalakaua had won the throne by defeating Queen Emma, the widow of Kamehameha IV. Many Hawaiians (including most Big Island representatives) believed Emma, with her strong anti-American sentiments, would have been a better choice.

Even after her defeat, Emma's supporters, including Nawahi, continued to press her claim to the throne. Nawahi, George Pilipo (representing North Kona), and other native Hawaiian representatives who shared their views also continued to oppose King Kalakaua in the legislature for many years.

However, Kalakaua considered the agreement essential. His supporters dominated the legislature and the treaty was approved in 1874. The king then personally went to Washington, D.C. to promote ratification by the United States Senate. From the viewpoint of the sugar industry the treaty was a tremendous success, yet many native Hawaiians continued to have doubts and suspicions. It did bring prosperity, but few Hawaiians benefited from it.

In the 15 years after the treaty, sugar exports increased ten fold from 25 million to 250 million pounds. Hawai'i exported only raw sugar, which was then sent to San Francisco for refining, mostly by the German-born Claus Spreckels. As soon as he heard about the Reciprocity Treaty, Spreckels, who was already involved in beet sugar in San Francisco, went to Hawai'i and began buying land despite objections from Nawahi, Pilipo, and other opposition members of the legislature.

Spreckels did have the support of King Kalakaua (secured by a personal loan to the ruler), who made it possible for the San Franciscan to buy not only land, but also water rights. By 1890, he controlled one-third of Hawaii's sugar production. He grew it, milled it, shipped it, and then refined it.

This growing industry had at least as much impact on the Big Island as it did on the other islands. By 1884, there were more than 30 plantations and sugar mills from Kohala on the north to Puna on the south. Sugar brought significant changes to the Big Island as it did to the rest of the kingdom.

These alterations included the concentration of economic, political, and social power into the hands of a small number of haole planters and the importation of thousands of Asian workers to supplement the declining Hawaiian population. Indeed, the overthrow of the Hawaiian monarchy in 1893 was, to a large extent, a successful effort to protect the sugar industry, suffering from an 1891 American law

that paid domestic sugar growers a bounty. Despite the Reciprocity Treaty, the bounty destroyed much of the advantage Hawaiian growers had enjoyed for the American market. To sugar growers, annexation seemed to be the best solution to ensure permanent prosperity.

Control of the entire industry was in the hands of a small group of financial houses, later called the "Big Five," which ran everything from Honolulu. Many of these financiers were descendants of missionaries. The plantation owners themselves formed the Hawaiian Sugar Planters Association (HSPA), founded in 1894, but the Big Five held the real power.

The HSPA and the Big Five purchased an unsuccessful beet sugar refinery in Crockett, California, across the bay from San Francisco, and converted it to a cane sugar plant in 1906. Run as a cooperative for several decades, the California & Hawaiian Sugar Refinery (C&H) was in an ideal location, with both water and rail facilities. Hawaiian planters shipped their raw sugar from the islands' mills in bulk to Crockett, where it was refined, packaged, and distributed throughout the United States.

By the early twentieth century, "big sugar" controlled not only that industry but, through several interlocking directorates, most of the business in the territory. Their financial empire included the C&H Refinery in Crockett, the Bank of Hawai'i, the Inter-Island Steam Navigation Company, Matson Navigation Company, the O'ahu Railroad and Land Company, the Honolulu Rapid Transit Company, the Honolulu Gas Company, the Hawaiian Electric Company, and Liberty House department stores.

None of this would have been possible without cheap labor. Larger plantations employed as many as 3,000 workers in the fields. Because of the declining population and the additional belief that Hawaiians were not particularly good field workers, immigration seemed to be the only hope for cheap labor. There were a few Chinese laborers in the islands as early as the 1850s, but the big push to import contract laborers came in the last quarter of the nineteenth century. The Reciprocity Treaty with the United States and the resulting impetus to increase sugar production made the need even greater.

Sugar was not the only driving force for encouraging immigration. The very survival of the nation, with its population in decline, was of great concern to King Kalakaua when he came to the throne in 1874. Since Hawaiians were not able to sustain let alone increase the population by themselves, the king suggested "suitable immigrants" be brought to Hawai'i to intermarry with natives and increase the population.

Over the next quarter century or so Chinese, Indians, Pacific Islanders, Portuguese, Japanese, Indians, Filipinos, Koreans, and others all were enticed to Hawai'i. The resulting shift in the ethnic mix of the population is startling. In 1876, the population of the kingdom was around 55,000, and nearly 90 percent were either Hawaiian or part Hawaiian, while Asians made up about 4.5 percent. By 1900, the population of the then territory had nearly tripled to 154,000. Yet Hawaiians and part Hawaiians accounted for only 26 percent. The combined total of all Asian groups made up 56.5 percent.

The haole population increased from 6.3 percent to 17.5 percent, still a small minority in numbers but increasingly influential in wealth and power. In effect, there were three Hawai'is by 1900. The old Polynesian Hawai'i, which after a century of contact with Americans and Europeans, had largely been replaced by a western society that stressed monogamy, private land ownership, Christianity, a constitutional monarchy, and western dress as well as customs. Haoles dominated this Hawai'i, with the support of the monarchy and much of the aristocracy.

The second Hawai'i was that of the new immigrants. Many came to Hawai'i with labor contracts and expected (and were expected) to return home after they expired. Mostly confined to the sugar plantations, immigrants lived largely according to the customs, traditions, and religions of their homelands, turning inward and paying little attention to affairs outside their own communities. Each ethnic group tended to live in separate plantation villages, with little intermingling. The Japanese in particular, ultimately the largest Asian immigrant group, were more reticent about engaging with and marrying Hawaiians than the other groups were. When workers came to Hawai'i, they brought wives with them or later sent for picture brides from Japan.

The third Hawai'i, which was isolated, remote, small in numbers, and continued to practice the ancient customs and religion was that of the old Hawaiians. Like the immigrants, this group also tended to isolate themselves from the larger society.

Immigration was controversial. Hawaiians feared and resented their diminishing influence as the number of Asians grew. Nearly all the newcomers considered themselves temporary laborers working on a contract, who would save money and return home when the contract expired. However, many didn't return home, either because they could not or because they moved on to other places that promised economic advancement. Some went on to California and elsewhere, but many remained in Hawai'i. Of those who remained, a few went to Honolulu or Hilo and opened small businesses, though they generally continued to isolate themselves by community and played little role in larger Hawaiian society or politics.

Asian immigration also caused international tension. The Chinese and Japanese governments from time to time complained about poor conditions under which

their citizens lived and worked. The United States government also expressed concern. Those who hoped that at some point the United States would annex Hawai'i worried about the growing Asian population of the islands and how it would work against this goal.

In 1881, the American Secretary of State, James G. Blaine, expressed concerns at the growing number of "highly objectionable" Chinese laborers in Hawai'i. He speculated that if the Hawaiian Islands should lose their independence, they might come under the influence of the "Asiatic system," rather than "the American system, to which they belong by the operation of natural laws." Honolulu newspapers expressed very similar ideas. Among haoles in Hawai'i, the demands of sugar (more immigration) clashed with the fear of importing large numbers of Asians. Indeed, one of the reasons that Portuguese were enticed to the islands is that they were not Asian, although to many they were not exactly "white" either. The Portuguese often served as "lunas" (overseers) on the sugar plantations. There were even intermittent attempts to entice German and Scandinavian immigrants, though these efforts met with little success.

Sarah Lyman, writing to her sister in New England, described a Hilo plantation in 1865. Each imported laborer received a sum of money in advance and then a monthly salary with room and board. "Many of them," she believed, "will no doubt be better off here than they were in their own country." Yet true to her calling, she worried that "unless some plan is adopted for exerting a religious influence upon them, they will grope in the darkness the same as they have done." Looking over the cane field, she saw "Celestials who are just from China." The group consisted of 38 men and 10 women who wore "the Chinese costume which consists of wide trousers and a loose frock, the women dressing just like the men, only that their frocks are longer, coming to the knees."

To Lyman, the Chinese seemed "more uncivilized than the natives, but it pains me to see the women thus employed in the field for they are small in stature and look slender—as though they could not endure much hardship." Even so, these women sang in the fields leading Lyman to suggest that they liked this work better than "washing, for several of them have tried at that and they neither seem to know anything about that, or like it."

Immigration from Asia, then, alleviated one of the problems confronting the sugar industry. A second quandary was water, and sugar requires an enormous amount of it. The production of one pound of sugar requires up to 500 gallons. Irrigating a relatively small 100-acre plantation can require one million gallons a day.

In areas such as Hilo and Hamakua, rainfall is plentiful, though not always consistent. In other areas such as Kohala, rain falls in the wrong places so irrigation

was a necessity. The transportation and diversion of water to grow sugar became a major industrial and technological feat in the late nineteenth and early twentieth centuries. The Hawaiian sugar industry depended on moving large quantities of water over long distances.

By 1920, the sugar industry of the territory diverted 800 million gallons of water each day and pumped an additional 400 million gallons from wells. Even in areas like East Hawai'i where water was plentiful, production generally increased with regular irrigation.

Because these water projects did not receive support from the government, only the significant financial resources of the Big Five and men like Claus Spreckels made them possible. Although small irrigation ditches existed in the 1850s, it was not until the 1870s that the large-scale construction of ditches began with the Hamakua Ditch on Maui (not to be confused with Hamakua of the Big Island). Spreckels built a second ditch, completed in East Maui in 1879.

The Big Island's ditch projects started later than others in the islands and benefited from the lessons learned. The need was greatest in Kohala where, by 1900, five small plantations had each tried independently for several years to get more water. Their attempts resulted in small, unreliable, and easily contaminated supplies. It was clear that these autonomous efforts were doomed. The Bishop Museum and Bishop Estate, which owned much of the watershed in the area, undertook to build an irrigation ditch that would sell water to the plantations.

After a feasibility study suggested that the idea was both practical and profitable, two ditch companies were formed. The Kohala Ditch Company, established in 1904, was the first. The Hamakua Ditch Company (again, not to be confused with the Hamakua Ditch on Maui) followed in 1906.

The five Kohala plantations—Union Mill, Kohala Sugar, Niuli'i Plantation, Halawa Plantation, and Hawi Sugar—committed to buying water, and the Kohala Ditch Company sold stock and bonds to finance the venture. Chief engineer for the project was Michael O'Shaughnessy, who was then completing a ditch on Maui. The March 1905 contract with O'Shaughnessy stipulated that it had to be finished in 15 months.

It was an ambitious project over very rough territory. Building wagon access trails on the edge of Kohala cliffs was more terrifying than building the ditch itself. In some places, wagon trails were impossible so work crews cut 5-foot-wide trails for pack animals.

The workers themselves were 600 Japanese contract laborers, paid an average wage of $1 per day. Hand drilling by Japanese was cheaper than using air or electric

drills to bore through the lava. It was obviously rough and dangerous work, and during construction six workers and many mules died when they fell off the steep cliffs. Even many of the sturdiest of workers, according to one report, were so exhausted after a few weeks of work in the dark and cold environment that they required hospitalization.

The first section was completed in June 1906; the second portion a year later. The entire Kohala Ditch was 26 miles long, though the name "ditch" is somewhat misleading. Through the mountains, it consisted mainly of tunnels. There were 57 in all, the longest of which was 2,500 feet. The entire effort included 16 miles of tunnels and 6 miles of open ditch, with the remainder consisting of wooden flumes. The ditch itself was lined either with cement or stones as far as Hawi; the tunnels had cement linings; and the flumes, which were 7 feet wide and 6 feet deep, were caulked and tarred.

Built at a relatively low cost of $600,000, the ditch returned a profit for many years both by selling water and renting land the company owned in Kohala and Hawi. By the end of the twentieth century, much of the ditch had been abandoned or fallen into disrepair, but portions of it continue to be used to deliver water and another section became an amusement ride for tourists. Michael O'Shaughnessy would go on to fame (or infamy) as the developer of the Hetch Hetchy water system that still delivers water to San Francisco and surrounding communities from the Sierra Nevada.

Once the Kohala Ditch was completed, investors turned their attention to the Hamakua coast. As in Kohala, Hamakua plantations tended to be small and independent. This arrangement differed from just about everywhere else in the islands, where plantations generally were large, with one or two dominating a given region. Large plantations could afford to build their own ditches; smaller ones could not and thus depended on profit seeking corporations to supply needed water.

While the Hamakua coast, with abundant rainfall, did not depend as heavily on water for irrigation as did Kohala, the plantations there still needed water to run their mills and to transport the cane from the fields to those mills. The Hamakua Ditch Company, formed in 1904 and soon renamed the Hawaiian Irrigation Company, built two ditches. O'Shaughnessy started the project as chief engineer, but soon left after a dispute with one of the financial backers.

The Upper Hamakua Ditch, rushed to completion by January 1907, was not a financial success. Because its hasty construction created unlined ditches, it was prone to leak and the quickly built access trails and flumes deteriorated. This required constant and expensive maintenance. By 1915, its original flow was reduced by one-half, and as much as 85 percent of the water was lost before it reached its destination.

Expensive repairs that year, a virtual reconstruction in many areas, helped somewhat and kept it going for a few more years. By the end of the 1920s, however, maintenance and additional work stopped.

The Lower Hamakua Ditch, on the other hand, did turn out to be a good investment. Opening in the summer of 1910, it was 25 miles long and included 45 tunnels. As with the Kohala Ditch, the construction crew consisted largely of Japanese, plus some Hawaiians, Koreans, and Chinese. They earned $1 a day on this project to bring water to Hamakua coast plantations.

In addition to irrigation, the Hamakua plantations used water to deliver harvested cane from the upland fields to the mills, usually located on the coast. The terrain of the Big Island made transportation especially difficult. The solution was an elaborate network of flumes—ditches and wooden chutes that traversed gorges—that literally washed the cut cane down the mountains to the mills. Once there, additional water was required both to process the cane into raw sugar and to generate electricity.

In addition to water diversion ditches and flumes, the sugar industry also spawned railroads on the Big Island and elsewhere. With the exception of those near Hilo, all plantations on east and north coasts of Hawai'i suffered from a lack of suitable harbors. Trains could both move cane from the fields to the mills and then transport the raw sugar from the mills to ports for shipment to Honolulu or to California refineries. By late 1870s, there were proposals to build two railroads on the Big Island to move sugar to harbors. Early plans called for a line from Honaka'a to Kawaihae, with a branch leading to North Kohala.

Samuel Wilder, who had already built a railroad on Maui and owned a fleet of sailing and steam ships, proposed instead to build a line from Kohala to the tiny harbor of Mahukona, 11 miles closer than Kawaihae. He wanted the other terminus at Niuli'i, on the northeast Kohala coast. The project would require at least a dozen trestles to carry the track over deep gulches.

Wilder was born in the United States but settled in Hawai'i in 1858. By the late 1870s, he was the kingdom's Minister of the Interior, and in that capacity he signed a charter in 1880 establishing his own Hawaiian Railroad Company. Using 100 Chinese laborers, the work of building the roadway for the narrow-gauge railroad began in 1881.

Rails and track supplies came from Germany. Initial purchases of rolling stock came from Britain and arrived in 1882. The first engine—the Kinau—came from the Baldwin Locomotive works in Philadelphia. As with subsequent engines, the Kinau was disassembled and crated in Philadelphia, shipped around the Horn, and reassembled. It arrived at Mahukona in November 1881, was reassembled in eight

days, and was ready for trial by early December. A British engine arrived a few months later, along with six passenger cars and a few flat cars and boxcars. The British engine proved less reliable than the American one, however, and Baldwin Locomotive became the primary supplier for subsequent purchases.

As with ditches, the terrain of Kohala meant that grading and laying the track was a difficult job. The largest curved trestle on the line was 300 feet long and 45 feet high. Another one had a radius of 76 feet, making it one of the sharpest turns on any railroad. Yet despite the difficulty, by January 1883, the last mile of track was laid and the railroad—just under 20 miles long—became the second common carrier in the Kingdom of Hawai'i.

In May 1883, King Kalakaua made an official trip over the new line and at the same time dedicated the statue of Kamehameha I in Kohala. The story of this statue is remarkable. Commissioned by the king a few years earlier, it was created by an American who lived in Italy. When completed, it was shipped to Paris for bronzing and then loaded on a ship for Honolulu. The vessel unfortunately went down off the Falkland Islands, presumably destroying the sculpture. Insurance money paid for a replacement, and as part of his coronation celebration in February 1883, the king dedicated it in front of the Judiciary Building in Honolulu.

Meanwhile, someone managed to salvage the original statue, and an English sea captain eventually discovered it, missing one hand and the spear, in a Falkland Islands junkyard. He bought the sculpture for $500 and took it to Honolulu, where he sold it to King Kalakaua for $875. Since the replacement was already in place, most people agreed that the slightly damaged original would be most appropriate in Kohala, near Kamehameha's birthplace. The royal party arrived in style aboard a Russian warship on May 8. The crated statue, now repaired, was loaded on the royal train, all six coaches filled to the limit by the king and his entourage.

Two hundred horsemen and the Royal Hawaiian Band participated in four days of ceremonies, which included placing the statue beside the road between the Star Mill and Kohala Plantation. In 1912, the statue was moved to Kapa'au and placed in front of what was then a county court building, where it still stands. When the event was over, the king returned to Mahukona, but he went by horseback, possibly feeling safer after his earlier experience on the train. The railroad was a success, though, and passenger cars on the train were thereafter called Kalakaua cars in memory of that royal excursion.

The little railroad went through a series of owners and name changes after Wilder died, but continued in operation until World War II. On December 8, 1941, the United States Navy closed the port of Mahukona out of fear of Japanese

submarines, and trains stopped running west of Hawi. By 1945, improved roads and trucks provided a preferable alternative for cane hauling, and the railroad was abandoned completely.

Wilder dreamed of a second narrow-gauge railroad from South Hilo to Hamakua, but he died before he could raise the money. Political unrest in the late 1880s and 1890s, ultimately leading to overthrow of the monarchy, meant nothing was done with this project until 1899. In that year, both the Wilder family and Claus Spreckels (who owned a large part of a Hamakua plantation) sold out their interests on the Big Island. Spreckels subsequently did the same with all of his Hawaiian interests and returned to San Francisco.

Meanwhile, Benjamin F. Dillingham, who was then completing a railroad on Oʻahu, took an interest in the Hilo coast. With partners Lorrin A. Thurston, the Hawaiian Republic's Minister to Washington, and Mark P. Robinson, who had been Queen Liliʻuokalani's Minister of Foreign Affairs, Dillingham hoped to expand Big Island sugar production south into the previously uncultivated Puna District.

Waiakea Mill on Hilo Bay was then the southernmost plantation. It also was the first Big Island plantation to have its own narrow-gauge railroads in its fields. Dillingham wanted to move south, and in 1898 he planned a large mill at Olaʻa 8 miles south of Hilo. He then applied for a charter to build a railroad to transport the sugar from Olaʻa to Hilo.

Under the charter from the Republic of Hawaiʻi, the Hilo Railroad received authorization for 50 years to build anywhere on the Big Island with free use of government lands. Dillingham wanted his new project to be standard gauge (4 feet, 8 inches), unlike all other railroads on the islands which were narrow gauge (3 feet).

In fall of 1899, the new Hilo Railroad ordered two locomotives from Baldwin Locomotive Works in Philadelphia, and they arrived in Waiakea in spring of 1900. Dillingham's crews meanwhile had been grading and laying track. They built south to Olaʻa Mill and then continued on to Kapoho, near Cape Kumukahi, where Dillingham organized the Puna Sugar Company. Later he built a drawbridge over the Wailoa River and extended his railroad through Hilo to the Wailuku River at the north end of town. Trains then ran the 25 miles from Hilo to Kapoho.

Unfortunately, poor sugar harvests and grasshoppers depressed the industry in the first decade of the twentieth century. Compounded by the Panic of 1907, Dillingham and associates had trouble keeping both the mills and the railroad in business. Fortunately, there was some relief with the development of a new lumbering industry for koa wood in forests above Pahoa, and the railroad managed to survive.

Yet Dillingham and his associates concluded that if they wanted increased profits they would need to upgrade the old wharves in Hilo to attract large shipping lines. With approval from Congress, the railroad agreed to build a new wharf with a breakwater and a 1-mile railroad extension to serve the wharf. However, one of the conditions of approval was that Dillingham and his partners needed to extend their railroad north along the Hamakua coast, ultimately as far as Honaka'a Mill, 50 miles from Hilo. Work on the extension began in 1908, and by 1913 the line reached 34 miles north to Pa'auilo.

Building the Hilo Railroad was a greater (and more expensive) engineering feat than building the ditches. It required 13 steel bridges, the highest 93 feet over water, and another that was over 1,000 feet long. To cross the Laupahoehoe and Alihaie gulches, the track ran inland where the gulches were narrower, crossed them on curved trestles, then returned on the other side toward shore. The track for the impressive bridge over Maulua Gulch, 19 miles north of Hilo, first went through a 2,700-foot-long tunnel before crossing the gulch.

Construction costs eventually exceeded even Dillingham's considerable resources. From 1899 to 1915, he and his associates spent over $6 million to build the 100-mile railroad. They went broke and the railroad went into foreclosure in 1916. Sold for $1 million to Theo H. Davis Limited, one of the Honolulu Big Five, it was then renamed the Hawai'i Consolidated Railway.

By the 1920s, the reorganized railroad was running sightseeing specials along the Hamakua coast whenever passenger ships were in port. For a time early in that decade, the railroad was quite profitable, serving both passengers and freight. In the early years, it carried over 600,000 passengers annually, but by the decade's end those numbers declined to only 78,000. By 1936, passenger travel had dropped so low that the passenger cars themselves were retired or converted to haul away bagasse, the post-milling residue of sugar cane.

Passenger business increased again during World War II because of gas rationing and the need to transport marines from Hilo to Pa'auilo, en route to camps at Waimea. Many of the old coaches were reconverted, and the railroad carried over 100,000 passengers in 1943, most of them marines.

Financially, the railroad again did well until the April 1, 1946 tsunami hit. The estimated repair cost for damaged tracks and rolling stock was $500,000, and by this time many plantations increasingly used trucks. Considering the restoration cost too high for what seemed a dubious future, the owners offered to sell the railroad's right of way, bridges, and tunnels to the Territorial Highway Department and Hawai'i County Supervisors.

When the territorial and county governments shortsightedly rejected this offer, the entire rail stock was sold as scrap to a San Francisco company for $81,000. They had just about finished dismantling the steel bridges when the highway department decided a deteriorating Highway 19 needed improving. They quickly made a deal with the scrap company to buy the remaining bridges and the dismantled pieces that had already been sent to Hilo for $302,723. This was nearly four times as much as they would have spent if they had accepted the railroad's original offer.

Though some plantations continued to use undamaged sections of the railroad south of Hilo, by the end of 1948 all operations ceased. The legacy survives with several current highway bridges originally built for the railroad, and its memory is preserved in a museum at Laupahoehoe.

FROM LABOR STRIFE TO WAR

Immigration, railroads, and irrigation ditches made the sugar industry possible and profitable, but it also required backbreaking labor from those who worked in the cane fields or built the railroads and ditches. Remote from the power center of Honolulu, Big Island plantations were run by "lunas," (overseers), often of either Scottish or Portuguese ancestry. They frequently exercised their authority over the largely Asian workers with harshness and even brutality.

Though the workers often grumbled, they were completely powerless and unable to work collectively to improve their condition. Suspicious of one another, the laborers tended to associate only with others of their ethnic backgrounds. Each group maintained its own traditions, published its own newspapers, set up its own food markets, and, in the case of the Japanese, established its own schools.

This division along cultural lines made it easy for owners and lunas to divide the workers themselves and resist demands for improved working and living conditions. Sometimes the harsh and unfair treatment by the lunas led to violence, both individual and collective. There were also work slowdowns from time to time. Laborers building the Kohala railroad staged a brief strike and actually did see a resulting slight improvement in wages, but this was unusual.

Hawaiians themselves were generally not involved in labor disputes. Even though many islanders resented haoles after the overthrow of the monarchy in 1893, they tended to distrust immigrant workers even more. Prince Jonah Kuhio, for example, the territorial delegate to Congress in the first decades of the twentieth century, especially feared the Japanese, suspecting them of having long range plans to bring Hawai'i into the Japanese empire. Consequently, an uneasy alliance sprung up between Hawaiians, who after annexation were the largest voting block, and haoles, who controlled much of the wealth of the territory. This alliance allowed a ruling Republican oligarchy to dominate politics as well as the economy until World War II. Hawaiians also usually received higher wages than Asian workers, helping to cement this relationship with haoles and further separate them from immigrants.

Some plantation workers resorted to alcohol and drugs to relieve the drudgery. As early as 1873, Chinese laborers reportedly smoked opium on a Hilo plantation. Because of opium or alcohol, many workers were unfit for duty on Monday mornings. To escape these conditions, Chinese and Japanese help often moved from the plantations to Honolulu and Hilo as soon as their contracts expired. Still others went to California to work on the railroads or in agriculture.

This meant there was a constant need for new laborers. To induce them to stay, owners instituted a "Bonus" System that paid workers additional money once a year for those who averaged 20 days of work or more per month. Though the Bonus System itself was controversial because it encouraged laborers to work when sick and because the amount paid varied by ethnic group, the higher wages did allow some workers to save enough money to leave the plantations eventually. Conversely, it also kept them from leaving until the end of the year in order to collect the bonus.

American immigration policies complicated life for the Hawaiian Japanese. An increase in immigration to the United States in the first few years of the twentieth century produced rising anti-Japanese sentiment, particularly on the West Coast. In an attempt to prevent an international crisis that could have resulted from an outright ban on immigration, President Theodore Roosevelt reached a "gentlemen's agreement" with Japan in 1907. Under this agreement, the Japanese government would discourage emigration to the United States mainland. California and other western states went further, passing laws preventing Japanese from owning or leasing land.

In the same year, President Roosevelt signed an executive order prohibiting immigration of Japanese from Hawai'i to the mainland. Returning to Japan was increasingly not an option either. A rapidly rising standard of living in that nation in the years before World War I meant that Japanese plantation workers in Hawai'i could no longer afford to go back.

Unable to return to their homeland or to move to the American mainland, many Japanese resigned themselves to remaining in Hawai'i, where they attempted to maintain as much as they could a Japanese lifestyle. Unmarried men sent for picture brides from Japan. Many left the plantations of East Hawai'i and moved to the Kona coast to grow coffee on small farms leased from corporations or large Kona landowners. By the 1930s, the Japanese made up more than 50 percent of the Kona population. They lived in Japanese-like villages, sent their children to one of eight Japanese language schools, and prayed in Buddhist and Shinto temples and shrines. They even substituted a coffee blossom ceremony for the

traditional Japanese cherry blossom festival. The names of long time restaurants, grocery stores, and other businesses in the Kona mauka communities of Kainaliu, Kealakekua, and Captain Cook are reminders of the pre–World War II influence of the Japanese.

Their coffee farms were small, averaging only 6.75 acres in 1938. Compared to life on the sugar plantations, coffee growing was a welcome change. The work was hard and the hours generally longer, but the independence and absence of lunas made it more bearable. However, they were now at the mercy of fluctuating coffee prices. At least on plantations, the paternalistic conditions largely shielded them from adverse economic aberrations.

Though the Japanese held a numerical majority on the Kona coast, they had virtually no political influence. Instead, large landowners dominated politically and economically. Haoles made up less than two percent of the population, but they owned the land that they leased to coffee farmers, the largest coffee mills, the grocery distribution companies, and the banks and insurance companies. They extended loans to the farmers who pledged their future crops, hoping that the price of coffee at harvest time would cover their annual borrowing. It often did not, and as discussed in chapter six, the farmers found themselves sinking deeper into debt by the 1930s. The average amount of money owed per farm in 1938 was $1,777, a large sum during the Depression. The farmers were not in a very strong position to challenge the haole political elite.

Despite these conditions, Japanese coffee farmers on the Kona coast were better off than the plantation workers who remained behind in East Hawai'i in many ways. While there were strikes and protests against working conditions as early as 1841, workers seldom succeeded in achieving their goals. In 1881, Norwegian laborers went on strike at Castle and Cooke's Hitchcock Plantation near Hilo. They complained of bad food, severe punishments, and penalties for being sick. In October, they left the plantation and went to Hilo, where they were promptly arrested for desertion and ordered to return to work. They appealed to Supreme Court in Honolulu, but lost. Defeated, all they could do was write home to Norway, advising people not to come to Hawai'i.

In 1891, there was a strike by Chinese plantation workers in Kohala. Three hundred laborers on the Kohala, Union Mill, and Hawi plantations refused to work. When they rebuffed an order to return, the local deputy sheriff inducted natives as special policemen who followed the workers as they headed back towards the plantations. When a few strikers stopped to pick up stones, the police attacked with whips. The laborers panicked and ran into the cane fields. Police then attacked a

nearby Chinese camp, demolished it, and seized every Chinese worker they could find. In the end, 55 Chinese went to jail for assaulting government officers.

Strikes on the other islands met with a similar lack of success. In 1909, the Great Strike began on Oʻahu and lasted for four months. Whereas previous boycotts usually focused on mistreatment by lunas, this one was specifically about higher wages. As usual, the planters won by dividing the workers along ethnic lines.

In 1919, the Japanese Young Men's Association, representing five Hamakua plantations, met in Hilo and established a labor organization. They demanded an eight-hour day, wage increases, and the abolition of the bonus system. Japanese on other islands responded by organizing themselves as well. They formed an Interisland Japanese Federation of Labor in Honolulu. Filipinos then set up a similar Filipino Federation of Labor. The Hawaiian Sugar Planters Association (HSPA), representing the owners, rejected all demands and both groups decided to strike in 1920.

The HSPA again tried to divide the strikers along ethnic lines. When the boycotters were evicted from their homes, they moved into camps set up by Shinto temples, churches, and the Japanese Federation. The crowded conditions in camps made the strikers and their families especially susceptible to the worldwide killer flu epidemic of 1920. The strike continued for six months, but ultimately the planters sustained complete victory, and the workers returned to their jobs. Nevertheless, Japanese and Filipino strikers had joined forces, and this cooperation would prove more successful in the future.

The most famous Big Island labor trouble came with the "Hilo Massacre" in August 1938. The strike that led to it did not originate in Hilo, and actually it was unrelated to plantation conditions. Instead, Hilo workers wanted to support Honolulu longshoremen, who were striking for higher wages and for preferential union hiring by the Inter-Island Steamship Company. This company, which had a monopoly on inter-island shipping, owned Aloha Airlines and the Kona Inn, and was itself largely owned by the Matson Navigation Company. The workers wanted wage parity with West Coast longshoremen; the company, like most island employers, wanted to maintain lower wages as a cushion and competitive advantage to offset transportation costs. Although the Inter-island Steamship Company was doing very well financially, they completely rejected union demands and replaced the longshoremen with strikebreakers.

The people who crossed the picket line loaded the Hilo-bound S.S. Waialeale, and the ship's arrival in Hilo Bay prompted the August 1 demonstration. The mostly young demonstrators began gathering at 6:30 a.m. at Pier 2 to protest both the

anticipated arrival and subsequent unloading of the ship. The Hilo marchers were not themselves on strike, but the demonstration showed that union supporters on the Big Island no longer divided themselves along ethnic lines. It also showed solidarity with their fellow workers on Oʻahu. As often happens with estimates of crowd numbers, witnesses put the number of demonstrators at anywhere from 80 to 800. Subsequent observers, using photographs of the event, generally agreed that the number was probably around 200.

Despite warnings from the Hilo Police the demonstration continued, and singing marchers were met by a force of 60 officers and men, armed with guns, bayonets, and tear gas. When the ship docked around 9:00 a.m. and began to unload, some of the union supporters moved towards the pier. When police orders to stop had no effect, some policemen threw three or four tear gas grenades. The strikers dispersed, but then quickly reassembled in a nearby small park.

The police next tried to disperse the crowd with fire hoses by pumping water from the bay, but this effort was ineffective and only served to clear away much of the tear gas. The union supporters then resumed their peaceful march toward the pier. The police chief apparently believed that the ship's own heavily armed guards would fire on the crowd unless the officers could prevent them from getting close to the ship. In a difficult position, the chief ordered his men to change their ammunition from buckshot to smaller and less harmful bird shot, but apparently some of the men either did not hear the order or chose not to obey it.

At around 10:20 a.m., the police fired several shots into the crowd. Seven of these used bird shot, but nine of them were of buckshot. Fifty people were hit, including two women and two children. At least one man was bayoneted and another had his jaw broken. Harry Kamoku, one of the Hilo union leaders, claimed that the police "shot us down like a herd of sheep. We didn't have a chance. They shot men who were trying to help wounded comrades and women. It was just plain slaughter, brother."

Kamoku exaggerated a bit. Fortunately no one was killed, but at least 25 people required hospitalization, and a labor leader was crippled for life. Soon people were referring to it as the "Hilo Massacre," though conservative newspapers called it an "incident." But whether massacre or incident, the event shocked everyone, made newspaper headlines for weeks, and ultimately resulted in a territorial investigation.

The one result that did not occur was a union victory. Strikers were defeated, but the labor solidarity and new union organizations remained. It would not be until the end of World War II, however, that there would be a successful strike for higher wages and closed shop hiring in Hawaiʻi. The war put the movement on hold.

World War II changed everything else as well. Though the Big Island did not experience the dramatic and tragic events of Pearl Harbor, the outbreak of battle on December 7, 1941, affected residents on all islands in direct and personal ways. Before the day was over civilian rule was suspended, and Hawai'i became the first place in the United States since the Civil War to come under direct military rule. Lieutenant General Walter C. Short assumed the position of military governor of the territory, declared martial law, and suspended the writ of habeas corpus. Though Short himself was relieved of duty a few days later, his successors continued military rule throughout the war.

Civilian leaders protested and repeatedly tried to end martial law, but without success. The United States Supreme Court later declared the imposition of military rule unconstitutional, but few residents in the territory complained very loudly while it was in effect. Indeed, businessmen enjoyed a period during which prices could rise while wages were frozen.

The rationale for military rule was obvious; the forces of another nation had physically attacked the territory. And to make the situation even more serious in the eyes of many military and governmental leaders, the islands' population contained a significant percentage of people who were either born in that nation or descended from those who were.

In 1940, 37 percent of the territory's population was of Japanese ancestry. Nearly one-quarter was first generation, born in Japan. In Kona, nearly 53 percent were of Japanese ancestry. Moreover, in the 1930s, Japanese nationalism had been especially strong on the Big Island. An anthropologist studying the Japanese in Kona reported that the first generation regarded all news from Japan as infallible about the war between them and China and considered all other news as "Chinese propaganda." Japanese sailors whose ships visited the Big Island in the 1930s often found friends and relatives in both Hilo and Kona. The Honolulu Japanese newspaper Nippu Jiji reported late in 1937 that there was a steady flow of recruits from Kona (mostly second generation) into the Japanese army for service in the war against China.

Pearl Harbor led to hysteria in California and other western states that resulted in the internment of 110,000 residents of Japanese ancestry. In comparison, the magnitude of the "problem" in the Territory of Hawai'i was overwhelming. Although there was no sabotage or subversion and Japanese residents of the territory exhibited as much patriotism as other ethnic groups, they lived under a cloud of suspicion.

Even without this suspicion, the territory was obviously in danger. Military authorities acted swiftly to prevent additional damage. They closed all bars and service

stations until further notice on December 7. They arrested about 100 Japanese leaders and imposed a nightly blackout throughout the islands. Mahukona harbor in Kohala was also closed, and the marines leased nearby Hapuna Beach from the Parker Ranch, fearing it would be used as a landing site for Japanese troops. The beach would later serve as an amphibious marine training area.

These fears had some justification. Before Pearl Harbor, Japanese military planners regarded the Hawaiian Islands as a potential addition to their Greater East Asia Co-Prosperity Sphere. Some strategists suggested bypassing heavily fortified O'ahu and concentrating on the sparsely populated and poorly defended Big Island as a stepping stone to the rest of the territory.

Three weeks after Pearl Harbor, on December 30, a Japanese submarine actually attacked Hilo by firing about a dozen rounds of 5-inch high-explosive shells toward several oil storage tanks close to shore. The shells missed their intended target and did only minor damage to a pier. Most of the shells landed at the Hilo Airport, convincing troops stationed there that an invasion was underway.

A naval ship docked in the bay returned fire and drove the submarine away. Physical damage was minimal, but the blow psychologically was great. Still shaky from Pearl Harbor, military rule, and nightly blackouts, Hilo residents now heard and saw enemy shells literally fly over their homes. Additional attacks on Maui and Kaua'i brought the war very close to home. Hilo "Minute Men" began stringing barbed wire around important utilities such as the gas company. Though it is doubtful this effort would have prevented an invasion, at least people were actively engaged in defense.

In Kona, the impact was less dramatic, but still intrusive. Like Americans everywhere, residents accepted rationing for gasoline, tires, and liquor. As elsewhere, there were blackouts at night that even prevented driving past sunset at first. However, the additional concerns of a war zone with a large resident Japanese population meant the military government imposed restrictions on residents that did not apply elsewhere in the United States. A West Coast-type solution of relocating and interning all of Hawai'i's 157,000 Americans of Japanese Ancestry (AJA) was seriously considered in Washington and supported by President Franklin Roosevelt. The attempt was successfully resisted by local authorities in Hawai'i as unnecessary and logistically and economically infeasible. Instead, military authorities imposed restrictions that continued long after the time the Japanese seriously threatened Hawai'i with invasion.

Kona was divided into two sections, north and south, with the boundary near where the current hospital is located. Travel between the two required a police permit.

Years later, one resident would remember the travel restrictions as one of "the most difficult things." Additionally, there were posters in many places cautioning people against speaking the Japanese language, presumably because it would lead to subversive activity.

Japanese residents who were not American citizens (virtually all first generation immigrants) could not gather together in groups of more than ten without a permit; even funeral attendance required one. Before long, soldiers seemed to be everywhere. For a time, many of them camped on Konawaena School grounds; others used the hospital; there was another unit at Holualoa School. One resident later admitted that these restrictions were more of an inconvenience than a real burden. But the presence of such a large percentage of Japanese in the population created a very "tense feeling." The hostility of their neighbors increased the uneasiness.

Hilo businessman and political leader William C. "Doc" Hill expressed the opinion of many that "A Jap is a Jap even after a thousand years and can't become Americanized," and it was not restricted to just haoles. Filipinos and Koreans also resented Hawai'i's Japanese because of what the Japanese military did to their native countries. The tension sometimes spread within the Japanese community itself as second- and third-generation men and women blamed their parents and grandparents for the hostility directed against the Japanese in general. Maintaining traditions, language, and dress, the younger generations charged, made them appear "un-American." About 40 people from Kona were actually interned and sent to the mainland. One of them was a Honaunau coffee dealer and storekeeper who had lived in Kona since 1907:

> I was taken, too, although I resisted strongly, saying that I hadn't done anything wrong, that they didn't have any good reason to take me. They told me that, since I was pure Japanese, they had to take me away, as they were going to take all the Japanese away. So I gave up, although I didn't sign my name, which was what they told me to do.

He was taken first to Kilauea, then successively to mainland camps in Colorado and New Mexico. He admitted that the camps were relatively comfortable and the food was good. Under the Geneva Convention, internees "were treated and fed just as well as American soldiers." He remained in the camps for three years. Letters from his wife and children were not restricted, though they were opened and apparently read. Returning to Kona after the war, he found his store empty as his wife had been unable to manage it in his absence.

At first, military authorities rejected Japanese volunteers when they tried to enlist in the army. When the restriction was finally lifted, five times as many men responded to the call than were requested. The 100th Battalion, with Hawaiian National Guardsmen, served in North Africa and Italy. The 442nd Regimental Combat Team of Hawaiian volunteers saw bloody hand-to-hand combat with German troops in northern Italy. Both units suffered heavy casualties, received thousands of medals, and gained respect that helped diminish some of the anti-Japanese hostility once the conflict ended.

While war raged in Europe and in the Pacific, the military used the Big Island to train thousands of troops. The largest facility was on the Parker Ranch near Waimea. After the November 1943 victorious and bloody assault on Tarawa Atoll in the Gilbert Islands, the 2nd and 5th Marine Divisions moved to the Big Island. They finished construction of the Waimea camp, renaming it Camp Tarawa. Ultimately the largest marine training facility in the Pacific, Camp Tarawa trained more than 50,000 men before it was closed after the war. The volcanic hills around Waimea were especially useful in training the men who would climb the similar hills of Iwo Jima.

Another facility, the Kilauea Military Camp in Volcanoes National Park, dated back to World War I. Originally established as a training area and rest camp for the Hawai'i National Guard, it served in World War II as a temporary detainment camp for those Japanese who were later transferred to the mainland. It also served as a prisoner of war camp, and included several Koreans who had been drafted into the Japanese Army and then captured by the Americans. The Korean prisoners now wanted to join the Americans in the war against Japan, but their repeated requests were rejected as contrary to the Geneva Convention.

The end of the war did not mean the end of hostility towards the Japanese in Hawai'i. A ceremony planned in Hilo to welcome home those who had been interned produced opposition from the Hilo Chamber of Commerce, the Rotary Club, American Legion, and other civic organizations. The Chamber of Commerce said it would be a "sad reflection" on the community to welcome a "group of people whom the government of the United States saw fit to intern for security reasons." The Hilo Tribune Herald went even further, opposing "the promotion of alien influence and customs as contrasted with the development of an American democratic community."

Yet the internees did come home, as did the survivors of the 100th Battalion and the 442nd Regiment. So did others who had served in the war: Hawaiians, Chinese, Korean, Filipinos, and haoles. Like Americans everywhere, the war changed them in ways that were both dramatic and subtle. Men from the most isolated area on earth had their horizons expanded by the experience of traveling to the mainland, Europe,

and Asia. The G.I. Bill allowed many veterans to receive a previously impossible college education. The returning war heroes, who had fought for freedom and received an education, were more likely in the future to insist on political participation. Indeed the new interest by ethnic groups in the political process within a few years would help break the half-century lock that the Republican Party oligarchy had on the territory, though it would take longer on the Big Island.

Those who stayed home were also changed by the war. The thousands of troops stationed on the Big Island helped expand horizons as well. One Kona woman, a little girl of seven at the time, recalled that during the war she saw for the first time both a man with black skin and another with red hair. Finally, for better or worse, Hawaiians acquired a taste for Spam.

POST-WAR TROUBLES

Peace did not bring tranquillity to the Big Island. Natural disasters replaced man-made adversity in the years following the war, and the economy of the Big Island, tenuous in the best of times, faced additional uncertainties.

On April 1, 1946, Hawai'i was struck by a deadly and destructive tsunami that hit especially hard in East Hawai'i. Tsunamis, which are sometimes mistakenly called tidal waves (the tide has nothing to do with it) result from massive movements of land, either onshore or at the bottom of the sea. Earthquakes, landslides, or volcanic activity all can cause a violent and massive displacement of water that in turn produces a series of rapidly moving waves on the surface. As these waves approach shallow water near shore, they increase in height and smash everything in their path. Often the earth movement that creates the tsunami occurs hundreds or thousands of miles away from the ultimate sites of destruction.

The earliest recorded Hawaiian tsunami occurred in 1837, and the source was an earthquake in Chile. The waves that crashed into Hilo were 20 feet high, and 14 people died. This is the tsunami that Titus Coan considered the voice of God, helping Coan spread the Gospel in Hawai'i (see chapter five).

Another tsunami, in 1868, killed 46 people in Ka'u and one in Puna. The waves in Ka'u were 60 feet high. The source was in Hawai'i itself, which brought the waves to shore almost immediately. In 1877, another Chilean earthquake spawned waves that killed five in Hilo. One person died there in 1923, after an earthquake struck Kamchatka, Russia and the oceanic repercussions were felt in the islands.

Nothing in the past history of tsunamis, however, prepared people for the "April Fools" disaster of 1946. An earthquake off Alaska struck early in the morning. Five Coast Guardsmen, staffing a 100-foot-tall concrete lighthouse that was 90 miles away reported no damage. But in less than an hour, a 115-foot wave washed away the lighthouse and its crew.

The waves then began moving towards Hawai'i, more than 2,300 miles away, at speeds of between 400 and 500 miles per hour. Many places in the Pacific basin were hit, including Half Moon Bay in California, where the waves carried small boats several hundred feet inland, tossed a car up in front of a house, and

drowned an elderly man walking on the beach. In Chile, the waves swamped several fishing boats.

Yet no place suffered more than the Hawaiian Islands. The waves first reached Kaua'i shortly before 6:00 a.m., and the eventual death toll there reached 17. Six more died on O'ahu, and fourteen more on Maui. The waves hit the Big Island shortly before 7:00 a.m. In Kohala's Pololu Valley, they reached a destructive height of 55 feet.

Laupahoehoe was a small village on a low-lying peninsula north of Hilo on the Hamakua coast. There was an elementary school on the point, as well as small cottages housing teachers, several of whom had recently come from the mainland to begin their teaching careers in paradise. Four instructors who shared a cottage at the end of the point noticed unusual swells at about 7:00. Each crest seemed higher, but then withdrew farther back into the sea.

The fifth wave deposited fish into the school yard, and several children who were just arriving for class began to pick them up. With the sixth one, everybody realized that the situation was not just unusual, it was deadly, and people began running inland to safety. The four teachers returned to their cottage to change clothes just as a wave crashed over it and collapsed the roof. Two of them were immediately lost; the other two climbed onto the now separated roof peak, which was rapidly carried out to sea.

At the edge of the point, the roof caught on some rocks and the teachers climbed off onto the temporarily empty ocean floor just as another wave approached. Both women disappeared, but one of them, Marsue McGinnis, resurfaced only to be pulled down again. When she surfaced a third time, she found herself floating past the top of the point's lighthouse. Grabbing onto pieces of wreckage, she hung on and floated in the ocean until she was finally rescued in the late afternoon. Masuo Kino was another lucky survivor. He later recalled that:

> The wave flipped me over and carried me toward the lava rock wall that
> rimmed the school. I recall telling myself, 'Gee, I'm going to die. I'm going
> to hit headfirst into that rock wall and I'm going to die.' But miraculously,
> part of the wave that preceded me smashed into the wall and broke it up.
> So I went flying through the wall, not headfirst into a stationary wall but I
> was rumbling along, rolling along with all the rocks.

Meanwhile, the school children were also caught by the waves. One man tried to rescue two children, but was forced to let one of them go to save the other when he himself was caught by the tsunami. Some children washed out to sea were caught in

the bushes and saved; others were swept out and never found. Before the day was over, 24 people died in the village of Laupahoehoe, 16 of them children and 4 teachers.

A few miles south, the island's largest sugar mill at Hakalau was destroyed, as were many of the bridges of the Hawai‘i Consolidated Railroad. In Hilo itself, the waves destroyed the railroad station and swept Engine 121, the railroad's newest, off the tracks as its engineer (who survived) made a mad and futile dash to get out of town and escape the danger.

The waves crashed into Hilo, reaching as high as 25 feet at Coconut Island in the bay. Huge boulders from the bay's breakwater, some weighing as much as 8 tons, were hurled onto the shore. The only ship in the harbor, which had several tons of dynamite in its hold, got underway in record time to head out to the safety of the open sea, possibly preventing an even worse disaster.

A total of nine waves came ashore that day. The hardest hit areas were those along the bay and a Japanese neighborhood called Shinmachi, just north of the Wailoa River. Homes in Shinmachi were either demolished or carried away and the business district along Kamehameha Avenue was devastated. Boats were tossed for hundreds of feet. As water surged in the streets, people fled inland in a sometimes vain attempt to escape. When the waves finally subsided, nearly 500 homes and businesses had been destroyed and 1,000 more were damaged. The $26 million estimated cost (in 1946 dollars) was enormous.

Of course property damage seemed less significant when the human toll was counted. In Hilo, 96 people died. In total, 159 people lost their lives throughout the islands. Many bodies were never recovered, and those found were taken to a temporary morgue in a Hilo ice house. The bodies were stacked in such haste that many actually froze together.

When Hilo was rebuilt, the area between Kamehameha Avenue and the bay was reserved for parks and recreation. Hilo residents hoped that they would never again face a day like the one of April Fools in 1946. Wishing, of course, did not mean an end to tsunamis. In 1952, and again in 1957, tsunamis came ashore and damaged or destroyed boats, homes, and businesses in Hilo and on other islands. Fortunately, neither of these tsunamis resulted in loss of life.

Then, on May 22, 1960, an earthquake of 8.5 magnitude struck in Chile, 6,600 miles from Hawai‘i. The Tsunami Warning Center, established after the 1946 disaster, issued a warning at 6:47 p.m and sirens went off at 8:30. The prediction was that waves would arrive at Hilo around midnight. Early reassuring reports from Tahiti were that crests topped out at 3 feet. Some people evacuated their homes, businessmen moved documents to higher ground, but many people thought it was

probably an erroneous warning. The relatively small tsunamis in 1952 and 1957 increased a sense of false security.

Water began to rise just after midnight, May 23. Because of a recent change in the warning system, some people expected a second siren that would indicate a real problem. The new procedure called for only one siren warning, and it had already been issued. Even the radio stations were confused by the procedural change. By midnight, the predicted time for waves to arrive, nothing dramatic seemed to be happening. Some people went out to watch what appeared to be a non-event. The waves crested 4 feet above normal, then receded to 3 feet below normal.

At 12:46 a.m., a second crest 9 feet above normal flooded the business district. The waves then withdrew to 7 feet below normal. These first two relatively harmless waves convinced more people of an exaggerated threat. Some who had previously evacuated returned to see what had happened. However, a third wave nearly 20 feet high raced ashore at 1:02 a.m. It quickly took out the power plant with an explosion, spreading darkness throughout Hilo and much of the entire island.

In just under 15 hours, the waves traveled the 6,600 miles to Hilo at an average speed of 442 mph. When the biggest wave hit, it was traveling an estimated 30 miles per hour or more and was 35 feet high. In this instance, curiosity literally killed as 61 people died in the early morning darkness and 43 more required medical assistance. Property damage in excess of $50 million included 229 homes and over 500 businesses. The Japanese neighborhood of Shinmachi again bore the brunt. As in 1946, huge boulders from the seawall were hurled hundreds of feet inland and parking meters along Kamehameha Avenue were bent parallel to the ground. The city's infrastructure—electricity, sewers, water mains, and bridges—was severely disrupted. Much of the fishing fleet was wiped out. It would take several years to recover from the physical and economic devastation.

There was only moderate damage elsewhere on the island, but even in West Hawai'i the waves reached 12 feet at Keauhou; 10 feet at Kahalu'u; and 16 feet at Napo'opo'o.

Destruction was not confined to Hawai'i. In Los Angeles, the tsunami sunk 40 boats and damaged 200 more. In Japan, the waves, which traveled 10,000 miles from Chile in 24 hours, killed 140 people and did considerable property damage.

The tsunamis of 1946 and 1960 resulted from events originating several thousand miles away. Tsunamis caused by events on the Big Island itself are potentially even more dangerous, because the interval between the earthquake and tsunami is very brief, providing little chance for warning. Anyone who experiences an earthquake while on a beach or close to the shore should immediately head for higher ground.

In 1975, for example, a 7.2 earthquake struck the Big Island. Several Boy Scouts and their leaders were camped at Halape in Volcanoes National Park, 15 miles from the epicenter. Fleeing a rock slide triggered by the earthquake, the scouts headed towards the ocean, where a tsunami killed 2 of the campers, injured 19 more, and killed 4 horses.

There are several obvious conclusions from the above accounts. First, tsunamis are deadly. Since the early nineteenth century, two dozen or more recorded tsunamis have killed 291 people in the Islands—most of them on the Big Island. Second, Hilo Bay is especially susceptible and vulnerable to tsunami damage. And third, tsunamis will inevitably strike and undoubtedly kill again.

Tsunamis are not the only natural events to threaten Hilo. The volcanoes also have destroyed property, occasionally taken lives, and threatened the city from time to time. The world's biggest volcano is Mauna Loa, whose summit is 56,000 feet above the floor of the sea; it is also one of the world's most active sites. Since the first recorded eruption in 1843 Mauna Loa has erupted 33 times, most recently in 1984. The most serious threat to Hilo from Mauna Loa, however, began in November 1880 and continued for nine months.

Volcanoes produce two types of lava, 'a'a, the rough crystal formations that result from spectacular explosions that spew lava through the air, and pahoehoe, the smooth steady ooze that leaves a velvety field as it makes its way toward the ocean. 'A'a eruptions are more spectacular; pahoehoe more dangerous because when it cools it forms lava tubes that move subsequent flows over very long distances relatively quickly.

In 1880, the flow began slowly moving down the hill. At first there was little concern in Hilo, but by the spring of 1881, the flow had reached to within 7 miles. A day of "Christian Prayer" in early June seemed to have little impact. Most residents remained calm, but a few left the area, some going as far as Honolulu.

By the end of June, the lava reached streams in the hills above Hilo, which allowed it to pick up speed. Reverend Titus Coan reported that as lava raced down stream channels, rocks exploded, and massive amounts of steam were created. At times, the flow moved as rapidly as the Wailuku River. There were frequent explosions—ten a minute according to Coan—as the lava now moved from 100 to 500 feet per day.

A stone wall was rapidly constructed to divert the flow away from the Waiakea sugar mill. In a desperate attempt to save the town, residents called upon the formidable Princess Ruth Ke'elikolani.

As the lava threatened Hilo, Princess Ruth was in Honolulu serving as regent in the absence of King David Kalakaua, then on his world tour. Much of what she did when

she arrived in Hilo in late July or early August stems from legend and without much documentary evidence, but the story is certainly worth repeating because what she allegedly did was certainly in character.

If Christian prayer could not stop the flow, perhaps an ancient Hawaiian ritual performed by a high-ranking chiefess could. She started up the hill to meet the lava and the horse pulling her carriage was not up to the task, so prisoners from the Hilo jail were recruited to pull it the rest of the way. When she reached the lava flow, the princess placated the goddess Pele by throwing 30 red silk handkerchiefs, purchased in Hilo, into the molten flow, as well as a bottle of brandy (or perhaps it was gin). Other stories tell of slightly different offerings. Whether because Pele was placated or the Christian prayers were finally heard, the lava stopped a few days later. It had come to within 1.5 miles of the bay, near the present site of the University of Hawai'i at Hilo. Many homes are now built on the lava that resulted from this 1881 flow.

Mauna Loa has also threatened the western side of the island. In 1950, an eruption flowed down into South Kona. No one was killed, but a small village and several ranch homes were destroyed.

One hundred years after the 1881 threat to Hilo, Mauna Loa's neighbor started to erupt in January 1983. Kilauea Volcano has flowed continuously since that time, making it the world's most active volcano. Indeed, since its formation between 300,000 and 600,000 years ago, Kilauea has always been active, with only occasional periods of inactivity.

Sometime between 50,000 and 100,000 years ago, Kilauea emerged from the sea and began to expand the area of the Big Island. Scientists are uncertain when the famous caldera at the top of Kilauea formed. Most activity occurs from lava flowing from vents in rift zones along the east and southwest sides of the mountain. Less frequent, but potentially more deadly, are violent eruptions from the summit that send molten lava flying through the air to the surrounding countryside. The most famous such occurrence was that of 1790, which killed over 400 men, women, and children in Keoua's army as he marched from Hilo to Kohala for his fateful meeting with Kamehameha (see chapter three).

Subsequent eruptions were less dramatic, but throughout the nineteenth century and early part of the twentieth, Kilauea was very active. Titus Coan described an 1840 eruption in his memoirs:

> Imagine the Mississippi converted into liquid fire of the consistency of
> fused iron, and moving onward sometimes rapidly, sometimes sluggishly;
> now widening into a lake, and now rushing through a narrow gorge,

breaking its way through mighty forests and ancient solitudes, and you will
get some idea of the spectacle here exhibited.

Historically, we know of over 60 specific eruptions, including the one that began in
1983. The current flow is the longest known eruption in the volcano's history and
shows no sign of stopping. To put it into perspective, one newspaper reporter
calculated that the current flow produces 40,000 to 45,000 dump trucks full of lava
each day and that the total amount since the beginning of the flow could cover the
little island of O'ahu to a depth of 5 feet. So far, several hundred acres of new land
have been added to the island as a result of the flows from the east rift zone, creating
a spectacle that attracts visitors from around the world. Currently, well over two
million visitors come to Hawai'i Volcanoes National Park each year to visit the world's
only "drive-in volcano." Many come by the busload from the cruise ships in Hilo Bay,
while others view the natural wonders from airplane and helicopter tours.

The eruptions have had a cost, however. Twenty-two people have died, mostly
because they insisted on entering restricted areas, and several communities and
buildings have been destroyed. Nearly 200 houses, a park visitor center, and a 700-year
old heiau, as well as other ancient sites, now lay buried beneath the lava. Several roads
along the south coast of the island remain closed. The Royal Gardens subdivision and
the villages of Kapa'ahu and Kalapana were destroyed in 1990. Officials stopped
counting the total dollar cost after it surpassed $60 million because both the state and
federal governments had by then declared Hawai'i County a disaster area.

These natural disasters obviously have an economic cost in addition to the toll in
lives. After the 1960 tsunami disaster, business leaders in Hilo searched for new
economic ventures to help rebuild their shattered community. One proposal
suggested Mauna Kea as a potential observatory site. The Hilo Chamber of
Commerce sent letters to all major American and Japanese universities inviting them
to consider the prospect of building an observatory on top of the mountain.

The idea undoubtedly seemed far-fetched to many. The mountain rises 32,000 feet
from ocean floor to summit, which itself is 13,796 feet above sea level. Mauna Kea
last erupted about 4,000 years ago but, though dormant, it is still forbidding. In
1823, Joseph Goodrich, a member of William Ellis' missionary group, became the
first white man to climb to the summit (see chapter five). He experienced patches of
snow, temperatures of 27 degrees, and air so thin that it gave him a headache. In the
winter, winds of over 100 miles an hour are not unusual.

A few years later, David Douglas, the Scottish botanist, climbed to the summit in
January 1831, lugging a 60-pound pack on his back. He also got a headache, but was

inspired by what he saw: "Man feels himself as nothing—as if standing on the verge of another world."

Despite the harsh environment, the summit is above 40 percent of the earth's atmosphere, and the minimal precipitation means that there are over 300 perfectly clear nights per year for observation. Even so, the remoteness of the Big Island, coupled with the potentially harsh environment at the mountain's summit, probably dissuaded most of the universities contacted by the Hilo Chamber of Commerce. Only the University of Arizona responded at first.

In 1963, a team from that university came to look at the mountain as a possible site. The University of Hawai'i considered a joint venture with Arizona, but then decided to build its own telescope. The first step was to build a road to the summit. Then with a grant from NASA, the Arizonans built an 88-inch telescope. Before long, other institutions from many countries expressed an interest in the site.

Within a few years, other telescopes built by Canada, France, Great Britain, and Japan turned Mauna Kea into a world-class observatory. Astronomers came from around the world to view the heavens from Mauna Kea. Most of the administrative offices and staffs for these telescopes were in Hilo; others were in Waimea. The proliferation was so successful that it even spawned a "Save Mauna Kea" movement, with opponents ranging from concerned environmentalists to native Hawaiians who consider development at the summit of a sacred mountain sacrilegious.

Turning Mauna Kea into an observatory was a creative attempt to improve the island's economy. But it was a small effort in comparison to the overall need. The next major economic threat did not result from a natural disaster. Instead, it resulted from problems in the sugar industry, the mainstay of all the islands' economy for over 100 years. Before World War II, sugar and pineapple together accounted for $90 million of the territory's total exports of $95 million. The vast majority went to the mainland in exchange for imports of manufactured goods and food. Pineapple was not grown commercially on the Big Island. There were attempts to grow it in the nineteenth century, but transporting the crop to market proved too difficult. Sugar, of course, dominated.

As in the past with sandalwood and whaling, the islands tended to rely on one or a very few products, with little economic diversification; for a long time it worked. Sugar proved very profitable, though obviously most of the profits went to the increasingly small number of growers.

After the war, several factors conspired to weaken the Hawaiian sugar industry. First, there was increasing competition of cane sugar from places such as Cuba and the Philippines. Second, beet sugar, grown in western states, competed with cane sugar. And third, costs in Hawai'i rose as workers finally found unity across ethnic

barriers, formed strong unions, and demanded higher pay. As with many other labor-intensive industries in the United States, Hawaiian plantations could not compete with wages paid in developing countries, or even with wages in Louisiana. Production actually continued to rise until the mid-1960s, but the industry itself was increasingly in trouble.

Even before the war, the Big Island's population had been in decline. It continued to shrink each decade from the 1930s to the 1960s before finally beginning a slow rise. The decline to a great extent was related to diminishing job opportunities. In the early 1970s, the Kohala Sugar Company announced that it would shut down operations gradually over three years, eliminating 500 jobs.

Big Island plantations consolidated in an effort to cut expenses (and jobs), while others simply ceased operation. By the early 1980s, the Hamakua Sugar Company, which was a consolidation of seven plantations on the Hamakua-Hilo coast, was the second largest plantation in the state. Size, however, did not stem the decline. Yields per acre dropped, partly due to operational difficulties caused by the lack of financial resources, which made it difficult to maintain and modernize equipment.

The sugar industry on the Big Island ended in the mid-1990s. The Hamakua Sugar Plantation processed its final harvest in 1994 and closed shop permanently. A few other mills operated until 1996, but they also went out of business. Sugar continued to be grown on Kaua'i and Maui, but it was no longer the state's most important product, and it was no longer grown at all commercially on the Big Island.

Like sandalwood and whaling in the past, sugar ultimately proved unsustainable as the primary product of the Big Island. Ranching and coffee and macadamia nut farming continued, but they were not enough to sustain the entire population and provide jobs to the thousands who had previously worked in the sugar industry.

A new product or industry was necessary, and the Big Island, like the rest of the state, looked toward tourism as a solution. And like the sugar industry before it, the tourist industry would cause dramatic social, political, racial, and geographic changes on the Big Island.

EXPLORERS, TRAVELERS, AND TOURISTS

Early travelers to the Big Island came not as tourists, but as explorers, missionaries, or scientists. Cook and Vancouver in the late eighteenth century were on expeditions sponsored by the British government to find the fabled (and mythical) Northwest Passage, and to explore the South Pacific. Charles Ellis, in his trip around the island in 1823, searched for appropriate spots to establish missions.

In 1825, Lord Byron, the cousin and successor of the poet who died the previous year, commanded the British ship that returned the bodies of King Kamehameha II and Queen Kamamalu to Hawai'i after their deaths from measles in London. When this sad duty was completed, Byron then undertook a scientific investigation of the islands.

His ship, the Blonde, was the first large vessel to anchor in Hilo Bay. Both Cook and Vancouver had avoided it, fearing that strong winds would blow their ships ashore. The breakwater in Hilo Bay is built on what is still called Blondes Reef, after the ship. The bay itself was for many years called Byrons Bay, at the insistence of Regent Ka'ahamanu. There is also a Byrons Ledge near the Volcano House Hotel.

This latter is appropriate, since Byron was the first to conduct a scientific study of the volcanoes. To make his visit easier, Ka'ahamanu sent 200 Hawaiians to assist the British in their journey up the mountain. When he returned to England, Lord Byron, like Cook and Vancouver before him, published his journals, further exposing both the Sandwich Islands and the remarkable volcanoes.

The next scientist to come to Hawai'i was the Scottish botanist David Douglas. During the previous decade he had traveled throughout California and Oregon, cataloging and naming plants and animals unknown to Europeans. He also sent specimens back to London. His most famous discovery was the California fir tree that still bears his name.

By 1834, he was on the Big Island. He climbed to the top of Mauna Kea, despite poor health and eyesight that was worse. In July, he set out from Kohala to walk the 100 miles to Hilo. Along the way, he had breakfast at the home of one Ned Gurney,

a somewhat suspicious Australian then living in Kohala and the last person to see the 36-year-old Douglas alive. The next morning his body was discovered in a bullock pit, one of several that Gurney had dug to trap wild bulls. A bull stood over Douglas' body inside the pit.

It is entirely possible, given his poor eyesight, that Douglas simply fell into the pit and was killed by the beast. However, there has always been a suspicion that Gurney murdered Douglas for his money. By the time his body reached Hilo, it was impossible to determine the cause of death. From there it was transported to Honolulu, handed over to the British consul, and buried in the Kawaiahao Church cemetery.

In the late 1830s and early 1840s, the American government also sponsored a scientific expedition, commanded by navy Lieutenant Charles Wilkes. Wilkes and his men explored parts of Antarctica and western South America before reaching Hawai'i in late 1840. They stopped first in Honolulu, then went on to Hilo in order to study the volcanoes. By this time, Hilo, in Wilkes' account, was a "straggling village rendered almost invisible by the luxuriant growth of the sugar-cane, which the natives plant around their houses."

The Americans remained for a few days in Hilo, set up an observatory at Waiakea Point, and then prepared to attack the mountain. Wilkes had, of course, read Lord Byron's account of exploring the volcanoes, and was quick to point out that the American expedition was quite different. Byron's journey was a kind of "triumphal procession"; the American version was more like "a May-day morning in New York, or a vast caravan."

Indeed, this "caravan" consisted of "two hundred bearers of burdens, forty hogs, a bullock, and a bullock-hunter, fifty bearers of poe (native food), twenty-five with calabashes, of different sizes and shapes, from two feet to six inches in diameter." Some of these bearers carried panels of a portable house; others carried cookware, tents, and knapsacks. In addition, there were:

> a large number of hangers-on, in the shape of mothers, wives, and children, equaling in number the bearers, all grumbling and complaining of their loads; so that wherever and whenever we stopped, confusion and noise ensued.

As they climbed, Wilkes was impressed by the "grandeur" of Mauna Loa. The dome was a bronze color, and "its uninterrupted smooth outline was relieved against the deep blue of a tropical sky." As he stared in awe, he was almost disappointed when

his traveling companion Dr. Gerrit P. Judd, the Hawaiian Minister of Foreign Affairs, directed his attention toward Kilauea. At first, all he saw was

> nothing before us but a huge pit, black, ill-looking, and totally different from what I had anticipated. There were no jets of fire, no eruptions of heated stones, no cones, nothing but a depression in the midst of the vast plain by which it is surrounded.

As he got closer to the crater, however, he realized that his first impression had been wrong. Indeed, he estimated that the entire city of New York could be placed within the crater and would hardly be noticed. The light from the volcano enabled Wilkes to read small print at night.

Leaving Kilauea the next morning, Wilkes and his party continued on to the summit of Mauna Loa. The temperature fell to as low as 17 degrees at night. When they finally reached the summit, Wilkes placed his astronomical instrument at the highest spot "and turned it upon Mauna Kea, to measure the difference in the height of these twin giants of the Pacific." He discovered that Mauna Loa was 300 feet higher than previous estimates, but still not as tall as Mauna Kea, which was 193 feet higher.

The party stayed on the summit for several days before beginning the trip back in mid-January of 1841. They returned by way of Kilauea in time to witness an eruption on January 17. Wilkes estimated that the volcano produced 200 million cubic feet of lava while they watched. When the expedition was over, Wilkes, like Byron before him, published his account of his exploration of the volcanoes.

The publicity from all these early explorers attracted others to the Big Island, especially to see the volcanoes. In 1842, Sarah Lyman wrote to her sister in New England that "it has become quite fashionable for individuals in civilized lands to make a trip to these fair Ocean isles." They often came for reasons of health, but the volcano attracted them to the Big Island. As yet, however, there was "no regular communication between this and other ports," which meant that travelers could be "detained here weeks, waiting for a vessel." Each year, Lyman reported, "more and more people wanted to see the volcano."

Getting there was definitely not half the fun. It easily took three weeks to sail from Honolulu to Hilo, visit the volcano, and make the return trip back to Honolulu. The editor of the Honolulu newspaper, The Polynesian, wrote about his experiences in 1847, estimating the cost at $50 and reporting that it took three weeks. Ten years later, another traveler reported the trip from Honolulu to Hilo took ten days. After

visiting the crater, he returned to Hilo and had to wait an additional week for a ship to take him back to Honolulu.

The journey from Hilo to the volcano was itself an arduous 30-mile horseback ride, which required an overnight stay. Early visitors took whatever shelter they could find; grass huts were a luxury. As more people ventured up the mountain, however, the prospect of building a more permanent shelter became practical. An open-sided thatched hut built in 1865, the first Volcano House, is certainly the earliest tourist "hotel" on the Big Island. Built between Kilauea and Mauna Loa, the structure had no furniture and only mats on the floor. The following year, in 1866, Julius Richardson built a frame, bamboo, and thatched hotel. Now there was a parlor, fireplace, and two rooms for sleeping. It was luxurious in comparison to what had been there before. One return visitor wrote that Richardson had "converted the sojourn here from a scene of suffering from cold and wet and hunger, into one of comparative comfort."

The most famous visitor to this Volcano House was Mark Twain. On assignment for the Sacramento Union newspaper, Twain would be termed a travel writer today, though he was sometimes more interested in entertaining his readers than he was in presenting a completely accurate view of his adventures. Nevertheless, his "Letters from the Sandwich Islands" (that term itself was outdated) firmly established his career as a writer and further publicized the wonders of the Big Island.

Twain set out for Hawai'i from Honolulu in July 1866 on the schooner Boomerang "as long as two street cars, and about as wide as one." The first night as he lay in his "coffin . . . snuffing the nauseous odors of bilge-water," he felt something "gallop" over his body. "Lazarus did not come out of his sepulcher with a more cheerful alacrity than I did out of mine," he wrote, but he was relieved to discover that it was "only a rat!" Soon, however, something else "galloped" over him. He knew it wasn't a rat and suspected it might be a centipede. It was worse:

> The first glance at the pillow showed me a repulsive sentinel perched upon each end of it—cockroaches as large as peach leaves—fellows with long, quivering antennae and fiery, malignant eyes. They were grating their teeth like tobacco worms, and appeared to be dissatisfied about something.

Twain had heard that cockroaches sometimes ate off the toenails of sleeping sailors, so he decided to abandon his bunk in favor of the floor. Alas, he was once again bothered first by a rat and then by "a procession of cockroaches" that "camped" in his

hair. Shortly, the ship's rooster started to crow "with uncommon spirit and a party of fleas were throwing double summersets about my person in the wildest disorder, and taking a bite every time they struck." With some understatement, Twain reported that he "was beginning to feel really annoyed."

Finally after this miserable night, the ship reached Kailua, "a little collection of native grass houses reposing under tall cocoa-nut trees—the sleepiest, quietest, Sundayest looking place you can imagine." From Kailua, he and his party rented horses for a trip to Kealakekua. He reported that these mares were "miserable affairs [who] had lived on meditation all their lives, no doubt, for Kailua is fruitful in nothing else."

The ride through Kona to Kealakekua Bay passed through coffee farms and orange groves. Twain believed that "Kona coffee has a richer flavor than any other," though unfortunately the coffee blight and American customs duties had taken their toll on the industry. He noted that while the coffee industry was slowly improving, the sugar industry was becoming more important to the Big Island. The previous year's sugar yield, he reported "was more than twenty times what it was in 1852," while the coffee yield had only doubled in the same period.

The best lands in both North and South Kona, Twain described, weren't in control of the native population:

> Indeed, the best of the lands on all the islands appear to be fast going into foreign hands; and one of the allegations made to me by a foreign resident against the missionaries was that their influence was against such a transfer.

Reflecting on the former name of the nation, Twain suggested that Captain Cook should have named the islands the Rainbow Islands: "These charming spectacles are present to you at every turn; they are as common in all the islands as fogs and wind in San Francisco."

When they reached Kealakekua Bay, Twain and his party visited a monument to Captain Cook (an earlier version of the current one), and then they hired a "kanaka" guide to take them to Honaunau by canoe. Impressed by what he found, Twain compared the heiau to the Egyptian pyramids. Both caused wonder and speculation as to how the huge stones were transported and raised.

He also saw Ka'ahamanu's Rock at Honaunau. His guide told Twain that the queen used to fly to this rock for safety, "whenever she had been making trouble with her fierce husband, and hide under it until his wrath was appeased." Twain doubted the story: "for Ka'ahamanu was 6 feet high—she was bulky—she was built like an ox—

and she could no more have squeezed herself under that rock than she could have passed between the cylinders of a sugar mill."

A few days later, Twain reached Kilauea Volcano, and like Wilkes earlier, was at first disappointed by what he saw. He compared it to the first time one sees Niagara Falls. It never quite meets expectations the first time. But when you see Niagara Falls for the fifth time, one wonders "how he could have been so blind and stupid as to find any excuse for disappointment in the first place." Twain experienced the same kind of "first visit" letdown at Kilauea, but at least was comforted because he "fully expected to be disappointed and so, in one sense at least, I was not disappointed." All he saw was:

> a considerable hole in the ground—nothing to Haleakala—a wide, level, black plain in the bottom of it, and a few little sputtering jets of fire occupying a place about as large as an ordinary potato-patch, up in one corner—no smoke to amount to anything . . . it is a large cellar—nothing more—and precious little fire in it, too.

The more he looked the larger the "cellar" seemed to appear, and he "was obliged to confess that it was rather over three miles, though it was hard to believe it at first. It was growing on me, and tolerably fast."

He spent the night at Volcano House. There was a lookout house about a half mile from from there where he viewed the volcano after dark. "The view was a startling improvement on my daylight experience. . . . The 'cellar' was tolerably well lighted up . . . the floor of the abyss was magnificently illuminated." Obviously over his initial disappointment, Twain "reflected that many years had elapsed since any visitor had seen such a splendid display." He and his companion watched until 10:00 p.m. and then "in a half-cooked condition, because of the heat from Pele's furnaces" returned to the Volcano House.

Twain was pleasantly surprised to find such "a good hotel in such an outlandish spot." Not only was the new building itself a welcome surprise, but the food was also good: "One could not easily starve here even if the meats and groceries were to give out, for large tracts of land in the vicinity are well paved with excellent strawberries." This was the flattering picture of the Big Island and the volcano that Twain presented to his Sacramento readers and before long to rest of the country, when his articles were published in a book.

Charles Nordhoff, another popular travel writer, painted a similar glowing picture of the volcano when he visited in 1873. Like Twain, Nordhoff described the "lava

lake" within the caldera of Kilauea. This was Halemaumau crater, which bubbled and erupted more or less constantly until the 1920s. It ceased for good (so far) in the 1930s, which is why nineteenth-century descriptions and drawings sometimes confuse present day visitors who do not see the same sights.

Twain, Nordhoff, and others also described the difficulties of reaching the volcano. Despite the Volcano House hotel at the top, there were no accommodations in Hilo itself. Nordhoff suggested staying at the large home of the sheriff, and if there was no room left there, assured readers that "someone" would surely take them in. The journey by horseback up the mountain took the better part of a day, but was not a particularly difficult trip as long as the horses were well shod and the riders well protected against inevitable wet weather.

Gradually, conditions for nineteenth-century tourists who wanted to visit the volcano improved. A new and larger Volcano House opened in 1877; that building is currently the Volcano Art Center. By the 1880s, there were tourist guide books available describing how to get from San Francisco to Honolulu, and from there to the Big Island and the volcano. From San Francisco, the Oceanic Steam Ship Company ran four steamers to Honolulu. Following the seven-day trip, passengers could stay at Honolulu's Hawaiian Hotel (the only hotel at the time) for $3 a day for room and board.

To travel to the Big Island, the steamer Kinau, owned by the Wilder Steamship Line, by then made a "Volcano Trip" once a month. The Kinau, according to the guidebook, was a "splendid steamer built expressly to run on this route, and is fitted with all the modern appliances to ensure the comfort and safety of passengers." Obviously travel had improved since Mark Twain's experience a few years earlier. The $50 fare included "everything"—six days on the ship, a 14-mile ride from the beach to Volcano House, all meals and lodgings, and a guide into and out of the crater. Visiting the volcano was certainly the cheapest, as well as the most interesting, part of a person's trip to Hawai'i.

The Kinau first went to Lahaina to deliver mail and passengers, stopped at a couple of other Maui ports, and crossed the channel between Maui and Hawai'i during the night. When passengers awoke in the morning, they would find themselves at Mahukona, where they would spend most of the day. Wilder's ship Kinau conveniently brought passengers to Wilder's train, pulled by the engine Kinau: "This is the shore terminus of a railway running some twelve miles into the Kohala district where are located some of the finest sugar plantations on the island." For $2 passengers could leave the ship and ride the train to the Star Mill, see how sugar is made, have lunch, and return.

In the afternoon, the steamer left Mahukona for Kawaihae. From the ship's deck, passengers could see Pu'ukohola Heiau and the "three great peaks of the island": Mauna Kea, Hualalai, and Mauna Loa. Leaving Kawaihae, the steamer then headed back north around to the windward side of the island, past Waipi'o and Waimanu Valleys, and down the Hamakua coast, where "the scenery is grand and picturesque." Numerous waterfalls, great fields of sugar cane, and dense forests all lay before the visitors. The guidebook told the tourists to note "the ingenious means employed . . . to land freight and take off sugar." In some cases, ropes strung from high cliffs were used to cradle the freight into ships anchored offshore. At another landing, a huge derrick lowered bags of sugar into the boats.

At nightfall, the Kinau reached Hilo: "no locality . . . conveys a more perfect idea of tropic." One could observe the "grand sight" where the 1881 lava flow "terminated just at the edge of town." Additional attractions included an "unsurpassed" ride through the Hilo woods and a "very pleasant trip to Coconut Island."

After seeing the sites of Hilo, where one could get good board and lodgings for $15 a week, there were many options for the hearty tourist. He could, if time permitted, rent a horse and ride around the entire island. This would take about three weeks, cover about 300 miles, and provide opportunities to climb Mauna Kea, descend Waipi'o Valley, and see all the island's sites.

Of course the main reason for the trip was to visit the volcano, and here there was more than one option. If you did not mind a long (but interesting) three-day, 61-mile ride, you could go from Hilo via Puna to the Volcano House. If you were not up for this trip, an easier way to visit the volcano was to continue on the steamer Kinau to Keauhou Landing in Ka'u (not to be confused with Keauhou-Kona).

At the landing covered with hard black lava, the traveler could rent a horse and ride to the volcano. Because of the rough terrain, the guidebook stressed that the only comfortable way to ride was astride the horse. This advice was "especially for the benefit of the ladies," who were advised to wear bloomers and short protective riding habits.

At the Half Way House, appropriately named for the middle of the journey, one could enjoy a glass of milk and a short rest. Like the Volcano House, the Half Way House was then managed by Wilder Steamship Company. Upon reaching Volcano House "in front of us opens the great Caldera, the Volcano of Kilauea!" The hotel itself had a cheerful fire, cozy bedrooms, and a dining room with "an abundance of good food, well cooked, and neatly served."

The highlight was a visit to the caldera. The guidebook recommended wearing "good, comfortable, thick-soled shoes for the walk." A guide would take you down to

the floor of it, past "the brink of the great pit, in which the liquid lava boils and rages." There, on the bottom of Kilauea Caldera one would witness a "gorgeous display in the 'House of Fire,' that would not soon be forgotten."

With visitor numbers increasing each year, the Volcano House Company, which assumed control from Wilder, built a new and larger hotel with a tower in 1891. When Charles Nordhoff made a return visit in 1893, he found "the changes here at the Volcano House . . . as great and surprising as those in the crater itself." The "excellent service and food [were as] good as one gets in Honolulu—better one of our party says."

By this time, transportation from Hilo also had improved considerably. There was now a 32-mile macadamized road from Hilo to Volcano House, replacing an old dirt road. Additionally, twice monthly passenger stage coaches met the steamer Kinau to take tourists on a ten-hour ride up the mountain, including a stop for lunch at Halfway House.

The Inter-Island Steamship Company soon offered an alternative to Wilder's Kinau. Their ship, the W.G. Hall, sailed a different route from Honolulu, down the Kona coast and along Ka'u to Punaluu. From there a tiny 2-foot-gauge steam locomotive, belonging to the Hawaiian Agricultural Company, hauled a passenger car for 5.5 miles up a steep grade to Pahala; it was a trip that took 45 minutes. From there tourists went by carriage or stage over a 19-mile road to Volcano House.

Railroad builder Benjamin Dillingham wanted to find an even better route. By 1902, he had extended his Hilo Railroad from Ola'a Mill to Glenwood Station, only 9 miles from the volcano and 2,295 feet above Hilo. With that improvement, it was possible to make a round trip from Hilo to Kilauea and back in a single day.

Early in the new century, a Greek immigrant named George Lycurgus managed and later (during the Depression) bought the Volcano House. "Uncle George" was a great promoter and the hotel became even more famous than it had been before. In 1940, a fire in the kitchen destroyed the entire hotel except for the wing that was the old 1877 building. Lycurgus rebuilt a brand new hotel, which opened 1941 (just as the war put a temporary end to tourism) and this is the hotel that remains today. Lycurgus also managed the Hilo Hotel, which opened in 1888.

There was more to the Big Island than just the volcano. As travel became easier in the twentieth century, there was an attempt to promote the entire island as a destination for tourists and investors. In 1915, the Hilo Board of Trade touted their city's and the island's charms in a promotional pamphlet. Hilo had the second most

important port in the territory, and the nearly completed $3 million breakwater would give the city "the largest and best harbor in the territory." Vessels passing through the new Panama Canal on the way to Asia could save 200 miles by using Hilo, as opposed to any other port in the islands.

Boosters bragged that the Inter-Island Steam Navigation Company had twice-weekly service from Honolulu and there were also regular stops by Matson and other large shipping lines. Nearby Kilauea volcano was "impossible" to describe: "It should be seen by every visitor to the Hawaiian Islands," who presumably would spend a little money in Hilo before moving on to the volcano.

Roads from Hilo through Ka'u and Kona are always good, the pamphlet claimed, admitting that there were "sometimes poor stretches, but these are always practicable for automobiles." The large sums spent on road construction were "rapidly rendering bad surfaces a thing of the past."

In the long neglected Kona section "the visitor will find some of the most beautiful scenery in the Hawaiian Islands," along with perfect climate, historically fascinating sites, and good accommodations. A visitor who spends a few days on the Kona side of the island would "find himself richly rewarded."

The promised "good accommodations" appeared a bit limited. There was "the beautiful little hotel at Kealakekua, maintained by Miss Paris" ($3 per day rate) or the "charming accommodation house owned by Mrs. Aungst" at Holualoa ($4 per day). From either of these destinations tourists could take day trips to visit all the sites in Kona. "Practically the whole of the district may be covered by automobile in entire comfort," though there were some sections where horses were advisable, if not necessary. Despite the claims of the Hilo Board of Trade, Kona, with a total population of around 8,000 people at the end of World War I, was not yet destined to be a major tourist spot.

The Manago family enlarged a noodle shop in Captain Cook into the Manago Hotel in 1917, but it appealed more to traveling salesmen than it did to tourists. Getting from a ship in Kailua to hotels in places like Captain Cook or Holualoa was a difficult logistical problem in a day before the availability of rental cars. And even if they could find a way to get to the Manago Hotel, for instance, there was little for the tourists to do once they got there.

KING TOURIST

In 1928, the Inter-Island Steamship Company, hoping to increase passenger service, opened the Kona Inn. This first real luxury hotel in West Hawai'i made Kailua a viable tourist destination for the first time. Fortunately, early plans to build the hotel on the site of the Hulihee Palace were rejected, and the Palace was saved. The Kona Inn, built just south of the Palace, provided both a convenient destination for passengers and activities to keep them happy. Though it had only 20 rooms, the inn provided a beach, swimming pool, tennis courts, and a good restaurant and bar. Promotional photographs, showing Hollywood celebrities dining graciously at the hotel, ensured that its rooms were booked months in advance.

Locals also used the Kona Inn as a kind of unofficial country club. Especially on Sundays, local residents dressed in their finest clothes and would go to the inn to swim, play tennis, and eat and mingle with tourists. For many years this site was the closest thing that the area had to a first-class establishment.

It has been many years since the Kona Inn welcomed its last guest. The dining room is still there, the main lobby remains, though it is stripped of most of its elegance. But for the most part the inn has been converted into a tourist shopping center that draws far more people than it ever did as a hotel. Nevertheless, the inn provided a hint of what would come.

Tourism grew very slowly after World War II, with little initial impact on the island's overall economy. Indeed, the population of the Big Island gradually declined each decade from 1930 to 1960. The entire island had 68,350 people in 1950 and would lose another 10 percent before beginning a gradual rise in the 1960s. North and South Kona did see a rise in population from 1950 to 1960 because of an expanding coffee industry and the beginnings of a tourist industry, but there were still no more than 9,000 people in the entire district.

Economically, Kona was in trouble. Despite rising coffee prices in the postwar years, the standard of living remained low. The condition of the housing stock and median incomes were significantly worse than elsewhere in the territory. In 1950, nearly half of the homes had no electricity, more than half had

no refrigerator, and more than a third had no running water. Some people suggested that expanding the infant tourist industry might improve this unfortunate situation.

In 1951, an estimated 18,400 tourists visited Kona. Three years later, Henry J. Kaiser announced plans to develop it into a resort area that would rival Waikiki, estimating that it would create 2,000 jobs. Kaiser lost interest, instead investing his money in Kaiser-Permanente health care and several resorts in Honolulu. While the idea of a rival to Waikiki may not have appealed to everyone, the idea of improving the Big Island's economy with tourism remained attractive. By 1956, with an additional hotel to accommodate them, 40,000 tourists visited Kona, more than double the number five years before.

When Hawai'i achieved statehood in 1959, the new state government saw tourism as a growth industry, especially for the outer islands. A Stanford Research Institute analysis singled out the Big Island as the one with more potential attractions than any of the others. Another study, commissioned by the state from the consulting firm of Harland Bartholomew and Associates produced, "A Plan for Kona" in 1960, which provided a list of recommendations for developing a major tourist industry in the area.

The plan came none too soon. Coffee prices started to drop again in the late 1950s, and Kona increasingly became a depressed region. While the Big Island as a whole had 9.3 percent of its housing classified as dilapidated, the figure for North and South Kona was 18.9 percent. Many more were simply "sub-standard." Median family income for Kona was approximately 20 percent lower than that for the entire island and a full 40 percent lower than Honolulu's.

The potential for expanded tourism was there because of the beauty of the rugged coastline, the climate, the large number of historical sites, and the possibility for sport fishing and other recreation. Indeed by 1959, even without new enticements, tourism had already supplanted coffee as the most important component of the Kona economy. Even though there were only 291 tourist rooms before the King Kamehameha Hotel opened in early 1960 (adding 105 more rooms), the service industry, including hotels, accounted for 33 percent of the region's economy. Coffee was responsible for only 25 percent. With coffee prices declining, the need to do something to promote additional tourism grew more important.

Before that could happen, however, many improvements were required to the region's basic infrastructure. A survey of local residents found the greatest needs were for improved schools, roads, water, fire protection, recreational facilities, housing,

airport, and shopping. Tourism would depend on hotels; hotels would require workers; workers would require affordable housing.

The Bartholomew study listed the high priority improvements necessary to turn Kona into a major tourist destination:

1. Relocation of the airport from Kailua-Kona to a "more suitable site."
2. Improvements to the shoreline in resort areas, such as Kahaluʻu Bay Park (the best beach in Kona).
3. A top-quality golf course. West Hawaiʻi had none at the time.
4. Expanded harbor facilities to promote deep sea fishing and boating.
5. Improved highways from Kona to other interesting points.
6. Extensive restoration of historic sites, such as the City of Refuge and the Ahuena Heiau near the King Kamehameha Hotel.
7. Riding and hiking trails.
8. Development of hunting and fishing facilities throughout the entire Big Island.

These improvements, it was predicted, would spur hotel and resort development, attract tourists, and fix Kona's sagging economy. By 1970, the report projected the service industry would constitute 55 percent of Kona's total income. Coffee would drop to a mere five percent. A side benefit of an expanded tourist industry would be the attraction of retired people, who would also enjoy the same facilities that would attract tourists.

Many of these recommendations were followed. The new airport at Keahole Point opened in 1970, as did an improved Honokohau Harbor. A new Hilton Hotel (now the Royal Kona Resort) opened and almost immediately expanded to 425 rooms in the 1960s, making it the largest hotel on the Big Island at the time. Other resort hotels soon followed between Kailua and Keauhou, and the Hotel Kamehameha also expanded. The original building, only 15 years old, was demolished to make room for a new, larger facility.

Meanwhile, the state's interest in developing tourism on the outer islands also began to focus on the Kohala coast, which had some of the best beaches on the island. That area also experienced economic decline with the phasing out of the Kohala sugar

industry. This coastline caught the attention of Laurance Rockefeller, who partnered with the Honolulu-based Dillingham Corporation to lease land from the Parker Ranch in the late 1950s.

The resulting Mauna Kea Beach Resort was the Big Island's first sizable destination resort. The Kona Village Resort actually opened a few months earlier, but the Mauna Kea received most of the publicity. Built on Kauna'oa Bay just south of Kawaihae, the resort included West Hawai'i's first golf course, designed by Robert Trent Jones Sr. Rockefeller had doubts about the feasibility of constructing a golf course on top of lava, but Jones discovered that the lava could be crumbled into fine, rich dirt that with water turned into fertile soil. After experimenting with several tons of crushed lava, Jones found that grass grew quite well. The golf course opened in 1964, a year before the resort itself was completed.

The retreat, which included 30 acres of gardens, cost approximately $15 million to build. It had only 154 rooms at first, but was decorated with Asian and Pacific art. Esquire magazine called it one of the costliest resorts in the world. More importantly, the magazine considered it one of the three greatest hotels in the world (the other two being the Plaza in New York and the Pitti Palace in Venice). Holiday magazine was a bit less enthusiastic about a hotel built in a "god-forsaken landscape," but admitted that it was like a "diamond tiara in the hair of a pygmy."

Even more to the point, speakers at the Dedication Luncheon on July 24, 1965, welcomed the anticipated and expected economic benefits the resort would bring. Shunichi Kimura, Hawai'i County Chairman and Executive Officer, noted that this one resort alone would increase the county's property tax base by four percent and its workforce by one-and-a-half percent. Hawai'i Lieutenant Governor William S. Richardson predicted that this was only the first of many resorts. The pattern of development, he believed, would help reverse the rapid flow of people leaving the Big Island for O'ahu, increasing the stability of the entire state.

Richardson promised the state would do its part in building new roads, providing deep water ports to import building materials, developing new water resources, and improving the airport. The opening of the Mauna Kea Beach Resort, he said, "marks the beginning of economic development in a beautiful corner of the State of Hawai'i."

Were these dreams fulfilled over the next 30 or 40 years? To some extent they were. The explosion of resorts on the Kohala coast, resort hotels and condominiums from Kailua to Keauhou, and the tremendous growth of new housing all created

jobs. They also significantly changed the physical landscape as least as much as nineteenth-century sugar plantations did. The number of hotel rooms available on the Big Island grew from 370 in 1952 to 686 in 1960 and over the next 40 years mushroomed to nearly 10,000 in the year 1999. Direct flights from the mainland to Kona, which United Airlines offered beginning in 1983, aided the tourist industry tremendously.

Not surprisingly, the growth was concentrated in West Hawai'i. By 1999, Kona had 4,315 available units and Kohala/Waimea/Kawaihae 4,033, but Hilo only 1,196. Tourism had a much greater impact in the west than it did in the more stable East Hawai'i.

The ethnic makeup of the permanent population also changed dramatically. In 1950, people of Japanese ancestry constituted 47.5 percent of Kona's population. Hawaiians and part-Hawaiians made up an additional 29%. Haoles accounted for only 6.5 percent. Forty years later, the total population had quadrupled (from 7,330 in 1950 to 29,942 in 1990). But in those latter year, haoles constituted 53.7 percent, Hawaiian 18.2 percent, and Japanese 13.4 percent.

Economically, by the end of the century, the Big Island's median income still lagged behind the rest of the state, but the gap was not nearly as great as it had been in 1950. Many of the new jobs created were in the low paying service sector, but others in the construction industry paid well. By the end of the century, even service jobs often paid more than similar jobs on the mainland, though the cost of living in Hawai'i was also higher. However, in the resort hotels the highest salaried management jobs, and even mid-level jobs, usually went to imported employees of the owning corporation and not to locals.

The shift to tourism did little to diversify the economy, as it still depended overwhelmingly on a single industry. This dependence was not unique to the Big Island; Maui and Kaua'i, and to a lesser extent O'ahu, had similar experiences. Despite the success, tourism has a downside. It is no more an economic panacea than what the sugar industry became. Moreover, the tourist industry is to a large extent controlled by outsiders. The major resort hotels are owned by huge multinational American and Japanese corporations, which may not always have the interests of the islands as their first priority. The sugar industry, though controlled by an oligarchy, was at least controlled by a largely local oligarchy.

Both the sugar and tourist industries were subject to outside forces beyond local control. For sugar (and coffee) competition from other countries, as well as tariffs and subsidies, influenced Hawaiian profits. With tourism, economic conditions elsewhere affected profits, and in this case mainly those of the mainland and Japan. Since the

overwhelming number of visitors arrive in Hawai'i by air, tourism is also influenced by fuel prices, airline strikes, terrorist attacks, and war. Natural disasters, such as the devastation caused to Kaua'i by Hurricane Iniki in 1992, also can have a negative impact. The next tsunami or further volcanic activity could do the same to the tourist industry of the Big Island.

Occasionally a natural disaster can improve tourism. This happened when Kilauea Volcano began to erupt again just as the sugar industry was declining. The drive-in volcano enticed tourists to stray from the Kona coast and travel to East Hawai'i and thousands of people poured into lower Puna and Hilo in order to make the trek. Many of them came from other islands in the state, since the number of annual visitors to the park far exceeded the combined total of residents and out-of-state tourists to the Big Island as a whole.

Conversely, a large numbers of visitors can overwhelm the infrastructure and negatively affect the environment of places such as the Big Island that have relatively small permanent populations. Nearly 1.3 million tourists visited the Big Island annually by the end of the twentieth century, with 80 percent of them staying in West Hawai'i. Tourism by its nature contains a certain amount of built-in tension between locals and visitors, but for the most part Hawai'i has been fortunate in avoiding clashes that have occurred in other parts of the world that depend heavily on tourism.

The very success of the tourist industry potentially can overwhelm roads, water, power, police, fire, and other resources, affecting the quality of life for residents and tourists alike. There is also the possibility of "too many tourists" discouraging others who wish to visit. Traffic jams in Kona sometimes reach mainland, big city proportions. In the last quarter of the twentieth century, while the number of vehicles in West Hawai'i tripled, new road construction was close to non-existent. Additionally, crime increased faster than the population, and by the 1990s the Big Island also had a significant drug problem. It may be unfair to blame these problems completely on the tourist industry, but there is certainly some relationship. It could be worse, for Maui (which has a smaller permanent population than the Big Island) has nearly twice as many visitors annually.

For better or worse, the growth of the tourist industry on the Big Island, and especially in West Hawai'i, profoundly affected and continues to influence the lives of the people who live there. After World War II, the island was still a somewhat sleepy, sparsely populated community dependent on agriculture and ranching. Travel brochure images of Hawai'i depict a calm and laid back environment where vacationers can forget all their problems and spend a few days in a tropical paradise.

This is, as a subtitle of one book succinctly puts it, the legend that sells. Unfortunately, along with the palm trees, sandy beaches, and nice weather, sometimes tourists also find crowds, traffic, crime, and fast food not too different from the life they left at home.

The campaign of the missionaries, planters, and others to "Americanize" Hawaii was ultimately a smashing success.

GLOSSARY

‘A‘a Rough volcanic lava, produced by explosive eruptions. See also pahoehoe.

Ahupua‘a A division of land parceled by natives, extending from the sea up a mountain. The purpose is to provide a community all types of terrain and climate to be self-sustaining.

Ali‘i Chief, chiefess, noble person.

‘Awa Kava. A bitter narcotic drink made from the roots of a pepper plant.

Great Mahele The land redistribution plan of 1848. Divided all lands in the kingdom, traditionally held by the king, giving portions to the king, government, nobles, and commoners.

Hale House. Home.

Haole Traditionally any foreigner, but usually applied only to caucasians.

Heiau A temple to worship one of the traditional Hawaiian gods.

Kahuna Priest.

Kahuna Nui High Priest.

Kanaka A person or individual; the subject of an ali‘i.

Kapa Traditional Hawaiian cloth, made from the bark of mulberry and other trees.

Kapu A taboo or ban. Violating a kapu could result in severe punishment or death. The traditional Hawaiian religious system was based on kapus.

Kava See ‘awa.

Ku The Hawaiian god of war

Kuhina Nui Co-ruler. A title retained by Ka‘ahamanu upon the death of Kamehameha I. The Kuhina Nui and king jointly ruled the kingdom. The position was abolished in 1864.

Kuka‘ilimoku The representation of the war god Ku, worshiped and protected by the kings of Hawai‘i.

Lono The god of agriculture and peace, worshiped during the Makahiki festival.

Luakini Large national heiaus, sometimes the sites of human sacrifice. Usually built at the seat of power of a king.

Makahiki Annual four-month festival of peace and thanksgiving in honor of the god Lono.

Makai In the direction of the sea, as in the "makai" side of the road.

Mauka In the direction of the mountains, as in the "mauka" side of the road.

Moʻi Hawaiian King

ʻOkina Pronunciation mark (ʻ) used to indicate a glottal stop, as in the English phrase "uh-oh."

Pahoehoe Smooth lava, produced by flows rather than violent eruptions. See also ʻaʻa.

Paniolo A Hawaiian cowboy; derived from the Hawaiian pronunciation of the word Español, or Spanish.

Pele The goddess of volcanoes.

Puʻuhonua A place of refuge or sanctuary. A person who reached a puʻuohonua after violating a kapu or being defeated in war could escape punishment.

Taro Traditional Hawaiian starchy root, cultivated to produce poi and other foods. The basis of the Hawaiian diet.

BIBLIOGRAPHY

Adler, Jacob. Claus Spreckels; the Sugar King in Hawaii. Honolulu: University of Hawaii Press, 1966.

Barrot, Theodore-Adolphe. Unless Haste Is Made: A French Skeptic's Account of the Sandwich Islands in 1836. Kailua, HI: Press Pacifica, 1978.

Best, Gerald M. Railroads of Hawaii. San Marino, CA: Golden West Books, 1978.

Bevens, Darcy, ed. On the Rim of Kilauea, Excerpts from the Volcano House Register 1865–1955. Hawaii National Park: Hawai'i Natural History Association, 1992.

Bingham, Hiram A.M. A Residence of Twenty-One Years in the Sandwich Islands, or the Civil, Religious, and Political History of Those Islands. Intro. by Terence Barrow, Ph.D. Hartford, CT: Hezekiah Huntington, 1847; Charles E. Tuttle Company, Inc., 1981.

Blackford, Mansel G. Fragile Paradise, the Impact of Tourism on Maui 1959–2000. Lawrence, KS: University Press of Kansas, 2001.

Bouvet, P. Ernest. The Final Harvest, The Hamakua Sugar Company 1869–1994. Hong Kong: 1995, 2001.

Brennan, Joseph. The Parker Ranch of Hawaii. New York: The John Day Company, 1974.

Broeze, Frank J.A., trans. A Merchant's Perspective: Captain Jacobus Boelen's Narrative of His Visit to Hawaii in 1828. Honolulu: The Hawaiian Historical Society, 1988.

Bryan, Edwin H. Jr. and Kenneth P. Emory. The Natural and Cultural History of Honaunau, Kona, Hawaii. Honolulu, HI: Bernice Pauahi Bishop Museum, 1986.

Cheever, Henry T. Life in the Sandwich Islands; or, The Heart of the Pacific As It Was and Is. New York: A.S. Barnes & Company, 1851.

Clark, John R.K. Beaches of the Big Island. Honolulu: University of Hawai'i Press, 1985.

Clarke, Ferdinand Lee. The Hawaiian Guide Book Containing a Brief

Description of the Hawaiian Islands. San Francisco, CA: Herald of Trade Publishing Company, 1888.

Clemens, Samuel Langhorne. Letters from the Sandwich Islands, Written for the Sacramento Union, Palo Alto, CA: Stanford University Press. 1938.

Clement, Russell. "From Cook to the 1840 Constitution: The Name Change from Sandwich to Hawaiian Islands." The Hawaiian Journal of History 14 (1980): 50–57.

Coan, Titus. Life in Hawaii, An Autobiographical Sketch of Mission Life and Labors (1835–1881). New York: Anson D.F. Randolph & Company, 1882.

Coffman, Tom. The Island Edge of America, A Political History of Hawai'i. Honolulu: University of Hawai'i Press, 2003.

Conde, Jesse C. and Gerald M. Best. Sugar Trains, Narrow Gauge Rails of Hawaii. Felton, CA: Glenwood Press, 1973.

Cook, James. Captain Cook's Voyages of Discovery. Everyman's Library, ed. John Barrow. New York: Dutton, 1967.

———— and James King. A Voyage to the Pacific Ocean; Undertaken by Command of His Majesty, for Making Discoveries in the Northern Hemisphere. London: John Stockdale, Scatcherd and Whitaker, John Fielding, and John Hardy, 1784.

Cordy, Ross. Exalted Sits the Chief: The Ancient History of Hawai'i Island. Honolulu, HI: Mutual Publishing, 2000.

Daws, Gavan. Shoal of Time: A History of the Hawaiian Islands. Honolulu: University of Hawai'i Press, 1968.

Dillon, Richard H. "Kanaka Colonies in California." Pacific Historical Review. 25.1 (February 1955): 17–23.

Dudley, Walt and Scott C.S. Stone. The Tsunami of 1946 and 1960 and the Devastation of Hilo Town. Virginia Beach, VA: The Donning Company, 2000.

Dudley, Walter C. and Min Lee. Tsunami! Honolulu: University of Hawai'i Press, 1988.

Dye, Tom. "Population Trends in Hawaii Before 1778." The Hawaiian Journal of History 28 (1994): 1–20.

Ellis, William. Polynesian Researches: Hawaii. New Edition, Enlarged and Improved. London: Peter Jackson, 1842; Charles E. Tuttle Company, 1969.

Engebretson, George. Parker Ranch, Hawaii's Cattle Kingdom. Carpinteria, CA: Legacy Publishing, 1993.

Ethnic Studies Program, University of Hawai'i. A Social History of Kona. 2 volumes. Honolulu: University of Hawai'i, Manoa, 1981.

Farrell, Bryan H. Hawaii, the Legend that Sells. Honolulu: The University of Hawai'i Press, 1982.

Fuchs, Lawrence H. Hawaii Pono "Hawaii the Excellent": An Ethnic and Political History. Honolulu, HI: Bess Press, 1961.

Greene, Linda Wedel. "A Cultural History of Three Traditional Hawaiian Sites on the West Coast of Hawai'i Island." www.cr.nps.gov/history/online_books/kona/history.htm: National Park Service.

Harland Bartholomew and Associates. A Plan for Kona, Prepared for the Hawaii State Planning Office. Honolulu: Hawai'i State Planning Office, 1960.

James, Van. Ancient Sites of Hawai'i: Archaeological Places of Interest on the Big Island. Honolulu, HI: Mutual Publishing, 1995.

Joesting, Edward. Hawaii: an Uncommon History. New York: W.W. Norton & Company, Inc., 1972.

Kamakau, Samuel M. Ruling Chiefs of Hawaii. Revised. Honolulu, HI: The Kamehameha Schools Press, 1991.

Kent, Noel J. Hawaii, Islands Under the Influence. New York, and London: Monthly Review Press, 1983.

Kirch, Patrick Vinton. Legacy of the Landscape: An Illustrated Guide to Hawaiian Archaeological Sites. Honolulu: University of Hawai'i Press, 1996.

Kona Historical Society. A Guide to Old Kona. Kalukalu-Kona, HI: Kona Historical Society, 1998.

———. Documenting the History of Ranching in Kona: An Oral History. Kalukalu, HI: Kona Historical Society, 1992.

Kona Japanese Civic Association. Old Time Kona Stories. N.p: Kona Japanese Civic Association, 1998, 2002.

Kuykendall, Ralph S. The Hawaiian Kingdom. 3 volumes. Honolulu: University of Hawai'i Press, 1938, 1953, 1967.

Lyman, Henry M. Hawaiian Yesterdays, Chapters from a Boy's Life in the Islands in the Early Days. Chicago, IL: A.C. McClurg & Company, 1906.

Malo, David. Hawaiian Antiquities (Moolelo Hawaii). Honolulu, HI: Bishop Museum, 1951.

Martin, Margaret Greer, ed. The Lymans of Hilo. Hilo, HI: Lyman House Memorial Museum, 1979.

Melendy, H. Brett. Hawaii, America's Sugar Territory 1898–1959. Lewiston, NY: The Edwin Mellen Press, 1999.

Merry, Sally Engle. Colonizing Hawai'i: The Cultural Power of Law. Princeton, NJ: Princeton University Press, 2000.

Mrantz, Maxine. Whaling Days in Old Hawaii. Honolulu: Tongg Publishing Company, Ltd., 1976.

Nordhoff, Charles. Northern California, Oregon and the Sandwich Islands. Centennial Printing. New York: Harper & Row, 1874; Ten Speed Press, 1974.

Nordyke, Eleanor C. The Peopling of Hawai'i. Second Edition. Honolulu: University of Hawai'i Press, 1989.

Obeyesekere, Gananath. The Apotheosis of Captain Cook. Princeton, NJ: Princeton University Press and Bishop Museum Press, 1992.

Osorio, Jonathan Kay Kamakawiwoole. Dismembering Lahui, A History of the Hawaiian Nation to 1887. Honolulu: University of Hawai'i Press, 2002.

Parker, Barry. Stairway to the Stars, The Story of the World's Largest Observatory. New York and London: Plenum Press, 1994.

Piianaia, Nancy. Traditional Food Establishments on the Island of Hawaii, Volumes I & II. Captain Cook, HI: Kona Historical Society, n.d.

Puette, William J. The Hilo Massacre. Honolulu: University of Hawai'i Center for Labor Education and Research, 1988.

Sahlins, Marshall. How "Natives" Think, About Captain Cook, For Example. Chicago, IL, and London: University of Chicago Press, 1995.

———. Islands of History. Chicago, IL, and London: University of Chicago Press, 1985.

Schmitt, Robert C. "Population Policy in Hawaii." The Hawaiian Journal of History (Honolulu) 8 (1974): 90–110.

———. "How Many Hawaiians Live in Hawaii?" Pacific Studies 19.3 (September 1996): 31–35.

———.Demographic Statistics of Hawaii: 1778–1965. Honolulu: University of Hawai'i Press, 1968.

———, and Eleanor C. Nordyke. "Death in Hawai'i: The Epidemics of 1848–1849." The Hawaiian Journal of History 35 (2001): 1–13.

Stannard, David E. Before the Horror: The Population of Hawaii on the Eve of Western Contact. Honolulu: University of Hawai'i, 1989.

State of Hawai'i. Department of Business, Economic Development, & Tourism.

www.hawaii.gov/dbedt/index.html: State of Hawai'i.

Stephan, John J. Hawaii Under the Rising Sun, Japan's Plans for Conquest After Pearl Harbor. Honolulu: University of Hawai'i Press, 1984.

Stephenson, Larry K., ed., Kohala Keia (This is Kohala), Collected Expressions of a Community. Kohala Library Fund, December 1977 (Third Printing, 2001).

Takaki, Ronald. Pau Hana, Plantation Life and Labor in Hawaii. Honolulu: University of Hawai'i Press, 1983.

Tate, Merze. The United States and the Hawaiian Kingdom: A Political History. New Haven, CT: Yale University Press, 1965.

Teggart, Frederick J., ed. Around the Horn to the Sandwich Islands and California 1845–1850, Being a Personal Record Kept by Chester S. Lyman. New Haven, CT: Yale University Press, 1924.

Thomas, Mifflin. Schooner from Windward, Two Centuries of Hawaiian Interisland Shipping. Honolulu: University of Hawai'i Press, 1983.

Vancouver, George. A Voyage of Discovery to the North Pacific Ocean and Round the World 1791–1795. W. Kaye Lamb, ed. 4 volumes. London: 1798; The Hakluyt Society, 1984.

Wagner-Wright, Sandra. History of the Macadamia Nut Industry in Hawaii, 1881–1981, from Bush Nut to Gourmet's Delight. Lewiston, NY: The Edwin Mellen Press, 1995.

Wilcox, Carol. Sugar Water, Hawai'i's Plantation Ditches. Honolulu: University of Hawai'i Press, 1996.

Wilkes, Charles. Narrative of the United States Exploring Expedition During the Years 1839, 1840, 1841, 1842. London: Ingram, Cooke, and Company, 1852.

Wisniewski, Richard A. The Rise and Fall of the Hawaiian Kingdom (A Pictorial History). Honolulu, HI: Pacific Basis Enterprises, 1979.

Wiswell, Ella L., trans. Hawaii in 1819: A Narrative Account by Louis Claide De Sauleses de Freycinet. Honolulu, HI: Bishop Museum, 1978.

Yardley, Paul T. Millstones and Milestones, The Career of B.F. Dillingham 1844–1918. Honolulu: University Press of Hawai'i, 1981.

INDEX

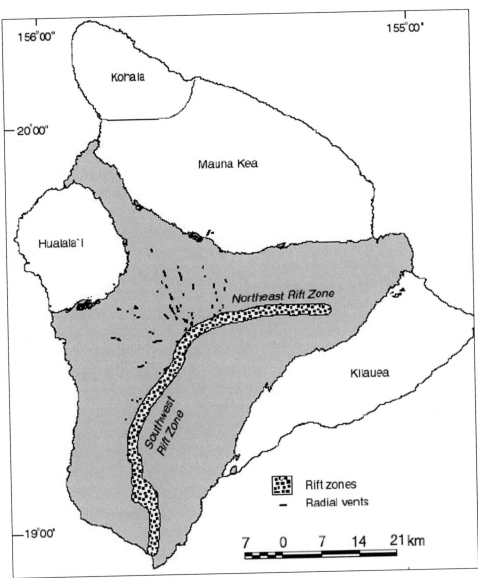

The five volcanoes that comprise the Big Island. Mauna Loa (shown in grey) covers 51 percent of the island's surface. Most of the volcano's eruptions have been—and probably will be—at the summit and along the two "rift" zones. Courtesy of the United States Geological Survey.